WATERMEDIA TECHNIQUES FOR RELEASING THE CREATIVE SPIRIT

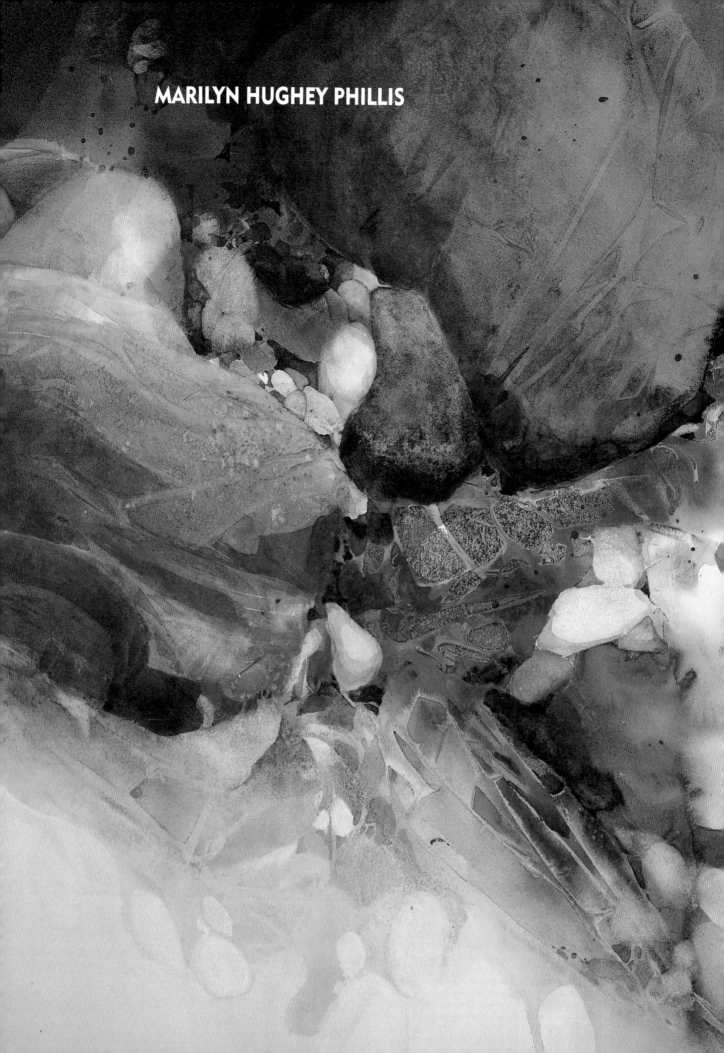

MARILYN HUGHEY PHILLIS

WATERMEDIA TECHNIQUES FOR RELEASING THE CREATIVE SPIRIT

WATSON-GUPTILL PUBLICATIONS
NEW YORK

Every painting is an adventure in the search for truth and beauty through the use of color, form, and light. I am always looking beyond the surface to depict how people respond to nature. It is not just what the eye sees, but what the soul senses, that I find important. This is what I want to communicate in my work.

Art on title page: *Hidden Treasure* by Marilyn Hughey Phillis. Transparent watercolor and gouache on Crescent no. 114 cold-pressed illustration board, 19½ x 29¾" (50 x 76 cm). Collection of Dean Witter Reynolds, Inc., Jackson, Miss.

Art facing contents page: *Frilly White* by Roberta Carter Clark. Transparent watercolor on D'Arches 140 lb. cold-pressed watercolor paper, 17 x 22" (43 x 56 cm). Collection of the artist.

All the art in this book, unless otherwise noted, is by Marilyn Hughey Phillis.

Copyright © 1992 Marilyn Hughey Phillis
First published in 1992 in the United States by Watson-Guptill Publications,
a division of BPI Communications, Inc.,
1515 Broadway, New York, N.Y. 10036.

Library of Congress Cataloging-in-Publication Data
Phillis, Marilyn Hughey.
 Watermedia techniques for releasing the creative spirit / Marilyn
Hughey Phillis.
 p. cm.
 Includes index.
 ISBN 0-8230-5698-8
 1. Watercolor painting—Technique. I. Title.
ND2420.P47 1992
751.42'2—dc20 92-13481
 CIP

Distributed in Europe, the Far East, Southeast and Central Asia, and South America
by RotoVision S.A., 9 Route Suisse, CH-1295 Mies, Switzerland.

Manufactured in Malaysia

First printing, 1992

2 3 4 5 6 7 8 9 10/96 95 94 93 92

In memory of Helen and Paul Hughey, who nurtured;
Richard Waring Phillis, who encouraged;
and to their legacy, Diane, Hugh, and Randall,
where love stays alive.

I would like to express my appreciation to Win and Don Dodrill, who first encouraged me to write this book, and to my family, students, and friends, whose moral support and patient listening meant so much over the long span of writing time.

I extend my heartfelt thanks to the many artists who shared their ideas and work with me. I felt it important to go beyond my own work to show the immense span of thought and expression in the field of watermedia painting.

It was a joy to work with editors Candace Raney and Janet Frick. Their practical suggestions, incisive questions, helpful criticism, and encouragement were greatly appreciated.

My thanks go to Jay Anning, whose design makes the book a visual reading pleasure, and to Ellen Greene for production supervision.

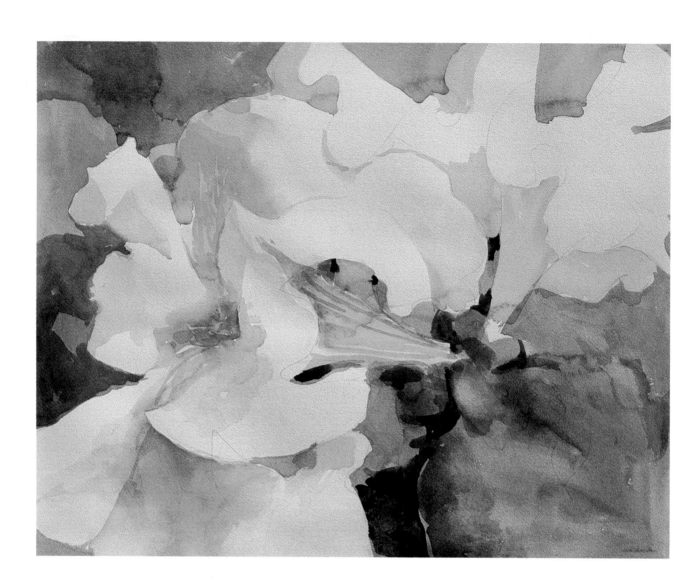

CONTENTS

INTRODUCTION

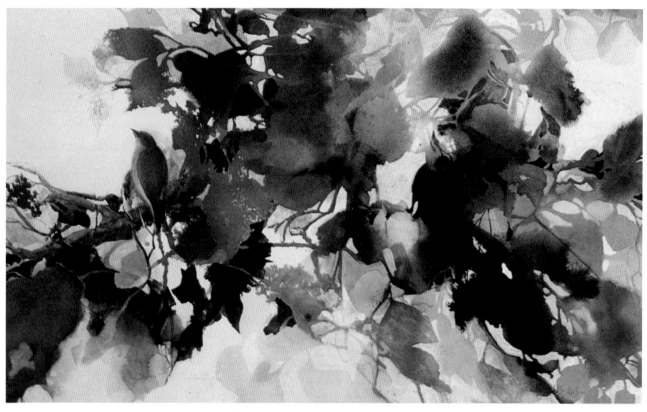

RHAPSODY IN BLUE
Watercolor, ink, and acrylic on Crescent no. 114 cold-pressed watercolor board, 13 x 21½" (33 x 55 cm). Private collection, Springfield, Ohio.

I began this painting quite spontaneously with a few pale neutral washes to establish an initial abstract pattern and sense of direction. Then I took a bold step and dropped staining colors of intense blue and green ink onto the partially dampened paper. As I moved the board from side to side, the ink ran in random patterns that later became branches. After this stage dried, I knew the painting had to celebrate the energetic return of spring—my favorite season.

Leaves were defined both by negative shape painting using acrylics and by adding some positive shapes in ink and acrylics. Notice the interaction of the forms of painting. The faint underpainting now added depth in the shape of distant leaves and branches. The freedom of spontaneity, coupled with later discipline of applied definition, fused into a vigorous creative statement.

Everyone has a source of creativity. It can be expressed in innumerable ways, depending on the unique experience of that person. Disbelief in the validity of personal experience and expression is the stumbling block for many artists, particularly as they measure themselves against the work and ideas of others. They hesitate to examine what they as individuals have to offer as something of real worth. But each artist does have a contribution to make. The purpose of this book is to encourage artists to discover their own creative gifts, which will add a personal stamp to their work. The book emphasizes that individual interpretation must be accompanied by strong conceptual development, good design, and well-developed technical skills.

Over the years of teaching watermedia classes and workshops, I have stressed that artists must build upon a strong foundation of basic training in drawing, painting, and design. No matter what direction artists eventually choose for the full expression of their work, whether it be representational or abstract, that foundation will support them as they explore more interpretive ways of making their statements. I continue to enjoy painting in both representational and abstract experimental styles and find that each approach seems to strengthen the other, as well as to stimulate ideas for further exploration in presentation. The search for growth in form and content never ends for any artist.

We all have different backgrounds and experiences that contribute to the sum of our being at any one time. The layers of experience in our lives all have an effect on our personal expressiveness. We can use these areas as undergirding and resource material more effectively as we learn to become more observant and to use the tools and techniques of painting in a visual and imaginative sense. We discover that we can transfer our ideas in an adventurous form of visual communication that captures the essence of conceptual expression.

Each person can examine the many past experiences that have made an impact on the self and find a visual way to express the form and emotion of that memory. Psychologists are well aware of this and sometimes prescribe art therapy to help people with traumatic life events that prevent them from functioning fully as healthy individuals. It is important for artists to know that they too can draw upon this source of personal information that makes one artist more responsive to nature, another to the human condition, and another to architectural subject matter. For me, it was the early response to woodlands, meadows, open sky, and rural life that has had a great influence upon my work.

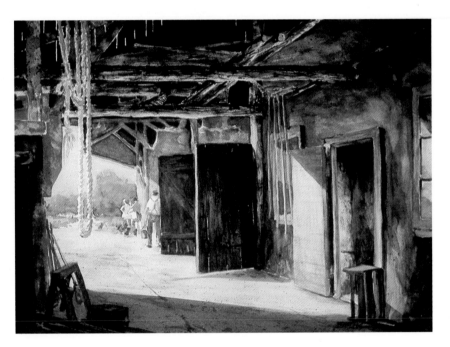

BARN DOORS
*Watercolor on Crescent no. 114 cold-pressed watercolor board, 13⅞ x 19¼" (35 x 49 cm).
Collection of Mrs. Janet Bury, Springfield, Ohio.*

This old barn brought back childhood memories of the farms of our neighbors. I chose to depict it in a defined rather than loosely interpretive way. The drama of the composition is emphasized by the contrast and direction of lights and darks as you look from the interior out into the sunlight. The major emphasis of the painting is on its structural elements, with the strong horizontal shapes contrasted against the vertical forms of the barn's doors and the hanging rope. Color, limited to browns and blues, makes value differences dominant. However, the purposely simple color scheme could have been more effective with some rich nuances of cool and warm variations within the limited palette.

EARLY VISUAL EXPERIENCES

One of my earliest memories takes me back to the age of three when I wandered through the woods across from our poultry farm in Kent, Ohio. I had no fear, only joy in being among the trees and flowers. I brought back a bouquet of trillium to my parents, not knowing they had been frantic with fear that I had become lost and perhaps fallen into the river at the edge of the woods. These gentle people taught me a lasting lesson of consideration for others and of environmental conservation. Yes, there was great beauty in the woods, but I could not go to that area alone until I was older, and woodland plants were not to be disturbed. My parents made their point without destroying the wonder of my small adventure.

From the time I could walk, my family had taken me to this beautiful stretch of woodland bordering the river. There they taught me the names of the birds, the trees, and the flowers. And it was there that I learned what "reverence for life" meant long before I ever heard of Albert Schweitzer.

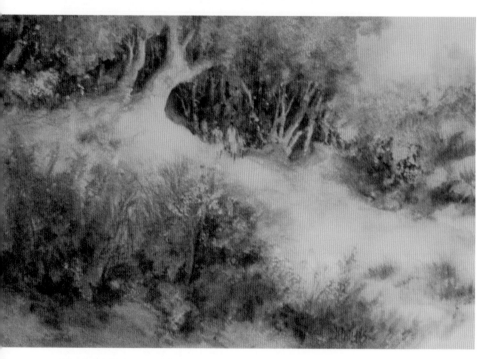

ANOTHER TIME, ANOTHER PLACE
Watercolor on D'Arches 140 lb. cold-pressed watercolor paper,
10 x 14¾" (25 x 37 cm). Private collection.

Walking in the woods with my parents was always a visit to another world of unending surprise and discovery. The forces of nature kept everything changing, although familiar landmarks remained constant, as symbolized by the old tree in this painting. Notice how the depth of the woods contrasts against the edge of the meadow, dramatizing the complexity and mystery of the woods. I chose to keep the color simple through the use of earth colors, yellow ochre, and burnt umber, mixed with a little viridian green. The wet-in-wet approach created a soft look that was appropriate for a look back in time.

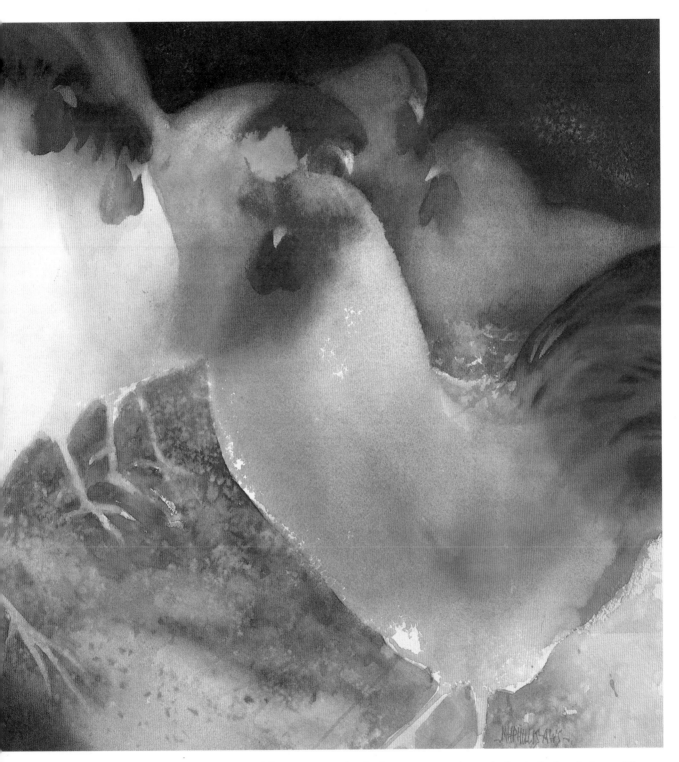

SUNRISE SERENADE
Watercolor on D'Arches 140 lb. cold-pressed
watercolor paper, 15¾ x 21½" (40 x 55 cm).
Private collection.

*All during my youth, chickens were my alarm clocks. At daybreak the cackling
and crowing began and increased steadily as the sun filled the morning sky. The
infusion of the glowing morning light in the chicken house is captured in this
watercolor, as well as the haughty attitude of the flock. Chickens amused me with
their pecking order, irritated me with their nervous nature, and nearly
asphyxiated me with their odor. In those early days, I was too close to their less
attractive habits to consider drawing them. It took years before they surfaced as
subject matter in my work.*

ARTISTIC TALENT

In my family artistic talent was expressed in a variety of ways. My father was a toolmaker, my grandfather was a molder, and both were natural carpenters. They helped build the home where we all lived. My mother could draw and paint with modest skill, as could some of my aunts, uncles, and cousins. There was an awareness of creative effort always. My grandmother had been a milliner in her early years and later put her creative energy into quilt making and crocheting. It was something we accepted without thinking "this is art." It was just part of life, as much as the hard work connected with a farm was an accepted fact.

I had access to pencils, crayons, and paper, but also to scraps of lumber, clay, sand, and household odds and ends that were a tremendous stimulus to the imagination. When my brother was a baby and I had no other playmates, I very soon learned to entertain myself with whatever materials were available.

ART EDUCATION AND CAREER CHOICES

Young people need to share the creative experience and be encouraged to participate in the wonderful world of the arts. We shortchange the future of society when we refuse them this opportunity.

In 1985, Congress mandated a national study of the arts in education by the National Endowment for the Arts. Its report, entitled *Toward Civilization: A Report on Arts Education,* emphasized the importance of the arts during the educational years. Included in the report was this statement:

> Young people missing out on arts education not only fail to become culturally literate, they miss the joy and excitement of learning the skills of creating and problem solving in the arts. They learn neither how to communicate their thoughts and dreams nor how to interpret the communication and thoughts of others.

I was fortunate that my parents believed in this philosophy years before Congress mandated that study. When I was four, my parents found an art teacher who gave lessons to young children. Once a week I was taken to the home of Alma S. Gardner, a most remarkable woman and talented regional artist. All during my grade school and high school years, I studied with her in her comfortable old Kent home. She taught me the fundamentals of drawing and painting, but most of all she instilled in me the importance of seeing with the mind and with the heart. She sparkled with excitement about the visual world. Her unceasing creativity and enthusiasm about color, shape, and placement were gifts she passed along to her students.

When it came time for me to go to college, I had to decide whether to major in art or in my other love, which was science. Because I had to make a living immediately upon graduation, I chose to major in

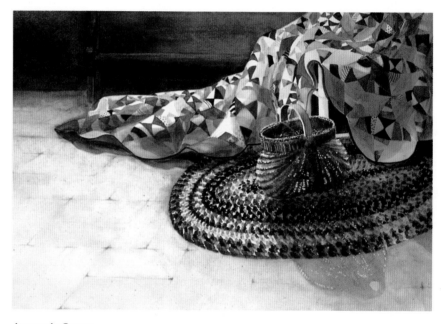

ALDULA'S QUILT
Watercolor on D'Arches 140 lb. cold-pressed watercolor paper, 19 x 27" (48 x 69 cm). Private collection.

Some years ago, I was asked to do a representational painting for a church auction. I grouped together some of our special heirlooms on the porch of the old house where we lived at the time, finally focusing on this arrangement of the chair, quilt, basket, and braided rug. The antique church bench in the background added a high horizontal thrust that helped to balance the composition.

Light pouring through the basket broke the shadow area into dancing dots of light falling across the quilt and onto the rug. I kept the brick floor simple as a neutral rest area for the more intricate compositional patterns of the still life. Once the drawing was done and a few photos were taken for reference, I was able to move the quilt to my studio for the completion of the painting. Although this work was done in a more tightly rendered manner than most of my painting at that time, I enjoyed the challenge and during the long hours of painting grew to appreciate the loving work our ancestors put into their homely creative efforts.

chemistry and bacteriology, with all elective hours devoted to art studies at Ohio State University. I became an analytical chemist for a few years and then, after our children were born, I returned to art classes at the Toledo Museum of Art School of Art and Design, as well as continuing studies over the years with nationally recognized artists. Thankfully, the combination of art and science broadened my knowledge and trained my thinking in analytical aspects to complement my more intuitive and creative nature. It also gave me a whole new world of conceptual art ideas for the future.

I share this personal information here as examples of the experiences and observations that made a difference in my perspective as an artist. You have your own memories and observations and ideas that make your viewpoint just as unique. Formal training sharpens artistic skills, but your sensitivity to the ever-changing world of man and nature provides the necessary emotional response to infuse a painting with your own energy.

THE CHALLENGE OF WATERMEDIA

My goals in writing this book are to expand artists' visions, to help them examine their individual creative approaches, and to encourage them to draw upon the vast conceptual resources available. The various exercises and techniques discussed are merely tools for you to use freely to activate fuller expression. When you are willing to explore new territory, you slowly develop personal style, and you search for more effective ways to convey content with depth and conviction. When you are willing to keep an open mind, establish a strong foundation in the basics, and become knowledgeable in innovative approaches in watermedia painting, there are endless possibilities for expression.

The joy of discovery is just ahead!

— MARILYN HUGHEY PHILLIS
A.W.S./N.W.S.
Wheeling, West Virginia

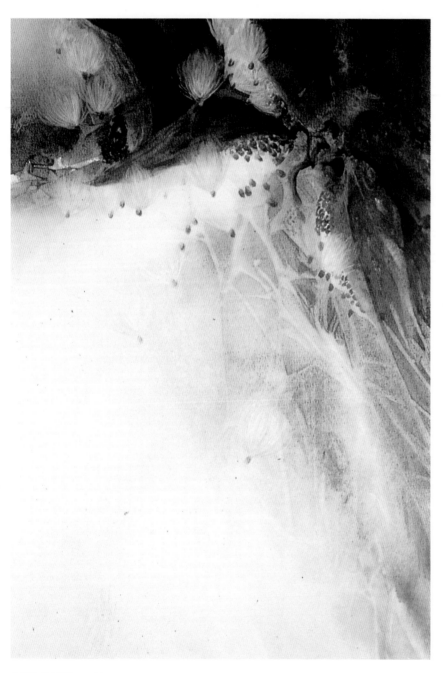

The bursting of a milkweed pod is a wonder. I tried to capture this magic moment as a gentle breeze blew the feathery seeds through the air. While much open space was left to give the feeling of atmosphere, the pods were suggested by pressing plastic wrap on a somewhat heavy application of pigment. A little negative shape painting further defined the forms. Touches of gouache were added to suggest detail in the floating seeds.

A MAGIC MOMENT
Watercolor and gouache on Crescent no. 114 cold-pressed watercolor board, 16 x 11¾" (41 x 30 cm). Collection of Mr. and Mrs. Dan Califf, Piqua, Ohio.

LEARNING TO SEE AS AN ARTIST

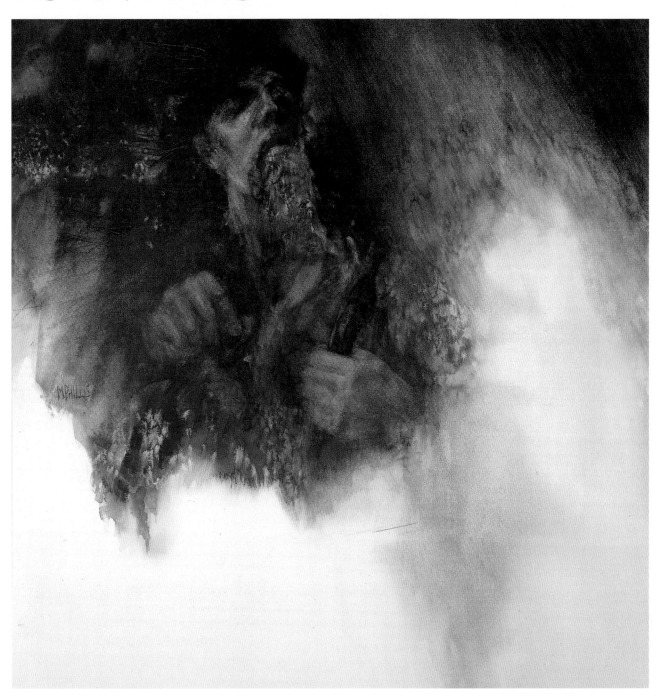

THE IMMIGRANT
Watercolor on Crescent no. 114 cold-pressed watercolor board, 19½ x 19" (50 x 48 cm). Collection of Dr. and Mrs. Randall W. Phillis, Amherst, Mass.

Part of learning to see as an artist is finding possibilities in abstract shapes and color masses. In this case I began with a large earth-toned mass of pigment floated on a damp surface. When that had dried, I turned the board in all directions and studied it carefully. A textured area seemed to suggest some sort of figure, so I developed it by lifting out pigment, much the way a sculptor takes away substance to bring out the shape within. Slowly the figure of a man emerged, and as his attitude became evident, he reminded me of my German and Scotch-Irish ancestors, all craftsmen or farmers of modest means, but proud people.

Each person sees the world in a different way. The scientist uses instruments to make precise measurements of a research subject. The carpenter examines projects for line and strength and durability. The psychologist sees beyond the outer facade of a person to examine the work of the mind and emotions.

The artist learns to see the world in terms of shape, pattern, color, line, and texture. In addition, the artist learns to become sensitively aware of subject matter. All these factors, as well as the artist's individual perception of the world, form the basis for unique personal expression.

Painting creatively requires an open mind, development of keen observation habits, and willingness to experiment. The painting process becomes a form of metamorphosis in which paintings evolve and change. Finished paintings are often quite different from their first shapes, yet there is a retention of some of the essence of those forms.

Working in mass shapes has been a natural process for me. It is a bit like looking at the clouds on a balmy summer day and finding all sorts of images appearing, changing constantly, and eventually disappearing. I often start a painting thinking first of the placement of a large mass of color on the white paper. Subject matter is of little concern in the beginning. Often some random texturing is done and I begin to "read" and "listen to" what is evolving before me. Certain things on that paper begin to suggest subject matter, always different and always a great discovery.

FOLKS

By Linda Weber Kiousis. Transparent watercolor on D'Arches 300 lb. rough watercolor paper, 29 x 22" (74 x 56 cm). Private collection.

Kiousis feels that "painting is search and research, with more interest in the what and why than the how." As a realist painter, she is an astute observer of nature and searches for a unique approach to make unusual combinations of subject matter. Her detailed compositions never reveal all, but instead create a state of mystery concerning the subject. The paintings have a magnetic pull on the viewer's imagination, creating an interchange of activity between artist and observer.

SHARPENING OBSERVATION THROUGH SKETCHING

Sketching sharpens the mind, hand, and eye as you learn to look closely at subject matter. Kimon Nicolaides wrote in *The Natural Way to Draw*, "Learning to draw is really a matter of learning to see—to see correctly—and that means a good deal more than merely looking with the eye."

Some sketches accurately record what the artist sees; others suggest the barest essentials of form to jog the memory for reference. Sketching and photography build a tangible and mental filing system so that as your creative vision expands, you can draw upon the rich resource material stored in the mind as well as in the sketchbook or photo file.

I tell my students to draw, draw, draw and to learn to see with accuracy and sensitivity what is before them. This builds a good backlog of information and trains the eye, mind, and hand to work together so that when the time comes for experimentation they will have a disciplined freedom to explore the many avenues of expression available in watermedia painting. Too many art students think they can bypass the discipline of drawing. They only shortchange themselves. Drawing is an invaluable skill. It demands an intensity of concentration and expression that leaves the imprint of

the artist in a most personal form. Anything that makes you more observant will add to the resources you can use to become more proficient and expressive in your work.

There are many ways of seeing and sketching that bring various aspects of subject matter into focus. Drawing as though seeing something for the first time intensifies observation and makes small variations in shape important for the added interest these small details give to the overall form.

Contour drawing is an approach in which you draw as though the pen or pencil were tracing the outline of the subject. Your eyes should be on the subject rather than on the paper, and your hand should move slowly and thoughtfully over the paper surface as the drawing takes shape. Betty Edwards adapts this approach in her book *Drawing on the Right Side of the Brain*.

One of the common compositional problems of an art student is concentrating on individual components before seeing the projected work as a whole. When I was in college, Hoyt Sherman, teacher in the art department at Ohio State University, had adapted aircraft identification methods for training art students in increasing visual memory and eye-hand coordination skills. Abstract

images of various complexity were flashed on a screen. We were armed with large sketchpads and thick sticks of charcoal, which we used to quickly capture these images from memory in a darkened room after the projected image had left the screen. It was demanding training, but great fun. The continued practice of this exercise did achieve its purpose of increasing visual perception and helping students to sense the whole image first before concentrating on the separate parts. That was an important lesson in compositional relationships.

Very quick sketches can be made by capturing the major movements of form to give a spontaneous direct look to a drawing and establish the primary structural or gestural landmarks of the subject. This is useful not only for speed, but for establishing a feeling of rhythm and kinetic energy in a sketch. Quick sketches are the artist's shorthand, serving as reminders of information about a subject, experience, or train of thought. Some artists keep an orderly sketchbook/journal for this purpose. Others keep loose papers filled with ideas and sketches. As long as they serve a purpose, it matters little how an artist keeps a running record of information and ideas.

HOUSE WITH WASH ON THE LINE
Pen and ink on paper, 1 x 4" (3 x 10 cm). Collection of the artist.

Because I paint with masses first and linear detail later, I sometimes do a drawing that designates the subject in mass shapes. This is useful in blocking out compositional forms as well as in discovering the relationship of one shape to another and the play of light and dark passages. Any form of sketching that is suitable to the artist's needs will be helpful, and often the impact of the subject suggests the sketching approach.

OHIO WINTER
*Pen and ink on scratchboard, 4 x 6"
(10 x 15 cm). Collection of the artist.*

*This winter view of our former home
in western Ohio takes the viewer from
the large creekside tree through the
mid-distant trees to the slowly rising
meadow and the buildings beyond.
My studio was the little house between
the barn and the main house.*

AMISH FIGURE STUDIES
*By Roger Haas. Felt-tip pen on sketchpad
paper, 8¾ x 12" (22 x 30 cm). Collection
of the artist.*

*Haas has a deep affinity for the Amish
people in his native Ohio. He makes
regular trips to their farms, where he
makes quick linear sketches that
provide reference material for later
paintings. Notice the economy of line
that gives information about gestures,
body build, and clothing.*

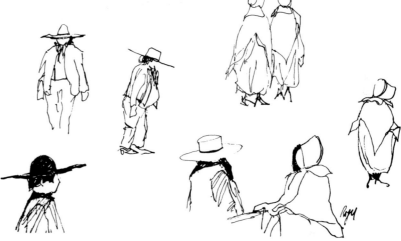

MRS. MILLER
*By Roger Haas. Transparent watercolor
on two-ply bristol board, 11½ x 15½"
(29 x 39 cm). Collection of the artist.*

*Haas has now created a painterly,
elemental statement reflecting how the
Amish live in harmony with the land.
The artist translates elements from his
sketches into paintings that glow with
an inner sincerity and simplicity. Note
the dramatic contrast of the figure
against the white house, and the way
the vertical thrust of the trees, porch
posts, and rails echoes the stance of the
woman.*

THE VALUE OF FINISHED DRAWINGS

Finished drawings are the more advanced development of an artist's thinking. They may begin as studies for another medium but often become full artistic statements by themselves. This does not exclude their use for future development in watermedia or oil, but it does indicate that the artist became so engrossed in the drawing at the time that it gave full conceptual and emotional expression to that particular surge of creative energy. These works are important developmental records of an artist's growth and emotions toward a given subject.

In a period of doing a series of self-portraits, Roger Mark Walton had half-completed a larger-than-life drawing when he was diagnosed with a sizable nonmalignant brain tumor. Surgery was scheduled for one month later. With this overwhelming news constantly on his mind, he chose to continue with his drawing project. By altering the gesture of the hand and intensifying the facial expression of the image in the portrait, he found a means to convey some of his feelings about the diagnosis and upcoming surgery. As a student of art history, he found that the portraits of Italian mannerist Agnolo Tori-Bronzino provided an important resource for making this statement.

After surgery, which successfully removed the tumor but damaged some nerves, the muscles on one side of Roger's face drooped for eight months. During this period of recovery, his energy was drained, but he felt he must work with his art to deal with this traumatic experience. He repeated the pose and lighting to emphasize the difference in the contours and expression of the face. He states, "This format might provide the viewer with a way to contemplate an image that one might not otherwise wish to view." As he worked on the drawings over time, he realized that the two portraits functioned as one work, not as two separate ones. In the final stages, they were completed together. (An example of Walton's use of drawing in the watercolor medium is discussed later in the book.)

The very process of creating art became a healing course of action that assisted the body and psyche in their rebalancing toward health. Therapists are well aware of this aspect of the use of creative energy. Art can be used to represent both the negative and positive and may help to give the individual a sense of constructive purpose. In a trained artist such as Walton, the artist continued to practice his skills even when circumstances were difficult. From this inner searching came two powerful works of visual art.

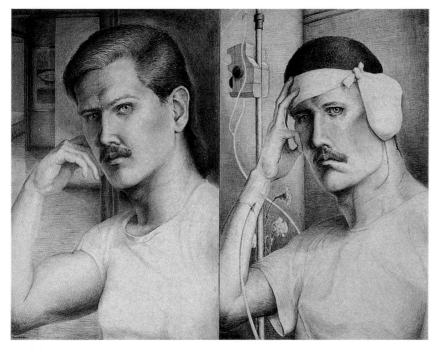

THE TUMOR
By Roger Mark Walton. Graphite on paper, 40 x 52" (102 x 132 cm). Collection of the artist.

This before-and-after self-portrait says with powerful emotion what the artist's mind contemplated before brain surgery and the struggle for survival and regaining of energy after the tumor was removed. The use of the diptych format adds to the drama of the full statement the artist wished to make about his condition.

DEVELOPING YOUR ARTISTIC VISION

Artistic vision differs with each artist. A sense of adventure and a playful attitude can be great assets in developing a new and more innovative approach. After all my traditional training in working on location, as well as painting and sketching from subject matter, I explored new ways of expression and slowly discovered the way of approaching a painting that worked best for me. It was simply utilizing all the visual imagery to which I had been exposed over the long years of preparation, and releasing this storehouse of information through my imagination. It was often a frustrating experience as I worked with shape, mass, texture, and spontaneous unplanned beginnings to learn to become responsive to the manipulation of paper, abstract shape relationships, development of pattern, and pigment action that led to discovering and developing the conceptual idea.

Some people work out ideas with thumbnail sketches, a valid and often-used method. I found working directly with the *movement* of paint was more stimulating to my imagination. What was happening on the paper began to suggest a direction, an image, an emotional response. This became an adventure in the creative evolution of a painting.

When this moment of discovery came, I would stop and examine the intuitive starts before me, turning the paper in all directions and letting my imagination roam freely until one or more ideas came to mind for subject and composition. This was the point where I took further steps to plan design, to refer to sketches or photos, or—when a subject was in mind—to do some further observa-tion. Often drawing with pencil or brush was needed, as well as careful thinking of how to plan the large masses and design the breakup of space. For many people this is a risky way to paint, and it works best under the experienced eye, but it is also useful for the less experienced painter because it stimulates creativity and brings forth ideas that might never have been tried. I have never felt that there were any overnight miracles to success, but rather years of dedicated hard work and experimentation. The miracles begin to happen once the fundamentals have been learned, used, and tried in unending variations.

I developed the three very different paintings you see here by letting my imagination roam freely, applying design skills, and staying tuned to what was happening as I worked with the fluid aspect of watercolor. In the process I discovered subject matter, developed shape, and fine-tuned the compositions.

The first painting departed from transparent watercolor to the use of collage and gouache. I wanted to build a more opaque surface in contrast with the transparent passages. Some old newspaper want-ad sections were torn and placed on the surface, then lightly painted over during the process so that the printing was somewhat veiled. Gradually shapes became buildings and figures.

Few sights and sounds of nature have more variety than waterfalls. Their diverse forms can range from the overwhelming beauty of a monumental wall of moving water to the elegance of a delicate tracery of falling lace. Depending on the height of the fall, the obstructions in the way, and the force of the flowing water, both the appearance and sound of the fall change. The artist needs to keep this in mind; to capture both the visual and auditory impacts of this subject is a creative challenge in the use of form and content.

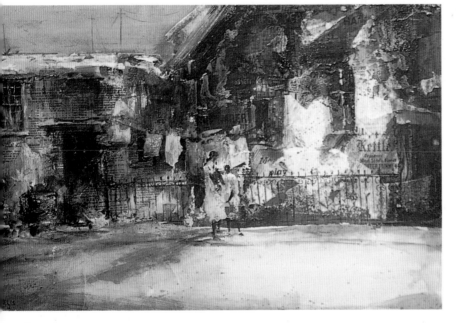

BACK STREET
Watercolor, gouache, and collage on Crescent no. 114 cold-pressed watercolor board, 11¾ x 18½" (30 x 47 cm). Collection of Mr. and Mrs. Stanley Benskin, Morro Bay, Calif.

An exercise in working intuitively with shapes and bits of newspaper collaged onto the painting surface began to bring back memories of childhood visits to the South. I did not want to specify place as much as feeling. The midsection of the painting holds the major points of interest, and I wanted to emphasize this area and provide an uncluttered space above and below. This required a great deal of playing with subtle form and value. The figures are integrated into the background shapes so that they evolve from the scene rather than being imposed on it.

This whimsical painting began on a wet surface with loose washes of transparent pigment. A small amount of texturing was done with a light application of salt on damp pigment where the woman in profile appears. There was no subject matter in the beginning, only the freely shaped abstract areas with plenty of open space for light.

When these first washes dried, I examined the work for further development. I had accidentally spattered the area in exactly the right places for eyes and mouth of the woman in the background. All I had to do was further define the mouth, add a touch of paint for the nose, and finish with negative shape painting around the head to create the face, hair, and hat. From then on it was pure fun creating the flowers, chair, table and figure in profile—all with negative shape painting. Some light drawing guidelines were done in the process and later erased.

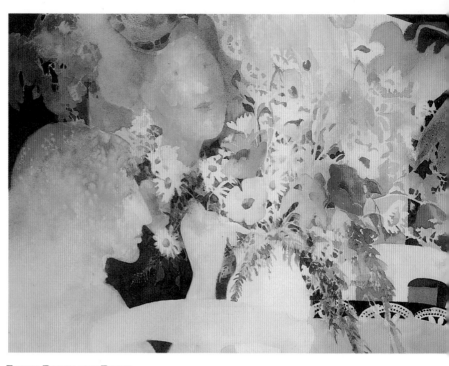

FIXING POSIES FOR ROSIE
Transparent watercolor on D'Arches 140 lb. cold-pressed watercolor paper, 13¼ x 19" (34 x 48 cm). Collection of Mr. and Mrs. Don Otto, Rocky River, Ohio.

I have worked on a series of loosely interpretive waterfall paintings that accent my emotional reaction to the subject rather than tight replication. I began this painting by applying large free masses of prismatic color to emphasize the play of light creating a rainbow effect on the rock surfaces. While the pigment was still damp, I used a spray bottle to soften edges and create some of the breakup of the falls.

There were two problem shapes that had to be redesigned. One was the large central rock and the other was a too-similar area just on the other side of the upper falls. I left the central rock as it was but broke the other mass into smaller shapes to create some variation of size. At the top of that mass appeared a most interesting creature. A frog was waiting to be developed and I couldn't resist that touch. He fuses into the rock and is one of those discoveries that is not instantly apparent. I often incorporate some sort of surprise into a painting when it seems appropriate.

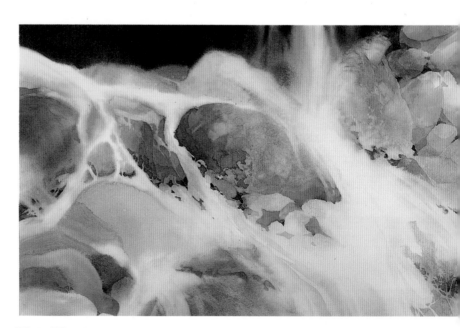

WHITE WATER
Transparent watercolor on D'Arches 140 lb. cold-pressed watercolor paper, 16¾ x 27¾" (43 x 70 cm). Collection of Dr. and Mrs. John C. Machell, Nashua, N.H.

DISCOVERING NATURE'S SUBJECTS

The artist who is directly influenced by observing subject matter in nature cultivates many useful perceptual and presentation skills. Decisions can then be made to rearrange shapes, eliminate extraneous material, combine some forms with others, or try various methods of focused organization to draw attention to certain aspects of the composition. The artist's creative energy is directed toward changing the obvious outer aspect of the subject to present a fresh view of the world around us.

Every artist eventually finds the most appropriate choice of expression for translating the source of inspiration to the working surface. Most of us began with representational renderings of subject matter and later discovered that if we wanted to express ourselves fully, we needed to do more than become human cameras. We had to find some way to interpret what was of interest to us and to place our personal mark on our work.

If you are a representational painter, you have many choices. You must cultivate your own way of seeing and thinking about your subject, so that your work becomes a unique expression of your interpretation of it. The mundane and redundant can be transformed into aesthetically expressive works with significant content.

Painting from actual subject matter is the traditional approach, but it is not the only one. Of primary importance for any artist is how an idea is interpreted so that it is organized with creative strength according to shape relationships, line, pattern, color, texture, and foremost, the inner response of the artist. The decisions you make about these factors provide the individuality that puts a personal stamp on a work of art as much as does your signature.

Homer O. Hacker takes a more pragmatic view of his subjects. He concentrates on design, color, and value relationships. The compositions carry strength of statement and often have a strong sense of place. He is well aware of the abstract understructure needed in good representational work and sometimes uses a quick abstract study to work out design problems.

Frederick C. Graff sees his subject matter in a way that concentrates on the use of white or the lightest tones as the positive shapes. He eliminates details and uses only the most important structural features. His chromatic tones are closely keyed, and pigment is applied in a loose, painterly fashion. He views his subject as if through veils of memory.

Roberta Carter Clark explores the simplicity of design through various studies using still life and floral arrangements. Her work as a portrait artist requires a sensitivity to the elements surrounding a figure as much as the ability to capture the likeness and inner nature of the subject. She finds that taking time to do other types of painting leads to the enrichment of her work in portraiture.

Linda Weber Kiousis enjoys searching for unusual combinations of subject matter. She combines things not normally seen together. She is a skilled representational painter who often injects a touch of humor into her work. (See page 15.)

Each way of looking at things is what captures the viewer's attention and begins the imaginative journey.

ANCIENT MARINER
By Homer O. Hacker. Transparent watercolor abstract study, 21 x 28" (53 x 71 cm). Collection of the artist.

The artist examined the scene from an abstract viewpoint to block out design shapes, color, and value relationships. He has used the lightest areas to frame the darker shapes forming the center of interest.

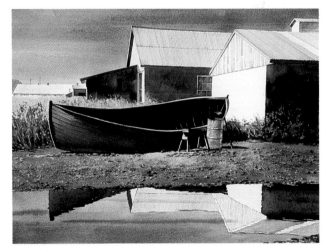

ANCIENT MARINER II
By Homer O. Hacker. Transparent watercolor on cold-pressed watercolor paper, 21 x 28" (53 x 71 cm). Private collection.

The artist was able to proceed with ease after blocking in forms in his abstract study of the scene. He maintained the simplicity of design, was selective in the addition of detail, and created a work of exceptional impact.

TROIS DRAPEAUX

By Frederick C. Graff. Transparent watercolor on Strathmore 500 series cold-pressed illustration board, 20 x 30" (51 x 76 cm). Collection of the artist.

Graff uses his interpretive skill to distill subject matter to its essence. This old home is simplified into large toned areas with a minimum of definition suggesting windows and other architectural details. Instead of getting occupied with features of the enclosed living area, the viewer is directed from the highlighted side porch and its flag onto the projecting front porch and the flags at its entrance. Notice how the passage of light moves the eye around through the painting and how shapes interlock into each other.

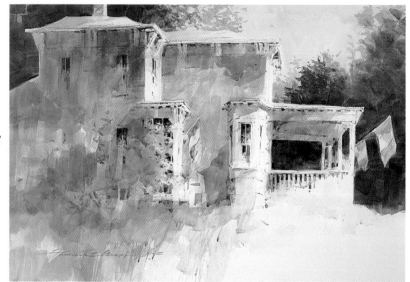

DAFFODILS WITH BLUE

By Roberta Carter Clark. Transparent watercolor on D'Arches 140 lb. cold-pressed watercolor paper, 30 x 22" (76 x 56 cm). Private collection.

This illustrates the value of unencumbered composition that can hold strength of statement through the use of directional emphasis. Note the strong vertical thrust of the vase and scarf and the counterpoint of horizontal lines in the scarf and floral arrangement. The surrounding space becomes an interesting shape as its line is broken by the daffodils and vase protruding into the adjoining areas.

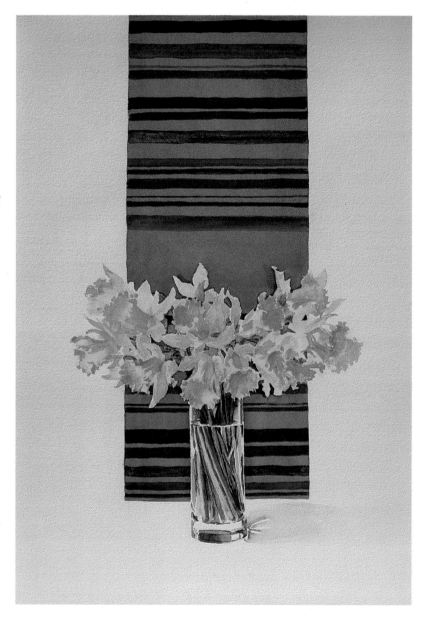

DEMONSTRATION: THE PATH OF INSPIRATION

Most of my painting is now done in the studio, but I spend much time observing and absorbing the world around me. My daily walks, my association with other people, the reading of a wide variety of books, visiting museums, and time for daily contemplation all contribute to visual, intellectual, and emotional enrichment. An artist cannot work in a vacuum and must learn to be sensitive to the shapes, patterns, and moods of nature as well as to the general experiences of life. The bustle of the city provides inspiration for some artists if they have learned to look closely at what is there before the eyes or deep within the heart.

I was asked by a gregarious artist friend whether I didn't get lonely painting in my studio. The answer was no. "Solitude is not loneliness. It is time for aloneness." I jotted down these thoughts in my sketchbook. Yes, the imagination does soar when one is alone, and there is a surge of energy as images form.

To develop a painting from the imagination, you need to acquire several skills. You will need the basic skills of drawing, painting, and design. You must learn to relax your mind and let creative images surface, and then select a conceptual direction from this process. You have to use your training and intuition to establish basic composition, remaining sensitive to the unexpected happenings in watercolor. Finally, you must use your analytical nature to pull together design and strengthen the artistic statement. It sounds complicated, but it becomes a natural process with practice—one that can be exciting, require very hard work, and if successful, be enormously fulfilling in the final result.

STAGE 1: STAYING FLEXIBLE

I began *Rainbow's End* with a flexible attitude toward evolving subject matter. The watercolor board had a Strathmore paper surface that accepts paint well; the watercolor flows easily and remains brilliant. I first dampened the back of the board with a sponge. This balances the dampening of the front and enables the board to lie flat.

Thinking in terms of *shapes* rather than *things* gives me many options for design and expression. In the early stages, it is important to leave plenty of white paper, which can always be covered later. With this piece, I decided to place the first shapes in the upper third of the painting and to play with pastel tones against bold darks.

I brushed water across the upper half of the watercolor board and sprayed water across the lower half. Then washes of cobalt blue, rose madder genuine, and aureolin yellow were floated onto the upper part. By moving the board from side to side as well as up and down, I let gravity distribute the color and make runs of pigment. A dark consisting of alizarin crimson, Winsor green, and Winsor blue was added to selected areas.

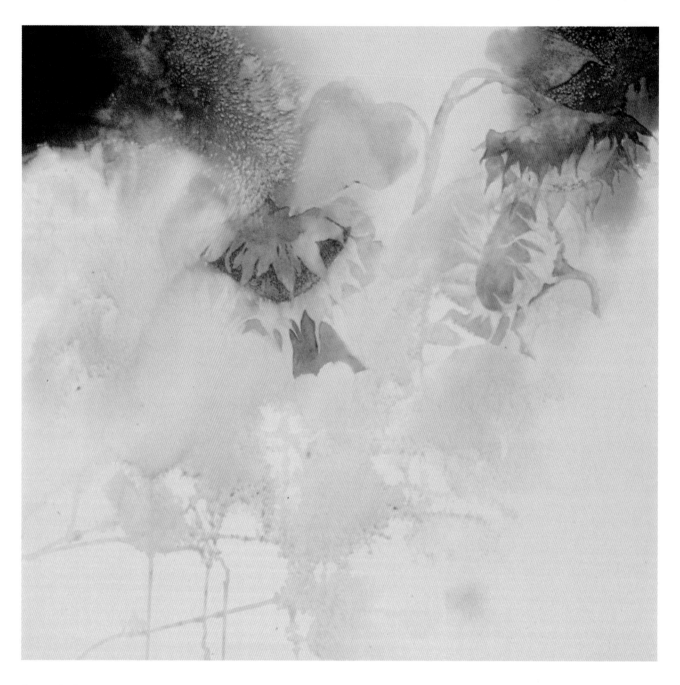

STAGE 2: SHAPES FORM

As the paper changed from a wet to a barely damp state, I added a little salt in a few selected places to create texture. When this stage was completely dry, I brushed off all the salt and studied the painting from all directions. With this particular start, the low dipping dark shape suggested a sunflower head, and I began to work out the initial compositional idea. Our large sunflower garden was ready reference.

Careful planning was needed to retain the freshness of the first washes and not let the design get too constricted or contrived. The first application of transparent color has a pristine look and charge of creative energy that, once lost, is almost impossible to regain.

With this in mind, I painted the seed pod of the central dipping form a darker tone that defined the petals above it. Then I placed a large dark shape above the head for further contrast. At the same time, the texturally suggested flower head and leaf forms read as background shapes and gave some depth to the painting. The lower petals of the dark head were defined by painting around them.

STAGE 3: A PAINTING IS BORN

Once I had an idea for the developmental direction, I needed to express my feelings. Thoughtful designing created the interplay of shape, pattern, and movement to entice the eye to explore the areas created by light and dark contrast. I wanted to suggest an infusion of light as well as variation of the masses of leaves and flowers as opposed to the linear forms of all the branches and stems.

Keen observation and lyrical interpretation were the keys to *Rainbow's End*. If I had not been so familiar with the subject, I might have been less freely expressive. But the subject came naturally from my imagination, stimulated by those first few amorphous shapes.

Note the variety of edge treatments. Though many areas are defined, values are kept close in some places to give the illusion of soft edges. The delicate weaving in and out of the original washes was preserved and gives an open, sunny feeling. Variation of repetitive shapes is an important aspect of design. The positioning of the flower heads varies; petals overlap and have different widths; all this makes for a more interesting variety.

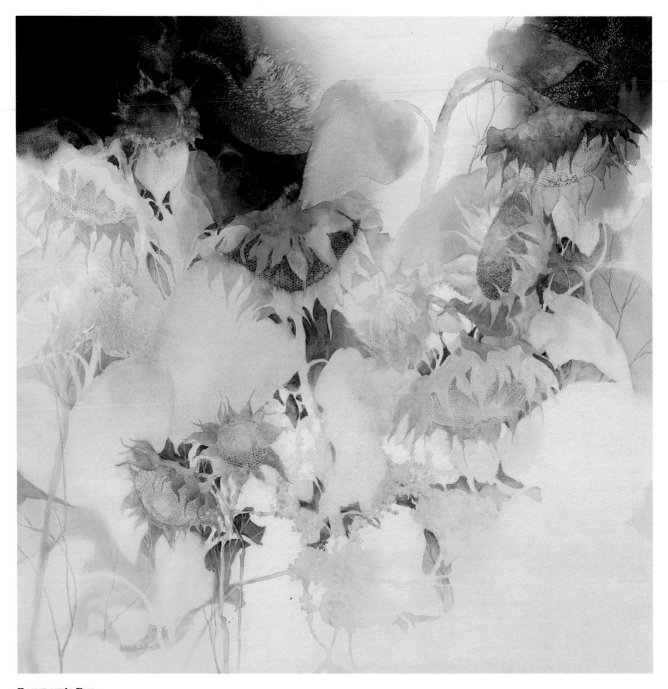

RAINBOW'S END
Watercolor on Crescent no. 114 cold-pressed watercolor board, 30 x 30" (76 x 76 cm).
Collection of Lela C. Warr, La Jolla, Calif.

THE MATERIALS AND TOOLS OF CREATIVE EXPRESSION

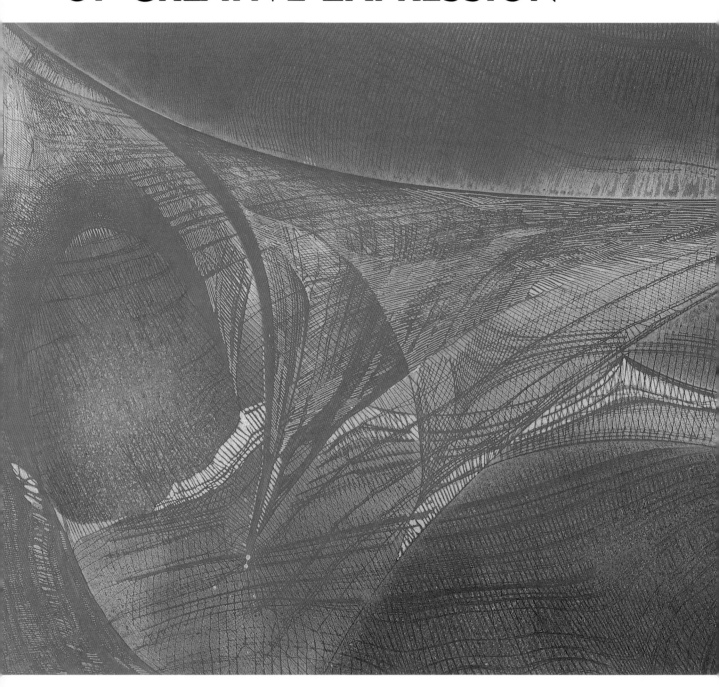

DIORAMA
By Maxine Masterfield. Watermedia ink on D'Arches 140 lb. hot-pressed watercolor paper,
24 x 32" (61 x 81 cm). Courtesy of Alan Gallery, Berea, Ohio.

Every artist possesses valuable tools that are constantly accessible and easily portable: the mind, the eyes, and the hands. To put this natural equipment to fullest use, we as artists learn to develop a keen sense of observation, thoughtful assimilation of information, and the discipline of organization in order to express through our work what is in our minds. We must cultivate a sense of curiosity about the world around us and channel this information into our minds to understand, question, envision, and carry out our creative purpose. In order to do this, we must lay a strong foundation of developing artistic skills, acquiring this knowledge through constant experimentation and practice.

This book will reflect continuing searches for artistic expression. An artist sings a visual song of color, line, shape, value, and texture bound together by movement, rhythm, repetition, variation, dominance, contrast, and proportion. Before the mature development of personal expression so necessary to make your work stand out from another's, you must learn the craft of painting and how to work with your particular media. You must also spend hours of practice refining the skills that will become a natural extension of your artistic vocabulary. These are the things needed to say what you want to say. As in music, a strong foundation must be made for the creative force to become a song of substance.

Too many artists in the early stages want to sing someone else's song, and their work reflects just that. But imitations are only the weak reflections of the originals. The artist will eventually find a way to say with originality what no one else can say in quite the same way. The search is lifelong if you continue to grow as an artist.

Masterfield is one of the leaders in experimental watermedia painting. Her work emphasizes a joyous and passionate involvement of expression. Diorama, *with all its moving energy and texture, was created by the use of cheesecloth overlays on ink. When the ink dried, the cheesecloth was removed and its image remained. Notice how Masterfield controls design expertly with the placement of sweeps of texture, pulling the viewer's eye across and around the picture plane. She has emphasized shape variation, movement, and texture, yet the subtle effects of soft color complement the more energetic dynamics of the painting.*

VERSATILE WATERMEDIA

In the twentieth century, an artist working in watermedia has an exciting and growing field of choices to make in selecting the right medium that will best suit the requirements of any particular artistic statement. In this book you will find examples of work done in a wide range of water-soluble media, including transparent watercolor, gouache, acrylic, casein, water-soluble pencil, and water-soluble crayon. All can be used singly or in combination with one another depending on the needs of the artistic statement.

Transparent watercolor: In this traditional form of watermedia, the pigment is made from mineral or vegetable colors and mixed with gum arabic as a binder, plus a wetting agent and preservative. Watercolor prices vary according to whether the pigment is coarsely or finely ground, the scarcity of the pigment, and the ease of manufacture. Watercolors come in pans, cakes, and tubes. Most professional artists prefer watercolors that can be squeezed from tubes.

I normally use Winsor & Newton Artists' Watercolours, which are of an unusually fine grade. I also use certain selections of Holbein and occasionally other brands because I enjoy experimenting with new colors. Experiment and find the brand of watercolors best suited to the needs of your work.

Gouache: Gouache is closely related to watercolor with the same basic ingredients, except that pigment may be more coarsely ground and white pigment is added to it to make it more opaque. Gouache can be diluted and used quite transparently. When used with just a little water, it gives a rich opaque look to a painting. In selected areas of J.M.W. Turner's watercolors, he included the addition of body colour, an older term for gouache. Many of Thomas Moran's great paintings of the American West also used gouache in contrast to the transparent passages of watercolor.

Acrylics: The acrylic medium is a product of twentieth-century chemists. This versatile medium is made of pigment, bound by an emulsion of plastic resin. Acrylics come in tubes, jars, or plastic bottles. The jar form has a creamier consistency than that in tubes, and the bottled form is the most fluid of all. I have found excellent results with Liquitex, Nova, and Golden acrylics, all of which have good covering properties with some differences in smoothness of application. The fluid acrylics have an intensity of color that can withstand considerable dilution without losing vibrancy.

Inks: Inks must be tested for lightfastness, as should all media used. The popular colored inks with which artists are familiar today were originally developed for commercial short-term usage for reproduction purposes and did not have a high permanency rate. However, many of the current inks used for fine art have a strong degree of lightfastness. I find FW inks made by the Steig Company excellent. Even so, I test all inks for lightfastness before using them; as an extra precaution, I frame the finished painting behind ultraviolet light-inhibiting plastic. The UF-3 and UF-4 Plexiglas both filter out 90 percent or more of the ultraviolet light. They are expensive. Tru-Vue clear acrylic filters out 97 percent of the ultraviolet light. This product is thin and should be used under regular plastic or glass glazing. Price variations in the various types of filters are another consideration. There are a number of other ultraviolet filters on the market, so find whatever kind fits your artistic and economic needs.

Casein: Casein is made from a milk base addition to the pigment and is permanent when dry. It gives a flatter, more velvety appearance than acrylic, which can have a tendency to look harsh under certain conditions.

Water-soluble pencils and crayons: These water-soluble products can be used for sketching or with water to dissolve into a more fluid form. They can be used effectively by themselves or added to passages of a watermedia painting to increase vibrancy or to add texture.

In using any of these various watermedia, the combination of technical know-how, expressive use of the imagination, and knowledge of design all combine to create paintings that become vibrant statements of communication between artist and viewer.

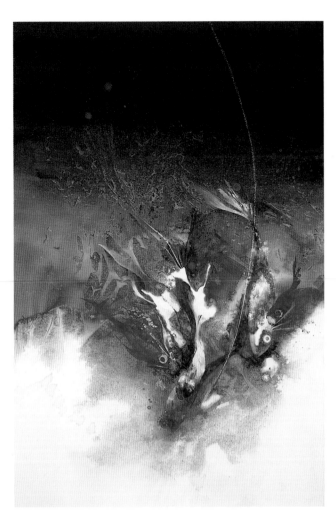

DEEP ILLUSIONS
*Watercolor and gouache on cold-pressed watercolor board, 20 x 30"
(51 x 76 cm). Collection of Mark Schmeidl, M.D., Sandusky, Ohio.*

Technical knowledge can aid artistic expression. Touches of gouache can add expressive opaque detail to transparent watercolor. In developing this abstract painting of diving fish, my initial challenge was to develop a design with a dark upper area that gradually fused into the light of the extreme lower area. Actual subject matter came later. I randomly applied a liquid masking agent to the lower middle section of the painting. While this was drying, I added removable stick-on circles and used masking fluid to add a few vertical lines. Once the masking fluid was dry, I dampened the painting surface and applied a free-flowing watercolor wash of warm darks, alizarins, and cadmium orange. This is an exciting, intuitive stage in the development of a painting.

Once the wash had dried, I further darkened some of the dark areas without diminishing the fresh look of the original wash. Now was the time to study the painting and develop a statement. I removed the masking fluid and discovered the nucleus of an idea. Fish shapes were defined with a minimum of detail, just enough to give a suggestion of their shapes. The long curved line going up from the fish was first sketched in chalk and then painted in gouache. It helped to add movement to the composition.

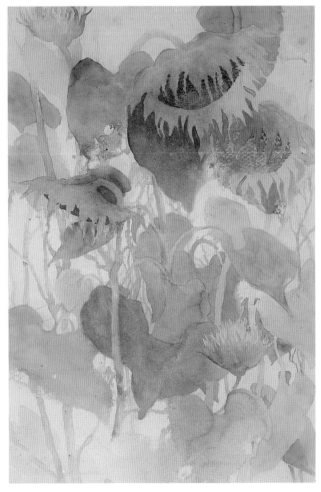

CURTAIN CALL
Watercolor and gouache on Crescent no. 114 cold-pressed watercolor board, 20 x 30" (51 x 76 cm). Collection of the artist.

Sunflowers provide an unending variety of shapes for an artist. The heavy bending head as it matures, the stalks providing strong vertical thrusts, and the shapes of twisted leaves all give just the right combination of shapes for an interesting composition. In this case I also chose to contrast the transparent watercolor of the flowers with opaque white gouache in the background.

This composition emphasized the flowers at the top. Note the overlapping shapes, the slight changes in attitude of the flower heads, and the petals that are a good contrast to the mass of the head and yet a part of it. The seeds were indicated by painting through nylon netting. Notice how the lower leaves are softly indicated so as to keep the emphasis on the flower heads.

PAINTING SURFACES

An enjoyable part of the watermedia artist's education is learning about the enormous variety of papers and boards available for watermedia use. It pays to experiment with as large a variety as possible to determine what surface best serves your purpose. I most often use D'Arches 140 lb. cold-pressed paper or Crescent no. 114 watercolor board, which has a painting surface of Strathmore paper. They both work well for direct painting, adapt to wet-in-wet techniques, and will withstand lifting of the paint from the surface. I have also used 300 lb. cold-pressed papers, a variety of hot-pressed surfaces, and the new Aquarius II paper. The other artists in this book also use a broad variety of painting surfaces, which will be noted individually.

Each paper has different characteristics, and you must take time to learn what a particular paper can and cannot accept. Some papers will take great abuse, from scrubbing out to lifting pigment. Others are better suited for direct painting. There are numerous sources of information, but the best source is your own practice and experimentation with paper surfaces. When I first began to work with a 300 lb. D'Arches cold-pressed surface paper, I had a terrible time. Because of the thickness of the paper, it soaks up water and pigment like a blotter. I had to adjust how I worked wet-in-wet in order not to lose brilliancy of color. But the paper can handle a lot of rough treatment. It can be used without stretching if needed. Spraying the back before beginning the front helps keep it flat. It is also a wonderful backing surface for collage.

GARDEN TAPESTRY
*Watercolor and rice paper collage on D'Arches 300 lb. cold-pressed watercolor paper, 20½ x 22½"
(52 x 57 cm). Collection of the artist.*

This work started in a spontaneous, abstract manner with few decisions other than working from upper warmth to lower cool colors, and working freely with big shapes of color. When this first effort dried, I painted thinned acrylic medium onto the backs of large torn shapes of thin rice paper that had pieces of bark embedded in it, and applied these shapes to the painting. The redampened watercolor bled through the rice paper, creating interesting forms and color. This was the stimulus for subject matter. Now I excitedly plunged ahead to work out the flower, leaf, and stem forms through negative shape painting. The finished painting seems to retain some of this energy of response.

BRUSHES AND OTHER APPLICATORS

I hang onto old brushes almost as if they were old friends. They have been through a lot with me and I keep them around just in case they could be useful again. I have one old sable oil brush from my early years. The bristles are worn to a bare hint of what they once were, but now this old friend serves as a lift-off brush. On the other hand, some of my fine old sable watercolor brushes continue to give good service. Quality brushes last a long time if care is taken with them. The better new synthetic brushes work well, are less expensive, but have a shorter life span.

I keep a variety of rounds and flats in varying sizes up to about 3 inches for the flats and a number 20 and 36 in the rounds down to a number 1 rigger, which is used for the last detail work. Hake brushes are excellent for wet washes and beginning applications of paint. I work with the largest brushes possible at the beginning of a painting, for I want to get down the large shapes and overall design. Smaller brushes come after that. There is no magic in a particular brush. It always amuses me when students ask, "What kind of brush is that?" It is the hand and the mind that have the magic!

Beyond brushes are a variety of ways to apply paint; some of these will be discussed in more detail later. Pouring paint and working without brushes at all can give stunning effects. Monoprinting, layering surfaces, spattering, scrubbing, pressing other materials onto the wet paint surface can all add an exciting dimension to a painting when done with skill and sensitivity.

Be cautious in using any particular technique of applying or manipulating paint. A painting should be seen first as a work of art, not as an exercise in exotic techniques. If unusual technical handling contributes to the overall strength of the work, then you have successfully integrated that technique into the completed visual statement of the painting.

Texture created without a brush can provide certain visual effects that work well for some subjects.

Get to know these techniques and their creative uses; they can enrich the surface of paintings and create a stronger impact than a brush could alone. For example, the common use of plastic wrap or waxed paper placement on pigment creates broken surfaces that can resemble rock structure, foliage, trees, and so on. However, these techniques can easily be too obvious, so be careful to modify and integrate them into the total statement.

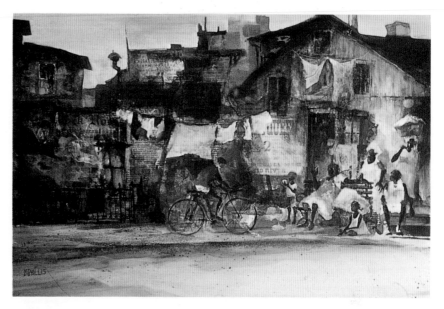

REST STOP
Watercolor, collage, and gouache on cold-pressed watercolor board, 12¼ x 19¼" (31 x 49 cm). Collection of Dr. and Mrs. Hugh R. Phillis, Nashua, N.H.

My family were transplanted southerners. My memories of those long trips during my childhood to Georgia and Tennessee resurfaced in a series of paintings. It was important to integrate the technical process within the painting so that the subject was more important than how I achieved certain effects.

The painting started quite intuitively with gestural shapes and random application of newspaper collage in the central area. Overlays of paint began to suggest buildings, and within the various value changes were places for people. Most were indicated with a minimum of change from the surrounding background. Slight value variations or the addition of head and limb structure were enough. Vigorous brushstrokes added texture to the surface, as did the collage. Texture stimulates the imagination and suggests subject matter.

SNOW CREST

Transparent watercolor on D'Arches 140 lb. cold-pressed watercolor paper, 21¾ x 29¾" (55 x 76 cm). Collection of Dr. and Mrs. Robert Sheriff, Houston, Tex.

This deceptively simple painting is a good example of textural emphasis within the structural format of a composition. I began by dropping paint onto the surface so that open space remained an integral part of the evolving composition. Then I placed plastic wrap over the damp paint and left it undisturbed until the paint dried. The resulting rock-like forms became the subject. Parts of the forms were modified with value, edge, and color adjustments. The mountain crests were sketched in after numerous tries for just the right shape, for this was of prime compositional importance. Once I had determined that line, I added the sky in a dark saturated wash.

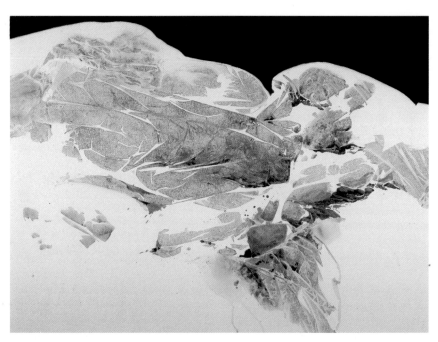

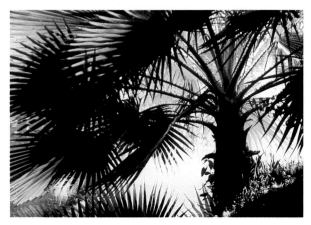

PALM TREES

Photograph courtesy of Richard Newman.

JUNGLE GEMS

Ink, watercolor, and gouache on Crescent no. 114 cold-pressed watercolor board, 29¼ x 14¼" (74 x 36 cm). Collection of Dr. and Mrs. Marvin Kanouse, Grand Rapids, Mich.

The intensity of color in this painting becomes a partner with the strong textural shapes to create the suggestion of jungle trees and growth. Ink was poured onto the surface, and plastic wrap was placed on it until the ink was dry, creating a marked texture. This was then greatly modified through brush painting over and around shapes to build the jungle forms. The intensity of color has a relief as softer diffused light pours down from the sky through the foliage.

WAYS OF WORKING: TIGHT VERSUS LOOSE

There are times when it is appropriate to paint a subject in an accurate, detailed way. If you are fulfilling a commission, that may be part of the buyer's requirement. Your artistic training should enable you to complete such a request with skill and satisfaction for both you and your client. For me, painting in this way is a particularly interesting challenge.

One such challenge was painting the sounding board of a hand-built harpsichord. I was asked to design the space fully, to create a floral design in whatever manner I wished, and to use an abundance of reds and blues. The buyers preferred more detailed representational work, so my research involved studying some of the classic paintings on harpsichords of past centuries. In the end, though armed with knowledge of the past, I relied mostly on my own close association with gardening and love of flowers.

The intense daily challenge of designing and painting proved to be a surprisingly enjoyable experience in spite of constant standing and bending over the instrument. I began to look at it as solving a most intricate puzzle. The design had to work well as an integrated whole, yet there had to be variation to add visual interest. In the end, both the owner and I were well pleased.

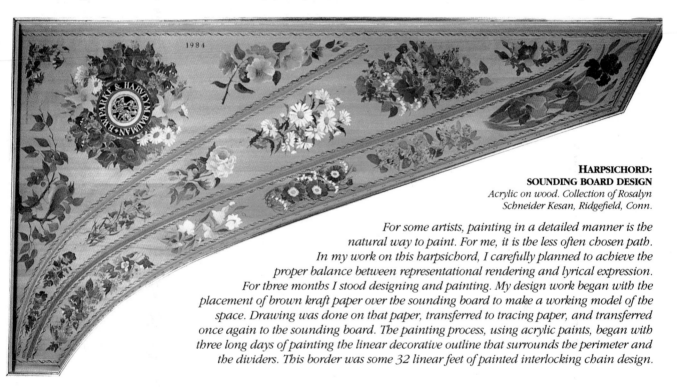

HARPSICHORD:
SOUNDING BOARD DESIGN
Acrylic on wood. Collection of Rosalyn Schneider Kesan, Ridgefield, Conn.

For some artists, painting in a detailed manner is the natural way to paint. For me, it is the less often chosen path. In my work on this harpsichord, I carefully planned to achieve the proper balance between representational rendering and lyrical expression. For three months I stood designing and painting. My design work began with the placement of brown kraft paper over the sounding board to make a working model of the space. Drawing was done on that paper, transferred to tracing paper, and transferred once again to the sounding board. The painting process, using acrylic paints, began with three long days of painting the linear decorative outline that surrounds the perimeter and the dividers. This border was some 32 linear feet of painted interlocking chain design.

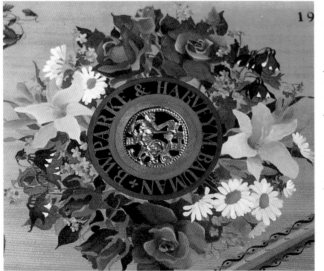

The gold medallion of the sounding board was the focal point, and I designed a wreath of flowers around it. Various sprays of different varieties of flowers filled the surrounding space. The addition of the bluebird and the cherry branches added a variation on the floral theme.

The lettering surrounding the medallion was the last work done on the harpsichord. The flowers were not difficult for me, but the lettering was frightening. The two names represent the builders of the instrument.

USING REALISM WITH A DIFFERENCE

Technical skills are paramount when working for accurate realism. Subject matter must be skillfully drawn, painted, and composed. There can be no fudging, for weaknesses in execution are immediately evident.

If you can combine expert technical skills to express intense involvement with your subject, you will bring to your work the unique participation of the imagination. The viewer senses this elusive magic touch and is drawn repeatedly into the painting for continued enjoyment. The oils of Vermeer or the watercolors of the late American painter Ogden Pleissner are good examples of exquisite craftsmanship coupled with the beauty of true observation and the response of the artist's inner spirit to a subject. The artist's response is the message, but it cannot be effectively communicated without the skillful use of medium and technique.

One contemporary artist who combines the discipline of training along with a unique form of observation is Linda Weber Kiousis. She is an unabashed realist who uses her skills through the watercolor medium to create works that always contain visual surprises, contrasts, or strange combinations of subject matter. She tickles our visual funny bone and makes us look at the world in a refreshing new way. She makes us *think!*

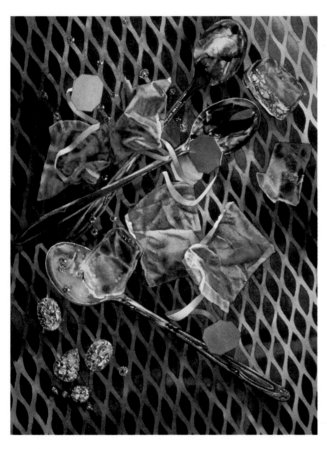

ICED TEA
By Linda Weber Kiousis. Transparent watercolor on D'Arches 300 lb. rough paper, 29 x 22" (74 x 56 cm). Collection of the artist.

Kiousis is a realist with a difference. Her detailed paintings are done with flawless craftsmanship, composed with intricate care, and cleverly conceived to present subject matter in unusual placement or combinations. In this painting, note the visual play on the word "ice."

Kiousis works on paper charged with water for the colors to float and mix. Once that is dry, she patiently builds layers of glazes until the desired effect is achieved. She prefers Winsor & Newton Artists' Watercolours and sedimentary pigments to give a grainy look.

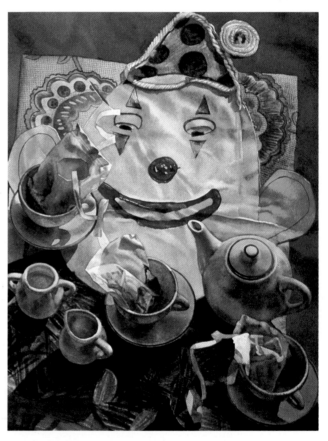

TEA A CLOWN
By Linda Weber Kiousis. Background concept by Carrie Weber, age ten. Watercolor on D'Arches 300 lb. rough paper, 22 x 29" (56 x 74 cm). Collection of the artist.

Combining creative thinking of adult with child can produce ideas from another world of vision. The adult concept of a child's tea set, dwarfed by adult tea bags, is further enhanced by the background of the child's artwork. The two form a delightful pictorial alliance that brings a smile and takes the viewer back to earlier days without the overuse of nostalgia.

EXPERIMENTING WITH TECHNIQUES

Artists sometimes forget to play, to have fun in their work. The "rules" begin to weigh us down and we wonder whether we are doing everything compositionally as we should. That very attitude can defeat the whole creative process. We need to take time to let our intuitive nature play with ideas, explore new techniques, and feel free not to succeed at all times.

Some artists set aside time just for free experimentation with materials and techniques. The search for new ways of expression can open up a whole storehouse of fresh ideas. Once something stimulates the imagination, there will be time later to bring it under the disciplined eye of design. The important thing is to let go and explore new territory.

Peggy Strohmenger remembers that as a child she created colored water by dipping crepe paper in it. She didn't really paint with the water. It was just the enjoyment of watching the transformation from colorless to color that captivated her. As a professional artist, she still continues the search for the new.

Play time is still an important part of the creative process for her.

Although Strohmenger is an excellent draftsman, she now rarely finds the need to start with a drawing or preconceived arrangement of nature. Rather, she begins "by reacting to a flood of intermingled colors, accidental drips, backwashes and puddles" where she finds surprise concepts and suggestions of nature. When specific reference is needed, she can always return to her garden, walk in the woods, or refer to her sketches and photographs.

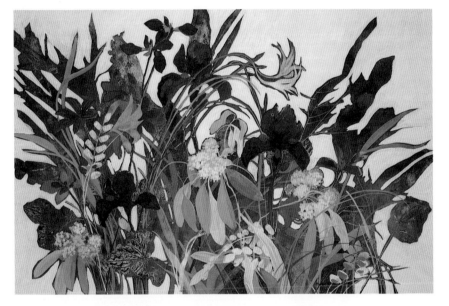

GOOD BEGINNING FOR A RAINBOW
By Peggy Strohmenger. Casein and watercolor on Crescent no. 110 illustration board, 19½ x 29½" (50 x 75 cm). Permanent collection of City of Brecksville, Ohio.

The artist wanted to achieve a live, vibrant feel of the growing garden through seemingly random arrangement of shapes. She used exaggerated colors and lush brushstrokes to give an emotional charge to the painting. She finalized the design by painting the background in neutral, light-valued negative areas, thereby opening up space but retaining some of the imprinted leaf shapes. The title refers to Iris, the Greek goddess of the rainbow.

LONG TIME NO SEA
By Peggy Strohmenger. Watercolor, inks, acrylic, metallic watercolor powder, collage, gouache, and water-soluble crayon on Crescent no. 110 illustration board, 19½ x 29½" (50 x 75 cm). Collection of the artist.

This painting began as an experimental exercise. Areas were taped off, paint was poured on with an eye to related colors, and then iridescent acrylic was dropped into some of the puddles. Layers of tissue were placed around the edges of the puddles, and the paint was allowed to creep up into the tissue, which was then set aside to dry and later used for collage. Sepia ink was brushed on to create contrast, and needed definition was added to the tail, fins, and head.

LAUNCHING THE CREATIVE JOURNEY

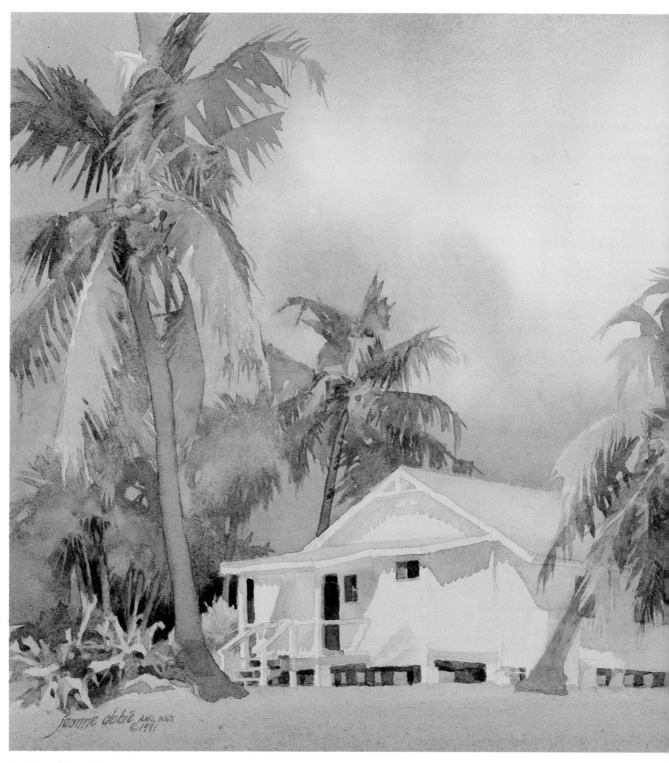

ROOM AND BOARD
*By Jeanne Dobie. Transparent watercolor on D'Arches 140 lb. cold-pressed watercolor paper,
10¼ x 14½" (26 x 37 cm). Collection of the artist.*

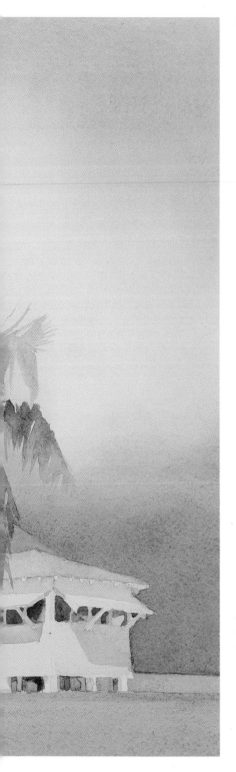

The artist develops a sensitive relationship to the natural world by savoring special intense visual experiences—moments of absolute concentration when time stands still and one relates absolutely to the surroundings. When this happens, the artist knows an exhilarating inner joy that leaves an indelible imprint on the mind. I once wrote a few lines of verse about this type of exhilaration:

> May your eyes always see nature
> As new, as wondrous
> Bringing
> Joy and inspiration.

This same sense of knowing occurs, too, in a more academic situation when one is learning a new subject or principle that seems difficult at first but finally makes sense. There is an inner connection of the new information with what the mind already has digested. When this connection gives new meaning and understanding, there is a wonderful sense of enlightenment. One of my students once came into class bursting with excitement. She had finally learned to see shapes rather than things. Her sense of discovery was wondrous. Yes, the flashbulb really goes on! The mind wants to shout, "I've got it! I understand!" It only means you are awake, fully awake, and all systems are go.

As artists, we often block these experiences by trying too hard to look for subject matter or technical answers to what should be coming from the heart. Yes, our academic training is important, but it must be coupled with our inborn human connection to nature. Then we can express with skill and with feeling what we want to say about our subject or concept.

In this watercolor of a Florida cottage placed against the immensity of the turbulent sky, the artist has created a statement of beauty and drama. Dobie has conveyed an intense visual moment by capturing the subtle nuances of atmospheric light that often cannot be recorded by camera. Note the important placement of shadow areas and the sensitive variation of warm and cool colors within the shadow areas, as well as this same variation echoed more dramatically in the palm leaves. The soft, glowing ground cover quietly provides the appropriate base for the structure.

FIND SOURCES OF INSPIRATION

When I am tired from working in the studio all day, there is nothing that refreshes me more than a walk. The grand old trees in my neighborhood, the well-tended gardens, and the quiet air all provide a change of pace. My mind and body recharge, and I become aware of the beauty of the moment. I become fully aware of what I am seeing. This requires a singleness of mind that can turn a walk into an exhilarating experience beyond ordinary casual exercise and observation. When I return, my mind has cleansed itself and is ready for whatever task lies ahead.

Artists must find ways to nurture their creative selves. In fact, anyone must find time to do this, for our lives become cluttered with busywork that drains our energies. It is possible to find renewing activities no matter what our environment.

I love to hike, and when time permits me to take to the trail, it is like a great adventure, for it is not often I can have this luxury. I store visual experiences that feed my mind and use them later in my work. Sometimes I take a camera or sketchbook, but more often I just absorb visual images. Unlike a camera's film, which retains a perma-nent image, the mind retains a transient image embellished by experiences and feelings. The artist's internal image is affected by the process of observing and reacting to the scene, as well as experiences that occur during the painting process. At both points there are alterations.

If you are without a sketchbook, notes and small sketches when you return home can create a quick and lasting record of the experience. Remember what it was about a scene that made an impression. Was it the shapes, the atmospheric conditions, the color, the close-up or distant view, or what? It often helps to make quick sketches that give you a feel for what you have seen: shapes, simple value studies, splashes of color, anything that will later help you relate to the scene. Note whatever made the deepest imprint on your mind without struggling for thought. Just let spontaneous words and images come to mind; refrain from judging their quality or immediate relevance. Trust your intuition. Those words and images are there only to trigger your mind into creating at a later time. The same applies to composition: That can be worked out at the appropriate time.

If you can put representational images out of mind for a while and focus on color and movement, another form of note taking can produce information based on "gut" feelings. Try an experiment. After you have seen someone on the street, quickly record what color seems appropriate for the way that person looks and walks. In addition, use a linear movement of your brush, pen, or crayon to indicate the type of energy associated with this figure. A slowly moving, depressed-looking person would call for a more undulating line, whereas an energetic figure would call for rapid up-and-down strokes. Think how you might incorporate hard and soft edges in this process. Just have fun and play with your responses to the subject.

Now do the same thing when you are observing nature. How does a great oak make you feel? What about a tiny flower or a beautiful waterfall? All these exercises let you get in touch with forms of response other than creating the expected natural image. This information, then, can be added to what is representative of its structure. By doing this, you have built a deeper and more accurate reaction to your subject matter.

A MATTER OF ENLIGHTENMENT
Acrylic on Crescent no. 114 cold-pressed watercolor board, 21³⁄₈ x 29³⁄₄" (54 x 76 cm). Collection of Mrs. Sarah J. Bennett, Canton, Ohio; courtesy of interior designer Michael A. Yannone.

A neighbor's water lily pond was the inspiration for this semiabstract painting. I decided to establish a rhythm of movement and a repetition of the curvilinear forms of flower and leaf shapes.

The lily shapes were masked out in the beginning while I established free-flowing washes of thin acrylic glazes. Once the general compositional theme was established, darker glazes were added to accent the abstract shapes. Finally I removed the masking from the lilies and added subtle definition.

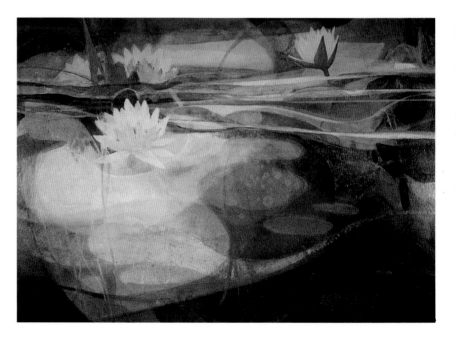

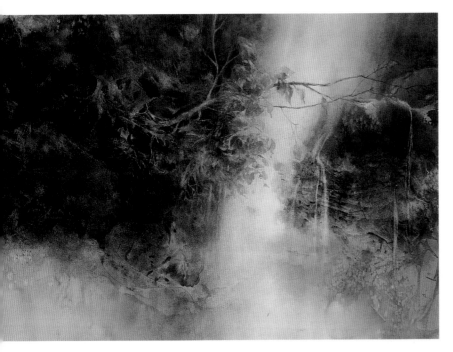

SYLVAN VEIL
Watercolor on Crescent no. 114 cold-pressed watercolor board, 20 x 30"
(51 x 76 cm). Collection of Mr. and Mrs. Robert Crumbacher, Rocky River, Ohio.

In the Appalachian woodlands, there is a lushness created by the abundant rainfall. Any hiker knows that when the ever-present mountain streams are interrupted by rocky outcrops or cliffs, they produce waterfalls. These are a welcome sight for the hiker and an inspiring source of subject matter for the artist. This painting recreates the memory of one such waterfall.

I dampened the surface and floated in large areas of random greens, blues, and browns along the upper areas. Some texturing was done by plastic wrap in order to create the random rock layers. I left the waterfall area open and sprayed along the edges to soften them. The overhanging branch acts as a directional guide to pull both masses together and move the eye from one side of the painting to the other. When the painting was dry, I added some detail work to define sections of the falls and some foliage areas.

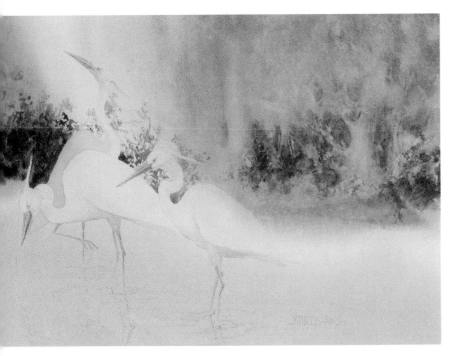

WHITE HERONS
Transparent watercolor on cold-pressed watercolor board, 9½ x 14" (24 x 36 cm).
Collection of Betty Murray, Dayton, Ohio.

When we lived in Piqua, Ohio, we discovered a herons' rookery not far from our home. It was a great pleasure to take an evening's drive to the rookery area. Armed with our binoculars, we could observe the flight patterns, landings, nesting, and water habits of these great birds.

This painting began as a compositional challenge in working with three major shapes: the water-sky area and the two adjoining foliage areas. Very free washes were randomly applied, and when they dried, one of the light areas near the right foliage looked like the upper body of a heron. That was the impetus for further designing. I placed tracing paper over the dried watercolor and began to work out the bird shapes. When I was quite sure of attitude and placement, I transferred the drawing to the dry watercolor surface. Minimal detailing of shadow areas, the addition of legs and beaks, and some negative shape painting of areas around the bodies completed the watercolor. The mood of evening mists pervades the composition.

SUGGEST A SENSE OF TIME AND PLACE

There is found in the arts an expression of the elements of time and place. Think back over trips you have made to museums and how often you gain a sense of specific time in relation to a work of art. For centuries artists have used a wide variety of personal ways to give symbolic and specific meaning to the aspects of time and place. Using symbols is one way to impart a sense of order to whatever an artist wants to express. This can be done abstractly, as will be seen later in the book. However, representational symbols can be used in work more obviously related to natural form. These symbols can speak with great eloquence when used with skill and restraint of statement and can tell us about the emotions of the artist, about time represented or remembered, and about location.

All living things go through a period of initial formation, on to maturity, and finally to death. It is part of the natural rhythm of life and has been depicted in various stages by artists down through the centuries. Time continues and life within the frame of time leaves its mark in a myriad of discernible ways. Artists may choose to concentrate on the geological processes of the earth, spanning eons of time, or may prefer to concentrate on the briefer span of human life. Whatever the choice, the artist almost always uses some form of symbolic presentation of subject matter, as does Roger Mark Walton in his moving watercolor concerning the death of a friend.

An artist who is willing to open heart and soul to the environment soon finds unending material from which to develop creative ideas. The lyrical paintings of Donald L. Dodrill illustrate one artist's poetic response to the world around him.

The theme of time interests Dodrill because time adds to the sense of place—the specific staging, lighting, and drama surrounding the subject. In his relationship to nature as inspiration for his work, Dodrill finds ample evidence of the effects and ever-present element of time as he observes the aging of trees, the decaying of organic matter, and the sprouting of new life all occurring close together as evidence of the continuing renewal processes of the environment. He states, "In using the theme of nature, my aim in painting is to project impressions and feelings realistically—to grasp nature's moods, beauty, and ugliness—using form, color, and design as a means to this end."

Artists who concentrate on the natural environment try to focus our attention on what is often overlooked. We observe what the artist has painted with new awareness of the subject and of the particular interaction of color, values, shapes, and edges that bring a feeling of the artist's personal response to nature. Not everything is immediately evident, and we begin to explore this visually created territory just as we would on location. The artist has created conditions that make us want to discover more. We want to linger.

The loss of a friend is eloquently expressed in this watercolor. The silent simplicity of format speaks of friendship, bereavement, the fragility of life, and the passage of time. It is as if each brushstroke is reconstructing the memories of the past. Note the reflections on the plate and the table. The vertical patterns of these light areas add a contrasting movement to the largely horizontal emphasis and guide the eye through the composition, avoiding what could have been a static design in less sensitive hands.

The slight diagonal thrust of the stem of the rose adds another important variation. The division of space in an approximately two-thirds to one-third ratio provides a large dramatic foreground for the placement of the plate, where the eye is drawn immediately into the subject and continues to dwell upon it in contemplation before moving with leisure into the light of the curtains and the reflections on the table.

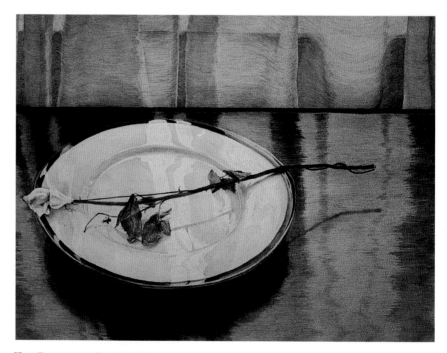

THE ROSE FROM LARRY'S FUNERAL
By Roger Mark Walton. Transparent watercolor on 300 lb. watercolor paper, 22 x 30" (56 x 76 cm). Collection of the artist.

BEGINNINGS AND ENDINGS

By Donald L. Dodrill. Transparent watercolor on D'Arches 140 lb. cold-pressed watercolor paper, 16 x 22" (41 x 56 cm). Collection of Mrs. C. William O'Neill, Columbus, Ohio.

In this painting with nature's elements playing supporting parts to the role of time, Dodrill captures the fresh wildflowers growing out of a decaying tree stump. The contrast in the time represented by both as the alpha and omega of existence drew Dodrill to the subject and later suggested its title. Masking was used to reserve the small flower shapes and weed stalks in the foreground. After the initial wet-in-wet washes were dry, Dodrill used a drybrush technique to add texture to the rough, weathered tree stump.

THE UNSEEN SEA

By Donald L. Dodrill. Transparent watercolor on D'Arches 140 lb. cold-pressed watercolor paper, 19 x 29" (48 x 74 cm). Collection of Mr. and Mrs. Geoffrey D. Manock, Columbus, Ohio.

This work was painted primarily from the imagination with assistance on details from photographic reference. The background was painted on a wet surface with various values of dark blues and greens blending and spreading across the surface. Careful sponging of selected areas later helped to bring into focus the sea life elements that appear in the painting. Slight texturing was done with a small amount of salt to suggest some of the varieties of underwater plants on the vast sea floor.

ESTABLISH MOOD

The many ways artists see are evident in the ways they express their visions in clearly personal and meaningful statements. Some artists deliberately choose not to express their feelings in their work. For others, this is the only way they can say with conviction what is foremost in their hearts. Such an artist is Dean Mitchell, who has closely studied nature in all its forms, including man's place in it. His paintings have a sense of total and compassionate submersion in the subject. The artist not only has observed the subject but has visually experienced it to the very depths of his being. He makes sketches and takes photographs for

reference, but to these he adds a sensitive awareness of the subject, which is the elusive element sensed by the viewer. The artist within has made the universal connection to the spiritual, which becomes part of the fabric of the painting.

Mitchell uses middle values and neutrals to build the feeling of mood within his paintings. His choice of more vibrant color is carefully selected and used sparingly for the greatest impact. Darks become a powerful force, sometimes bringing the viewer into the foreground, other times, adding mystery to a background from which the subject emerges. Lights are as carefully

planned, with the knowledge that light and dark contrast will direct the eye to chosen areas as well as to the focal point. The closely keyed value system in *Keep Your Eyes on Jesus* illustrates how effective is this approach to establishing mood in working with the human figure.

On the other hand, the more dramatic impact of *Fallen Grace* and *Eccentric* is partly achieved by the broader use of value and shape contrasts. These works immediately catch the eye. Their dominating forms and position against a light-value background provide the setting for immediate force of communication of the artist's vision.

KEEP YOUR EYES ON JESUS
By Dean Mitchell. Watercolor on paper, 22 x 30" (56 x 76 cm). Collection of Mr. and Mrs. Jan Adams, Irvine, Calif.

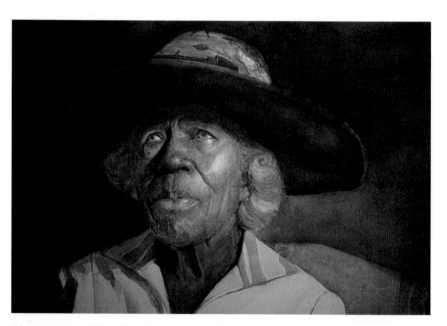

This is a powerful study of a woman in the dignity of old age who shows unswerving faith in surmounting whatever sorrow she may have faced during her lifetime. The artist has struck a universal note of suffering, hope, and survival in this painting. The establishment of mood by the use of closely keyed values and chromatic relationships keeps the focus on the tender repose of that face and the trusting look of those eyes. There are only the most subtle variations of warmth within the face, mainly on the nose and lips.

Mitchell directs attention through the gentle movement from shoulder to white hair and on to the highlighted cheek. Notice how the gray stripes on the blouse direct attention upward and the dark underbrim of the hat contrasts with the light of the face and the eyes. The artist has melted the far brim of the hat into the background and given the slightest touch of more vibrant blue to the crown of the hat. The economy of restrained use of color and lighting contributes to the overall impact of the figure.

FALLEN GRACE
By Dean Mitchell. Watercolor on paper,
24 x 18" (61 x 46 cm). Collection of
Maria and Gabor Nyeste.

This striking painting of an uprooted
tree captivates the viewer through its
implied sentinel presence over the
landscape and its final severance.
Mitchell has dramatically placed the
tree in a triangular position, with the
auxiliary small trunk at right angles to
the main structure adding an
energetic directional contrast. Mood is
established through the starkness of the
scene, neutral background tones, and
strong foreground values.

ECCENTRIC
By Dean Mitchell. Watercolor on paper,
20 x 30" (51 x 76 cm). Collection of the artist.

This painting brings attention to the
ultimate dignity of a subject that might
ordinarily be viewed as something to
ignore or hide from sight. This man is
part of nature with all its idiosyn-
crasies, and Mitchell has presented
him with love and respect for his
intrinsic worth. Note how surprisingly
similar this painting is in composition,
color, and mood to Fallen Grace,
despite the very different subject
matter.

ENHANCE YOUR MEMORY

If you paint on location or gather information there, observe not only the subject matter before you but its many subtle nuances of color, atmosphere, textural surroundings, and play of shape against shape. Added to this is the impact it has had on your imagination, for you must retain that sense of immediate excitement relating to your subject. As mentioned earlier, sketches and photographs are helpful, but they never replace what is surrounding you at the actual scene.

Homer O. Hacker for many years served as art director and chief photographer for the *Dayton Daily News*

(Ohio). His training as an artist and a photographer were combined when he left his commercial career and became a full-time fine artist. He has an excellent eye for composition, which he combines with careful draftsmanship to create representational work of exceptional beauty and impact. He strives to impart a sense of place and mood within his transparent watercolors by accentuating value contrasts, warm and cool contrasts in pigment, and selective placement of subject. Hacker uses his camera for gathering reference material, but he knows and practices the artist's freedom to

change elements within a photograph and simply extract what is most important for material in a painting.

Painting vacations to areas away from home provide a wealth of new material for an artist. Your photographic records, notes, and sketches of new places and people can be reviewed upon returning to the studio for serious painting. Remember not to slavishly copy your photographs or sketches, though: Learn instead to inject thought and emotion into the painting process as Homer Hacker did, in order to communicate effectively with the viewer.

CALYPSO KID
By Homer O. Hacker.
Transparent watercolor on paper, 21 x 28" (53 x 71 cm).
Collection of the artist.

Hacker uses his camera with skill, but the basis for this painting was a poor-quality slide that showed little detail of the face. The artist's training in drawing the figure came to the rescue as he added facial detail where needed. Hacker's creative decisions focused on the shape of the hat, its many loose fronds, and the play of light and shadow on the face.

He brought a wash of burnt sienna as the initial flesh tone across the face and added phthalo blue in the backlit areas, melding these into the warmer portions of the face. Finally, dark shadows were added along with a gold tooth and a gold earring to give a fine linear complement to the lines of the hat. The hat was painted in a variety of warm and cool tones to add interest and variety to its overall straw-colored natural appearance.

ON THE MOAT
By Homer O. Hacker. Transparent watercolor on D'Arches 300 lb. cold-pressed watercolor paper, 17 x 28" (43 x 71 cm). Collection of the artist.

It is difficult to paint subjects in motion. You must form an immediate impression of the action and reinforce your memory with photos and quick sketches. Compositional adjustments may be made later, when you finalize the design.

This dramatic painting of swans is beautifully composed with the placement of the birds on the water and their rippling reflection breaking across the surface. The dark, tree-filled shoreline is echoed in the river surrounding the swans with velvety protective darkness. Notice the luminous glow of the bodies in contrast to their dark background.

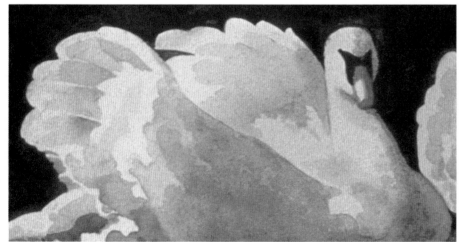

Here you can see the fine-tuning of detail without overdoing it. The feathers are only suggested by subtle nuances of color and shadow. The birds' positions and their relationship to each other are as graceful as those of ballet dancers at rest. Much of the work on the bodies is done wet-in-wet, thereby giving a soft contrast to some of the harder edges that push against the background and foreground. This variety adds interest and energy to the painting.

MAKE THE ORDINARY EXTRAORDINARY

A master painter goes beyond technical accomplishment to explore and transform the visual world so that the most humble subject becomes something remarkable. The time-honored experience of painting on location can provide the artist with firsthand observation of constantly changing conditions of light. For some artists this is a frustrating experience because nothing is constant; light, color, shadows, shapes, and values keep fluctuating. For the more attuned artist, awareness of the natural variations offers an opportunity for discovery of special moments when conditions are best suited for what the artist wants to express. The mind retains what the camera is often unable to capture, and the mind and brush together recreate the artist's vision. Then the work takes on a quality that rings with beauty and integrity.

For Jeanne Dobie, the exploration of optical glows that make color "sing, float, and vibrate" is one of the keys to making an ordinary painting extraordinary. She feels that an artist who has achieved technical excellence must take the next step and become aware of how thoughtfully he or she paints. She says, "I believe that an artist should work with concepts that transcend the medium and subject and give his or her work another more important dimension. An artist's understanding of color should extend beyond mere intensity. The challenge is to extract the elusive 'glow,' a reaction that occurs between one jewellike color and the colors that surround it—to key that color in such a way that it appears to glow optically!"

PIAZZA PATTERNS
By Jeanne Dobie. Transparent watercolor on D'Arches 140 lb. cold-pressed watercolor paper, 21 x 29" (53 x 74 cm). Collection of the artist.

Dobie finds that the excitement of creating lies within the artist's mind—in extracting from ordinary subject matter the potential for a composition, and transforming that subject into a painting of sensitive quality and form.

This actual scene had wrought-iron railings casting shadows, which were entirely eliminated. The emphasis was placed on the light pattern made by chairs and tables, which the artist rearranged for compositional purposes. A contrasting pattern of glowing shadow shapes was juxtaposed and interlocked into the tables and chairs arrangement, adding excitement and variation to the design. The figure was not a part of the scene but was added from sketches made from a previous observation.

Note the importance of this vertical human form: With its darker values and more colorful head, it adds a focal point to the work. The shadow areas and the man's head glow with subtle color. The variety of soft and sharp edges evident in the stone pattern of the piazza, the chairs, and the tables keeps the painting from becoming too harsh and overly busy with pattern. The final addition to this watercolor was the velvety soft background achieved by turning the painting upside down and adding a richly saturated dark to that area.

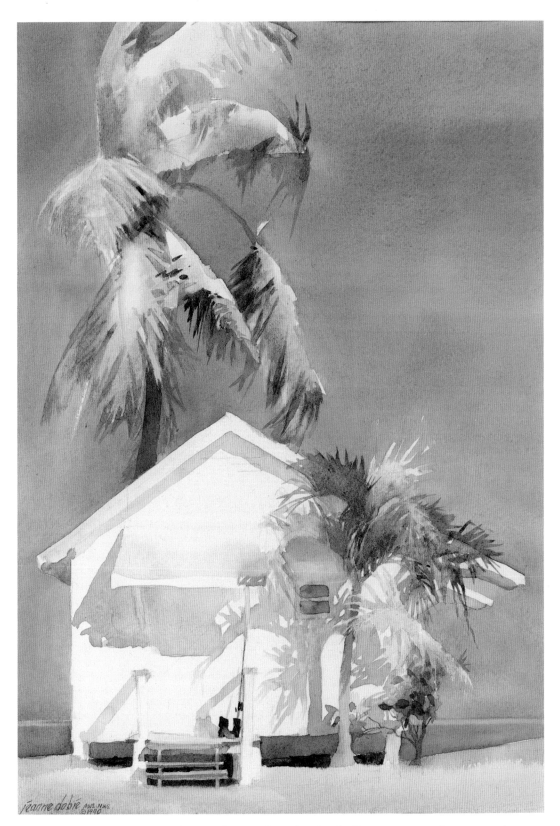

V.I.P. COTTAGE
By Jeanne Dobie. Transparent watercolor on D'Arches 140 lb. cold-pressed watercolor paper, 14½ x 10¼" (37 x 26 cm). Collection of the artist.

This simple scene from the Florida Keys—cottage, palm trees, and glimpse of ocean beyond—is brilliantly illuminated by Dobie's sensitive eye and brush to capture the tropical fusion of sun and ocean air. The lights were toned and painted first. Notice the subtlety of warms and cools within the shadow areas under the door overhang and behind the palm tree shading the cottage. The other colors and darks were selected to accent the established fresh, luminous lights.

SEARCHING FOR DESIGN

EARLY SNOW
By Arlene Lee. Watercolor on Strathmore
no. 114 cold-pressed illustration board,
16½ x 26½" (42 x 67 cm). Collection
of the artist.

A humble basket of apples becomes a subject of beauty as the artist fuses the
basket into the mass of background shape and extends it into the foreground
shadow area. This beautifully designed painting conveys a sense of reverence for
the small pleasures of nature as the artist delicately indicates nuances of light
and shadow, evolving subject, economy of detail, and balance of linear form to
mass. All is exquisitely placed. Nothing is to be added and nothing taken away.

Have you ever wondered why you are drawn to a work of art? What causes you to gravitate to that piece and return again and again? Beyond subject matter and concept, there are basic creative components that play an all-important role in building a strong compositional statement.

One of these fundamental design elements is the creation of interesting shapes or forms that can be used to sustain the viewer's attention. This holds true in both representational and nonrepresentational work. Shapes must have an aesthetic structure that gives the form meaning as a design element. Then the shape must display a sense of rhythmic emphasis and have some relationship to inner balance.

A sliced, polished section of an agate often shows beautiful natural design present in nature. The art of the caveman displayed an exquisite sense of feeling for meaningful shape and economy of statement, as has much of the art of the masters down through the ages. It is seen again in contemporary art forms such as the sculptures of Henry Moore, the paintings of Robert Motherwell, the mobiles of Alexander Calder, and the watercolors of Paul Klee. Joseph Raffael, Andrew Wyeth, and many of the artists in this book have developed a perceptive feeling for the importance of shape within their work.

The organization of shapes into meaningful relationships through variety of size and spatial intervals provides a compositional skeleton for the artist to express chosen subjects or ideas. The shapes can be organic or geometric. Once this structure is determined, the artist has a foundation on which to build, a basic structure onto which personal expression can be added so that the painting transcends its basic concept.

Mary Todd Beam has utilized her drawing ability and strong use of design in creating watermedia paintings of great strength. She is an astute observer of nature who is sensitive to the many nuances of natural change. Rocks and landscape are constantly eroding and rebuilding over time as moving water, wind, and weather fluctuations slowly or quickly recontour the natural surroundings. The artist's close association with the activities of the forest are reflected in many of her works.

Beam uses nature as her springboard to creative painting. Rarely does she attempt to depict a subject in a literal way. Instead she gives an even deeper meaning to a subject by imaginative interpretation and sensitive use of color, value, shape, edges, and the contrast of opaque and transparent passages in her compositions.

Paul Melia uses line to create a vigorous statement of observations of the world around him. His lines move freely to create shapes of infinite variety, always controlled by a superb sense of design. Shapes are echoed, overlapped, exaggerated, distorted to strengthen the composition. There is a feeling of intense, energetic enjoyment of the process of creating, which is not lost in the final painting. This exuberant joy of commitment to the creative process becomes a powerful means of communication with the viewer.

Carole D. Barnes finds nature to be a strong influence in the gestation stage and development of her paintings. Her early works were close representations of what she observed, but she found that she wanted to express more than the immediate visual scene. Now she tries not to depict as much as to interpret the essence of the subject. This type of thinking points up an important difference in contemplating subject matter, for it goes beyond the obvious postcard view to search for an inner reaction to the subject.

Barnes plays with shape and color, bringing hints of subject matter to the surface but always integrating these as design forms relating one to another toward making a compositional statement. The work goes through many stages and adjustments as it evolves, is fine-tuned, and reaches its final stages of expression. The paintings take on a contemporary look undergirded by the use of interesting and varied shapes, unusual color combinations, and the personal vision of one who knows the forces of nature.

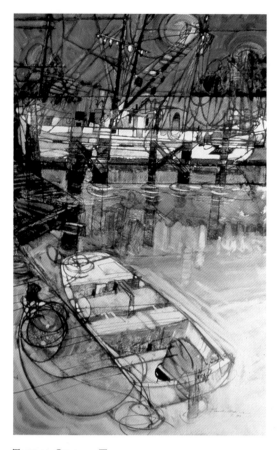

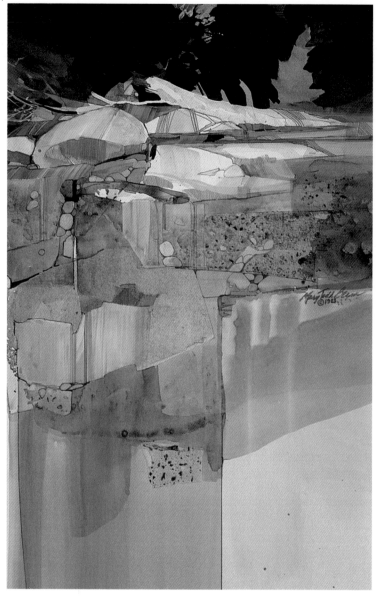

TARPON SPRINGS II

By Paul Melia. Transparent watercolor on gessoed Crescent no. 110 illustration board, 44 x 30" (112 x 76 cm). Collection of the artist.

What could have been a static, everyday painting takes on a charge of quiet energy through the unifying force of repeated circular shapes in the line on the dock, the lines from the masts, the tree forms, and the moon in the twilight sky. A secondary rectangular form within the boat is echoed through a variety of small and large similar shapes. Notice how the contrasting diagonal thrust prevents the painting from becoming stiffly perpendicular.

LIFESTREAM

By Mary Todd Beam. Acrylic, watercolor, and graphite on Crescent no. 1 watercolor board, 40 x 30" (102 x 76 cm). Collection of Dr. James Mitchell, Cambridge, Ohio.

This landscape, with its dramatic emphasis on the vertical format, conveys the varying and dramatic shapes and structures of nature. Rocks, trees, and stream are all indicated in a stylized way that alerts the viewer to their structural aspects. Take special note of the varieties of shape within shape.

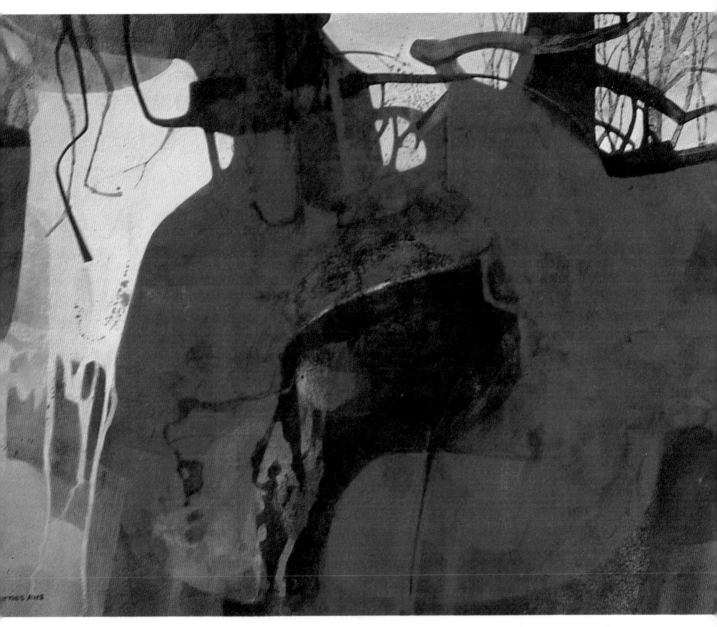

CONCERTO OF THE TREES
*By Carole D. Barnes. Acrylic on Strathmore Aquarius II watercolor paper, 22 x 30"
(56 x 76 cm). Collection of the artist.*

*The artist sized the paper with gloss acrylic medium and then glazed with rich
yellows and reds to build up a texture and pattern, sculpting out areas to simplify
design by using an opaque white toned with color. She used cool pigments to
recede and to provide a background for the tree shapes. Foremost in creating this
painting was striving for the essence, for the source of strong trees.*

SHAPE, LINE, COLOR

The artist begins to call attention to a composition through the use of shape, line, and color. One of these interwoven elements usually predominates, supplemented by the other two. Added to this must be the qualities of rhythm, repetition and variation, emphasis, balance, and proportion. Through training and practiced awareness of compositional form, the creative artist often utilizes design principles in an intuitive manner. The artist learns to see and use interesting shape, to use line expressively, and to select color that will have the intended emotional impact. The artist then assimilates this knowledge for easy access when needed. The secret is to know design rules, but to know when rules can be relaxed or broken.

Watermedia artist Fred Leach feels that "approaching a painting as a whole so that it functions as a unit rather than in fragmented areas provides structural unity to a composition." His paintings are dominated by interesting shape. Color is kept subdued, and line is used with exquisite contrast to shape. He states that creating a painting from overall design shape, "along with emphasis on simplicity and having a creative statement to make other than just making a pretty picture, are the elements of a strong painting." Other artists may echo this statement in their own ways, for the principle is basic. Leach says, "A good painting is a combination of thinking and feeling, otherwise a painting is either too sloppy or too stiff." He emphasizes that today's students need to learn how to draw and to design shapes in order to create a good foundation for their creative work.

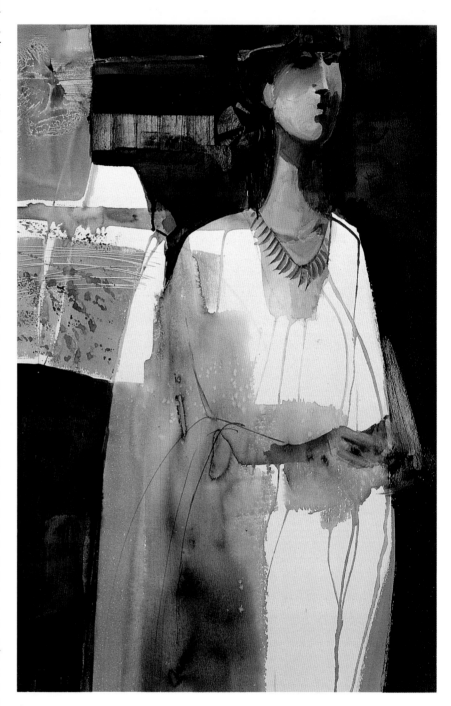

ARISTOCRAT
By Fred Leach. Transparent watercolor on Crescent no. 114 watercolor board, 40 x 30" (102 x 76 cm). Private collection.

This well-designed composition features a figure loosely defined by surrounding areas of dark negative shapes. Leach skillfully uses the dribbles and runs of paint to contribute to the delicate balance of shape and linear expression. The abstracted face combines form with just enough definition to portray the person's place in society. Color remains subdued, letting shape dominate. The composition stays alive because of the free handling of the brush, economy of added detail, and consistency of overall treatment.

WORKING WITH MASS AND SPACE

A large body of my work has found expression through examining the various elements of the larger natural scene. Perhaps my being nearsighted contributed to this choice, but I think I found the shapes of nature inspiring in themselves and fuel for the creative process. Even in doing a larger scene, I would tend to see it as an overall mass of various indentations, protuberances, and open spaces that provided the main statement of a composition. Then I would break it down into the elements of mass, line, color, value, and texture. This approach of seeing the overall shapes first may have made it easier for me when I began painting on a more intuitive basis, for that process always begins with large spontaneous masses.

When you look at shapes such as trees, people, or still-life objects, you see a variety of forms, but taking them as a whole, you see a mass as if they were all silhouetted. The many parts unite to become a larger whole that in turn describes the

space surrounding it. If you study oriental art, you become aware of the importance of space and mass. They are part of the interlocking opposites of design with negative space surrounding positive mass.

When a painting conveys the artist's genuine love of nature coupled with a sensitivity for well-designed placement of mass against space, the work gains an elegant simplicity of statement. Arlene Lee's paintings of the humble subjects of nature, coupled with her interest in the oriental arts, reflect a personal interpretation of often-overlooked subject matter. She states that she does not "look for paintings when she is outdoors," but rather she thoughtfully observes, stores impressions in a corner of her brain, and lets this brew along with the accompanying internal moods and feelings relating to this information. For her it is more important to internalize these impressions than to make a near graphic outline of a particular subject. She wishes to "take the

ordinary and imbue it with a glow."

Once Lee has decided on a subject, she wants first of all to make it look as natural as possible, as if she came across it accidentally. Many three-value abstract thumbnail compositional sketches are done to plan the set-up. If she has arranged a still life, she uses spotlights meant for indoor plants to highlight her subject so that the light never varies. When she has decided on the composition, she does a detailed drawing on tracing paper. Once all corrections are made, the drawing is transferred through graphite tracing paper to her painting surface.

All her paintings are started with the medium darkest mass to set the tone. Then, through direct painting and glazing, she weaves value changes and shape in and out of the original medium value mass area. The glazing enables her to make objects come forward and recede. Her dark areas are transparent so that the viewer feels that there is further depth behind what is seen.

GLIMPSE OF TIME
Transparent watercolor on Crescent no. 114 cold-pressed watercolor board, 14½ x 19½" (37 x 50 cm). Collection of Ruthanne Linde Berger, Shaker Heights, Ohio.

In doing this watercolor a few years ago, I wanted to contrast an interesting mass shape with fine linear movement and surrounding space. The stones, washed by years of running water, had softened edges and a variety of surface textural patterns. Their texture was barely suggested, but the light and dark values of shape against shape were accentuated. The fine runs of color going off to the edge of the surface brought a sense of movement of the water without overstating the fact. The mass shape divides the unpainted surface into a pleasing variety of negative shaped areas of space.

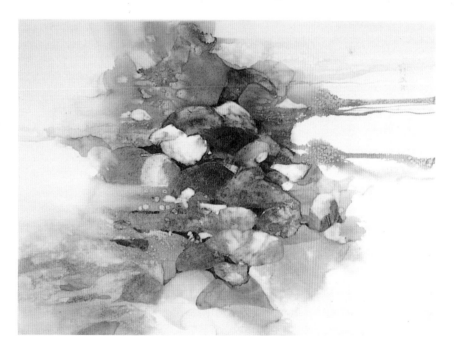

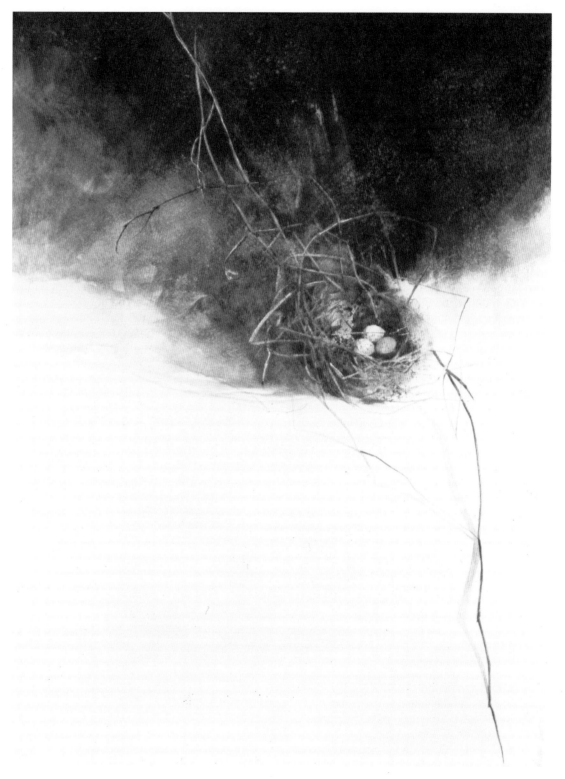

THE BIRD'S NEST
By Arlene Lee. Watercolor on Crescent no. 114 cold-pressed illustration board,
18 x 13" (46 x 33 cm). Collection of Mr. and Mrs. D. Weeden Wood.

Note the shape and placement of the mass from which the nest evolves. Lee paints
upright so that she can pace back and forth viewing her progress from various
distances. The elegant placement of linear form is the secret to a sense of activity
within the composition, for the eye follows this linear movement. Note the hint of a
shadow, which softly repeats the downward thrust of the line.

Working with Abstract Forms

From the beautifully designed use of mass and space as seen in Arlene Lee's representational paintings, we can move to another viewpoint that emphasizes the abstract nature of spatial, shape, and value relationships. These become the subject more than any specific reference to some recognizable form, even though there may be an underlying connection to actual subject matter. The artist's and the viewer's enjoyment is in form and structure, mass, and space for its own sake.

I explored a series of works related to earth forms some years ago. The challenge was in creating a counterplay of mass and line, horizontal and vertical thrusts, weight and weightlessness, drama and harmony. I chose to work with shape so that the surrounding space became an unobtrusive but interesting and important element in the design. I also decided to do this as a two-panel work, with one panel wider than the other. Each panel would hold its own as a design, but the two together would be greater than either alone.

This was a great learning experience, and several paintings came out of that series. Sometimes I would do a small watercolor compositional study or series of studies. Other times I would place a mass on the paper, and that would be my initial challenge. What other shapes should be combined with that first shape? What value changes would add strength? How was the surrounding space developing as a series of shapes? I kept colors in closely related tones, often in the earth color family.

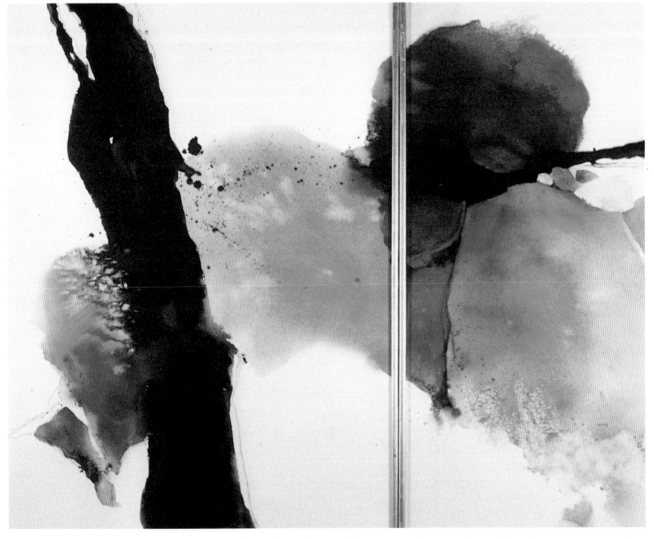

LANDFORMS—DIPTYCH
Transparent watercolor on Crescent no. 114 cold-pressed watercolor board, 30 x 22" (76 x 56 cm) and 30 x 14½" (76 x 37 cm). Private collection.

This work emphasizes the contrast of values, the carefully chosen placement of masses, and the importance of untouched space. The negative areas are as important as the painted surface. I tore black construction paper into various shapes to design the dark linear form and then painted it without hesitation. The drama of that thrust brings movement and contrast into the painting.

INTERLOCKING SHAPES

One of the problems of design is keeping the units of a composition related in some form without seeming contrived. There has to be a vitality and a feeling of unity to a work of art. Otherwise it becomes disjointed, with many separate but conflicting areas of interest.

The artist should be cognizant of shapes connecting together in some manner to create larger forms or design patterns. This is accomplished by varying hard and soft edges, by making value and color transitions, and by interlocking shapes from one area into the adjoining one. None of this should be too obvious, but it should be recognizable upon careful analysis of a painting, and it strengthens the compositional statement.

An artist's creative thinking often starts obliquely and takes many unexpected twists and turns before resulting in an approach to a specific composition. For example, Susan Graham passed by a red barn that had a green tarp piled in front of it and decided to try a red and green complementary color painting.

She chose to use the rectangular format of painting the barn head-on, using doors, windows, siding, and shadows to break up the space. She worked out a number of compositional sketches before deciding on the one that emphasized the interlocking shapes of the pigs into the structure of the barn. She states, "In order to carry the green used in the window throughout the painting, I added green to the board under the door handle on the left, and to the tiny square of wood on the bottom right, which also promoted balance." Green and red were introduced into the shadow areas to continue the complementary color theme.

Graham works transparently with many glazes of color, adding depth and subtlety of tone to her works. The building had washes of red, orange, and purple to achieve the final color. Greens were added in the chosen areas and carefully adjusted for brightness.

Representational watermedia painter Frederick C. Graff also prefers to work transparently. He searches out interesting locations and looks for structural subject matter that can be organized into strong compositional statements. He prefers to keep his color choices simple and closely related, with the major emphasis on value contrasts rather than color variations. Often he will block in the major masses of a painting with a wash of Davy's Gray and add color tones later.

Graff has developed a method of presenting his subject in a lyrical, understated manner that gives the major emphasis to value and shape relationships with interesting variation of interlocking forms. He prefers a vignetted form of painting, and within the first washes, he intentionally preserves areas of loosely defined white shapes to link with larger unpainted areas. His use of negative shape painting provides definition, giving general structural information to the subject without obsessive dwelling on it. For him, it is more important to imply form than to define every angle and detail. The viewer visualizes what is missing and becomes part of the creative process in doing so.

Note the way the pig shapes become an extended part of the foreground area and interrupt the straight line of the barn by breaking into the space above. Graham stated that in working out her design statement she ended up creating "a neatly organized painting with a touch of pig humor."

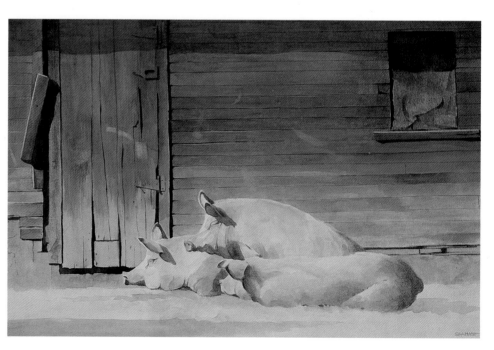

COMPLEMENTS
By Susan Graham. Transparent watercolor on Crescent no. 110 illustration board, 19½ x 29½" (50 x 75 cm). Collection of the artist.

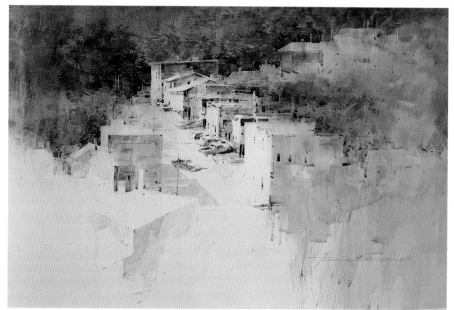

LEWISBURG

By Frederick C. Graff. Transparent watercolor on Strathmore 500 series hot-pressed illustration board, 20 x 30" (51 x 76 cm). Collection of the artist.

This painting was done with a series of light gray washes and colored glazes. Graff states that the cars, windows, and building foundations were strategically designed in order to emphasize the aerial perspective of the scene and to give a feeling of activity or interest. Notice how the architectural shapes of the buildings interlock into the large, tree-covered mass. The final steps were to soften some edges and to project light shadow washes that further developed plane directions and unified the different elements of the painting.

DIFFERENT SPOKES

By Frederick C. Graff. Transparent watercolor on Strathmore 500 series cold-pressed illustration board, 20 x 30" (51 x 76 cm). Collection of the artist.

This work is an excellent example of the design theme of repetition and variation. All the bicycles and tricycles are part of the large mass shape that meets the unpainted white area in front. One mass interlocks into the other through the linear forms of the bicycle shapes.

THE IMPACT OF DESIGN

The organization of ideas into a powerful compositional statement is the goal of most artists. They may differ in choice of subject matter and in the revelation of the artist's creative methods, but they wish to communicate effectively.

Interpretation becomes a personal choice, but beneath that is the foundation of good design. The emotional response to an idea needs the undergirding of organization of thought concerning form and space, color, value, line, and texture. The experienced artist can use this knowledge with relative ease. Less experienced artists often find the process painful, but come to recognize that it is part of what must be learned in order to express well what they want to convey in a work of art.

When an artist has learned control of skills, then true and effective expression of content is achieved. The soul of the artist speaks with authority in the creative work. When that happens, a dynamic sense of communication with the viewer is established. The imagination and vision of the artist can be presented with personal style and authority.

Marbury Hill Brown is a master designer of paintings that speak with tremendous power in their draftsmanship and compositional forms. There is an elegant simplicity of structure, coupled with freely applied pigment that utilizes the fluidity of the medium but is never out of control. His works incorporate a strong sense of the impact of nature's voice through the presence of the human form either by incorporating the figure in the painting or by implied human impact through the use of various objects symbolic of human activity.

LILY
By Marbury Hill Brown. Transparent watercolor on Strathmore four-ply bristol board, 22 x 29"
(56 x 74 cm). Collection of the artist.

This composition is deceptively simple in its large shapes and minimal use of exquisite detail. Although the lightest areas are toned, they appear to be white in contrast with the surrounding dark areas. The direct, fluid application of the medium lets brushstrokes become obvious and add energy to the wall surface. The interlocking of shape into shape—such as the head of the lily into the drapery—prevents the painting from becoming static in its simplicity and strengthens design.

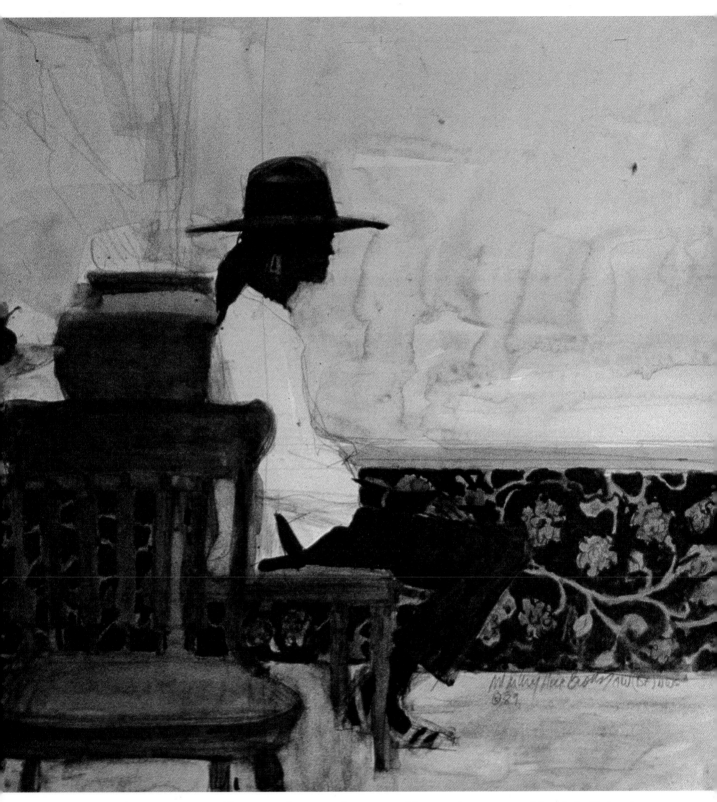

DIRTY WALL
By Marbury Hill Brown. Transparent watercolor on Strathmore four-ply bristol board, 22 x 29" (56 x 74 cm). Collection of the artist.

The woman fuses into the pattern of shapes to become part of the whole. Notice the intricacies of shape variation within the wall surface as it meets the figure and furnishings. The use of pattern in the lower portion of the wall adds a needed contrast to the other elements and repeats some of the organic shape of the fruit at the back of the figure. The artist's expert use of design serves to emphasize the mood of expectant waiting within the composition, yet prevent the painting from being static.

MAKING COMPOSITIONAL ADJUSTMENTS

There are times when a composition seems to lack resolution. This is a period of frustration for the artist, when the painting holds promise but the answer isn't forthcoming. When that happens, I put a painting aside for a time and go on to other things. Once I have taken my mind off the problem and let it relax with other projects—which can be anything from starting another painting to mowing the lawn—I find that new ideas begin to surface. Sometimes I won't return to a painting problem for days or weeks, but when I do there is a new way of viewing it that often offers unexpected decisions and approaches to solving the problem.

Many of my paintings incorporate my interest in the play of light, both as a source of illumination and as the creator of design shapes. I usually leave large areas of open space that is gradually narrowed to emphasize the point of interest in the work. I had developed a fresh, vigorous start for a rock and foliage theme. It was open, filled with light, and rather pleasing in color. But it just didn't seem complete. It had not arrived at the final compositional point where I felt that no more needed to be said.

This unfinished work hung around for quite a while until one day when I glanced at it and a possible solution came to mind. I would have to take a big chance by changing the subject, which would either solve my problem or add to my collage pile. Either way, I knew I couldn't lose. I decided to transform the rocks into flowers, add a bit more ground cover, and tighten up the composition without sacrificing too much of the feeling of light.

Light guideline drawing was done to block in the newly created flower forms. It was important not to lose the wet-in-wet transparent look of the original painting. The additions and adjustments had to fuse naturally with the initial work. Sometimes being willing to take chances, knowing that one may not be successful, gives an artist the freedom to try things that might not otherwise have been attempted. This really was not a terribly daring change, but it could easily have failed. An artist has to learn to be willing to change course, to be flexible and unafraid of failure if a decision should not work out. There is always another piece of paper waiting for a new start.

SPRING PRELUDE
Preliminary painting.

This rather pleasing beginning remained unresolved for weeks. Redesigning the rocks and changing them into flower forms provided a new solution to the compositional problem.

SPRING PRELUDE
Transparent watercolor on Crescent no. 114 cold-pressed watercolor board, 20 x 30" (51 x 76 cm). Collection of Doris F. Zimmerman, Kettering, Ohio.

Notice how the increased background area helped to create the flower forms, as did the subtle addition of tone in the foreground. The painting still retains its feeling of openness and light.

DEMONSTRATION: CREATING RHYTHM IN DESIGN

Rhythm is an intrinsic element of nature, and it also plays an essential role in art. The viewer's eye moves throughout a pictorial composition, accelerating and decelerating as it explores the visual territory created by the artist. When the viewer's eye is forced to stay too long in any one place or is awkwardly interrupted in its journey throughout the painting, the compositional framework is faulty and must be adjusted.

I find that standing to paint helps me move my arm freely to establish the initial large shapes and feeling of movement in a painting. The rhythmic aspect of that movement is present early in the painting process, a natural response of the body in the creative moment, but that rhythm must be refined in order to be well integrated within the work.

This process of refinement continues throughout the painting process. When I step back from the heat of the moment and begin to analyze what is developing, one of the first things I consider is whether the eye is moving freely throughout the painting and whether I have success-fully established a feeling of rhythm. Some rhythms may guide the viewer in a leisurely journey. Others may have more of a staccato movement, while others may create a feeling of impending drama or force of energy. The artist determines what is most suitable for a particular subject or concept. Shape, value, color, line, and textural relationships all contribute to the development of movement and rhythm. They are all part of the orchestration of elements that create a work of art.

A few years ago, I began a water-color with large gestural movements of the arm. Paint was brushed in a somewhat circular fashion onto a slightly damp surface. I wanted to leave open areas in unequal propor-tions around the mass of color, but did not have a preconceived idea of subject matter except for shape and movement. I had chosen blues and violets as my dominant colors and added accents of siennas.

When the initial wash was drying, I noticed a light midvalue shape in the background that resembled a profile of a bird's head and upper body. This became the beginning of a subject. As I examined the various areas of the early washes, excite-ment began to build, for I found the beginnings of my composition. The bird theme was apparent; all I had to do was pull it out of the mass of color through the use of negative shape painting to give needed defin-ition, and to open up a few areas to create other shapes that would give meaning to the painting. Excessive details were not needed if I wanted to retain the dreamlike quality of the original washes.

This type of thinking has its roots in some of the most primitive cul-tures. African sculptors will study a block of stone or a piece of wood for days before carving. They are trying to discover the spirit of that stone or piece of wood and bring it to the surface. Eskimo soapstone sculpture is approached in much the same way. There exists an image within the stone that is only to be released by the craftsman. The abo-riginal artist draws upon his dream journeys and lets them guide him in his work. As modern-day artists, we can draw on those inner resources that have been present in the human psyche for thousands of years. Coupled with the discipline of our training, this can lead us into some exciting creative directions.

STAGE 1: FINDING A THEME

I began by using free, rhythmic arm movements to apply a curvilinear mass of blues, violets, and siennas to a damp surface. The bird-shaped head in the right middle background provided the idea for the painting's theme. Darker areas were applied around the other bird groupings to block in the composition. Two design problems immediately became evident: The white tail of the far left dove was going into the darkest dark and attracting too much attention, and the ambiguous shapes and runs at the bottom were too similar.

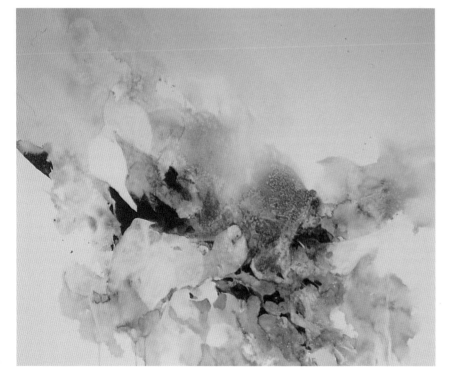

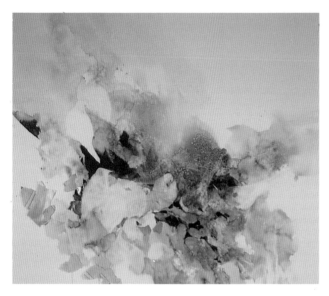

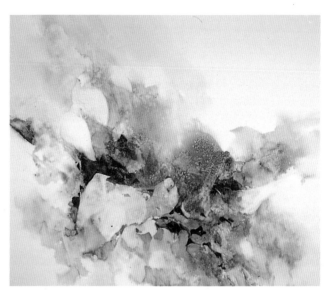

STAGE 2: CORRECTING DESIGN PROBLEMS

At this point I was pleased with a distinct feeling of rhythm in the painting, but I recognized design problems in the lower areas. I tore the classified section of the newspaper as a substitute for a midvalue tone and placed shapes in the problem areas. Note that in the early development of the birds, subtle adjustments were made in value changes surrounding them—all except for the bird in the very dark, problem area.

STAGE 3: ADJUSTING THE LOWER AREAS

By now I have painted the lower areas with a light midvalue wash to adjust shapes to a more pleasing balance. This area will be further designed by developing leaf shapes within by lifting out color and by negative shape painting. I also considered cropping the painting to strengthen its composition, but rejected this idea when I saw that the feeling of open space around the mass contributed to its design.

STAGE 4: REFINING DETAILS

Note the development of the leaves, stems, and branches. The far left bird was toned to pull its shape into the background forms. The central grouping of doves worked as a mass, but the heads of the middle ones were too flat, so these were modified to give some suggestion of shape as seen in the final painting. Note that the leaf shapes give meaning to the lower mass and contribute to the sense of rhythm.

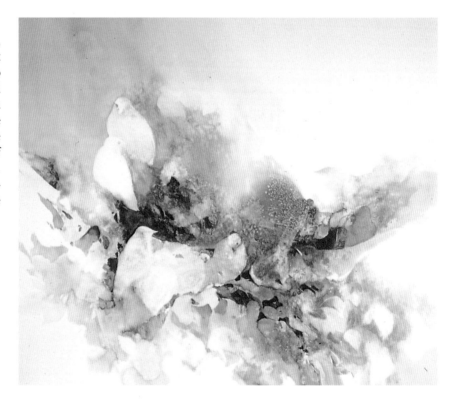

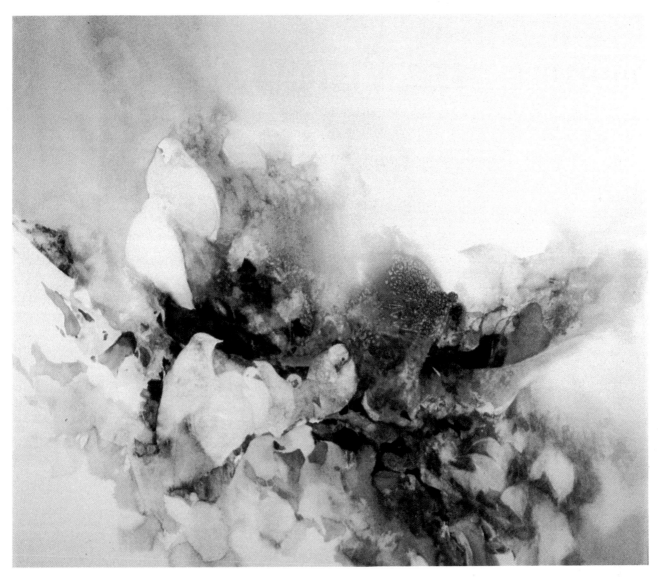

THE GATHERING
Transparent watercolor on Crescent no. 114 cold-pressed watercolor board, 26 x 30" (66 x 76 cm). Collection of Cara Smith Stirn, Pepper Pike, Ohio.

The finished work retains its ethereal character, aided by rhythmical movement as the eye travels in a curvilinear path. The forms suggest the essence of birds rather than accurate renderings. The variety of soft and hard edges provides the transition between form and space, intensifying the sense of mystery.

EXPRESSING YOUR INNER VISION

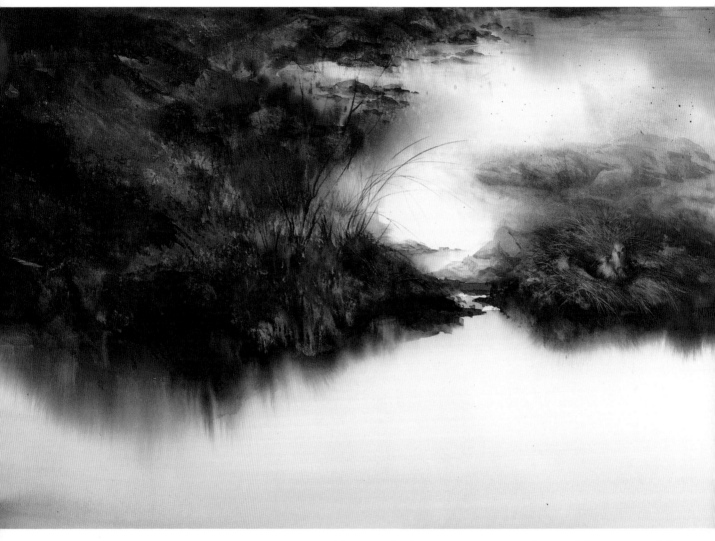

MORNING SHORE
*Watercolor on Crescent no. 114 cold-pressed
watercolor board, 18½ x 28½" (47 x 72 cm).
Collection of Dr. Diane E. Phillis, Riverside,
Conn.*

*As this work began to develop its own presence and sense of place, it reminded
me of my river just after flood time when all was quiet and shore life was stirring
again. Visual memories form part of any artist's inner vision. I remembered the
mud, the darkened overgrowth, and the river that brightened only with reflection
of the overcast sky. Sometimes shore birds built nests in the most unexpected places.
Using artistic license, I tucked a fledgling in the small mass of color on the right.*

All great artists convey a sense of inner vision—a special passionate, creative quality that illuminates their work and makes their perceptions of the world unique. And yet it is important to remember that inner vision cannot be conveyed without a solid foundation of technical training and experience. Also, there is no one way, no magic formula, no rigid set of rules in art.

The basic principles of design are there to be respected as the building blocks of expression. Beyond that, the involvement of the artist in presenting an idea becomes the intimate response of the artist's soul. Otherwise, work becomes sterile and technical. Watermedia artists must be aware of this, for all too often paintings emphasize technique and medium over concept and meaning. Artists who have chosen to work in watermedia should remember that *first of all* they are artists. They are translating the poetry of their spirits through the creative act of using personal visual language as a means of expression.

The inner vision of the artist may take on various forms of outer expression. The range goes from explicit representational to vigorous experimental work. The artist's personal response to the internal and external environment determines what is involved in the act of choosing the most effective format for the creative experience. Whatever process the artist goes through in determining the resolution of idea, medium, and format, it must provide the unique means for presenting the work with conviction, order, and expressive meaning. Only then does the language of art truly communicate.

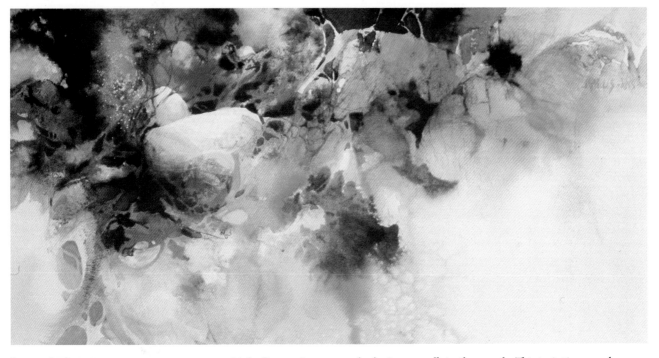

SPRING INTERLUDE
Watercolor, ink, and gouache on watercolor paper, 9¼ x 18½" (24 x 47 cm). Collection of Guy Lipscomb, Columbia, S.C.

Little discoveries are made during a walk in the woods. This painting was begun in my usual way of intuitively playing with color, shape and rhythm on a dampened surface. The important event was not the technical development of the image but that wondrous moment of recognition of what I wanted to say. The inner vision took hold and the outer training enabled me to express it in a manner that was charged with the emotion of discovery.

TRANSLATING YOUR INNER VISION

To translate inner vision into visual form, the artist must balance spontaneity with the continuous evaluation and refinement of composition. You constantly learn in the process, for you become your own best instructor.

If your initial work is done by improvising, one of your most difficult tasks is describing the process, sharing the inner workings of your mind. No two artists working in this manner approach it in quite the same way, but they do know that the skills they have learned from the discipline of their craft play an invaluable part in giving them the means to improvise. So first learn as much as you can about the principles of art, and set up a regular schedule to apply what you have learned. Then set aside regular time to experiment and play with ideas and materials.

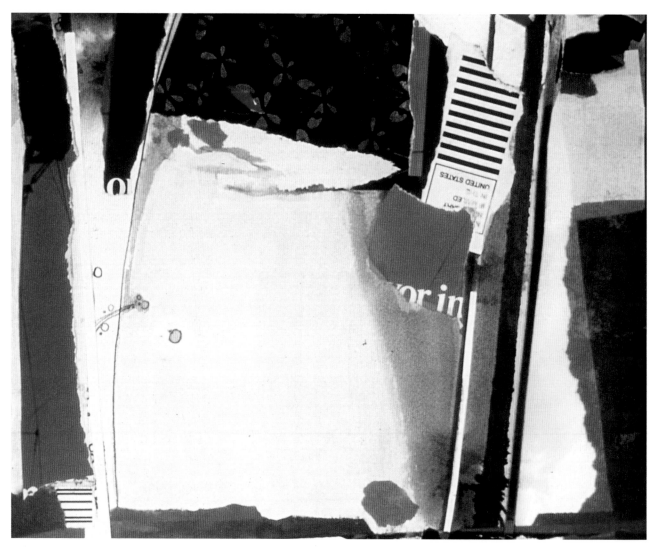

SUSPENDED INTERVAL
Watercolor, gouache, ink, and collage on watercolor paper, 9 1/2 x 9 3/4" (24 x 25 cm). Collection of Gloria Raymond Nesunski.

This collage uses pieces of old watercolors, printed materials, and hand-tinted rice paper along with watercolor washes and linear work painted with a fine brush. The fun of playing with space as a definite design element provided a starting point. The collage shapes help to define this central area and give vibrancy to the design.

THE IMAGINATION CLICKS

Although I often start a painting in a spontaneous manner, I am conscious of the eventual need for good design and strong structural underpinnings. Some years ago, I had one of those wonderful breakthrough experiences when what I have been exploring suddenly comes together. The imagination clicks! This happened when I made the transition from representational work to abstraction.

The particular piece started intuitively with great free, sweeping washes. As I turned my work around in all directions to study compositional developments, there were two initial options. One, if studied upside down, suggested the rough sea. The other, which became my choice, was a mountain theme.

It was important to keep my imagination open but couple it with awareness of design needs. The painting needed more value contrast, so I tore paper of different values into various shapes and sizes and placed the pieces around the painting as if I were making a collage. When the placement was proper, I painted the areas in related tones and contrasting values. After solving various compositional problems, I discovered that I had succeeded in expressing my inner vision in an abstract form.

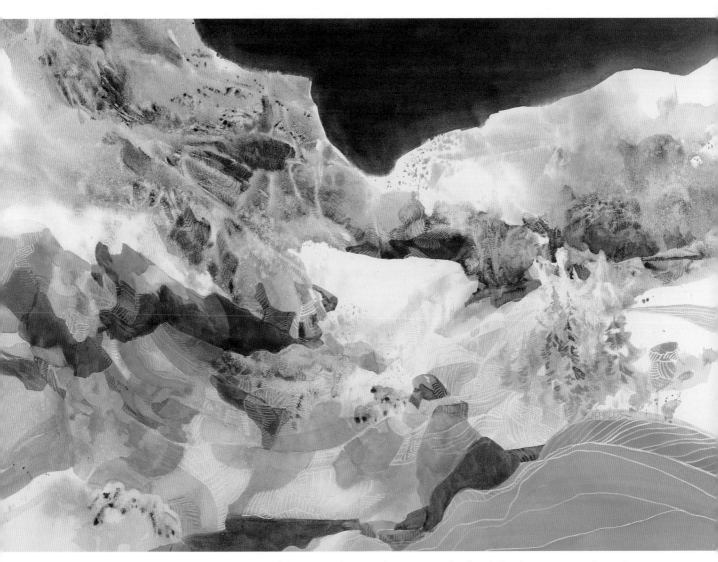

EDGE OF DAY
Watercolor and gouache on Crescent no. 114 watercolor board, 19 1/2 x 29 1/2" (50 x 75 cm). Collection of the artist.

Some of the original textural areas were further defined to suggest rocks and trees. The challenge was to preserve some of the initial accidental phenomena as well as give emphasis to structure and conceptual development. My last decision was the sky color, value, and shape. The sky was white and gave the painting too bland a look. The answer lay in giving the sky a rich, dramatic wash of dark value.

COMBINING STRUCTURE AND IMPROVISATION

Artists can combine the improvisational approach with a preconceived pictorial idea. Although we often give more attention to the final product than to the insight and conceptual development that produced it, we do sense some of the process that has taken the artist on his or her creative journey. The composition may be roughly drafted either mentally or on paper. Then, during painting, the artist can make innovative use of some of the exciting properties and accidents of watercolor. The artist may have a clear vision of the finished painting but will be aware that there is still room for some degree of spontaneity in use of materials within the basic design.

William Thon's imaginative approach to subject matter combines structured and improvisational methods. He knows his materials so well that he can handle them with the natural ease of long experience. His distinguished career in art has been filled with travels that have given him the opportunity to fill sketchbooks with impressions of what he has seen. These images are then translated into sensitive pictorial form that incorporates the lively use of watercolor's fluid properties. Thon makes expert use of line and of textural effects obtained through the various settling properties of pigment.

Thon's paintings are captivating because he goes to the heart of whatever he paints. His work finds perfection in imperfection; nothing is too pat. There is the feeling of life, of constant change, of the force of nature at work. He is a master of implication, and through that implied statement, one senses a greater reality of place and time. We become part of the experience.

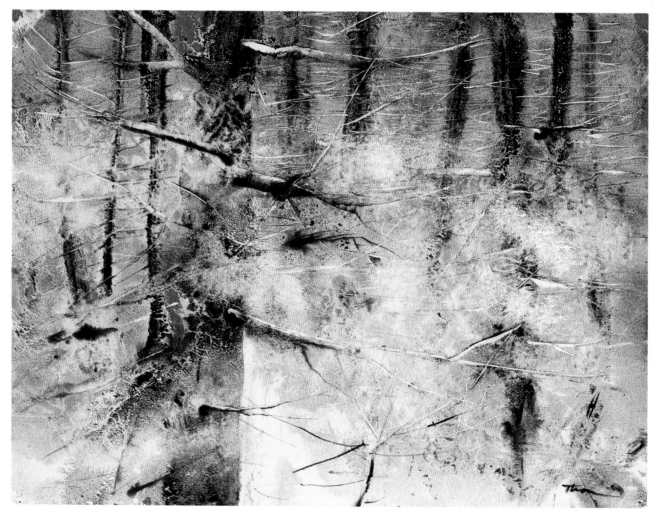

FEBRUARY SNOW
By William Thon. Watercolor on Fabriano 90 lb. cold-pressed watercolor paper, 20½ x 27" (52 x 69 cm). Courtesy of Midtown Payson Galleries, New York, N.Y.

This work masterfully activates the imagination. The transitory effects of winter winds and blowing snow are beautifully indicated. The trees provide an underlying sense of order, strength and stability. Their trunks and branches, sometimes seen, sometimes hidden by the flurries of snow, are a counterpoint to the encompassing activity of the weather. Only enough detail is added to give the essence of structural information.

TRANSFORMING NATURE'S IMAGERY

The intuitive start can take many directions and finalize in the discipline of conceptual and compositional decisions expressing the artist's vision. Glenn Bradshaw's lyrical casein paintings are developed from highly improvisational approaches, to paintings based on his close observation of nature. Over the years he has done numerous works inspired by the beauty of the moving water and ancient rock found in abundance near his Wisconsin summer home and the upper peninsula of Michigan. His more recent work explores geometric expressions representing the structure and energy system of nature derived from the land, rocks, waterscape, and wildflowers of these places he knows so well.

Bradshaw's painting methods begin with intuitive gestural strokes, using casein on rice paper. The paint bleeds through from one side to the other, and the artist flips the paper from front to back as it presents various shapes for development. Each overlay of casein adds to the evolving forms. Artistic judgment is applied to composition as well as to any connection with natural forms. If he finds it serves his artistic purpose, he may further develop some suggestion of connection to nature. He prefers not to depict specific places or things, but rather to point up the complexity and richness of pattern, texture, and color in a personal form of creative order and expression.

Bradshaw is a master of color orchestration. His works are rich in complex relationships that offer unexpected combinations of hues, tensions, intensities, and contrasts creating visually exciting variations to his compositional forms.

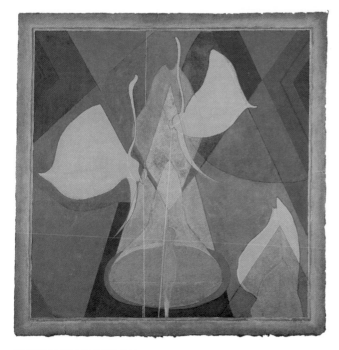

HORNED BLADDERWORT
*By Glenn R. Bradshaw. Casein on Suzuki rice paper,
37 x 37" (94 x 94 cm). Collection of the artist.*

The horned bladderwort is a wildflower found in the Eastern states along the margins of ponds and in peat bogs. Bradshaw's creative eye and mind have seen this common wildflower as an exciting shape to be used within the structure of geometric order. He has juxtaposed the dancing yellow floral shapes against a background dominated by cool angles. There is an echo in countless variations of a triangular theme, with a most elegant counterpoint of linear thrust accentuating some of the floral structure.

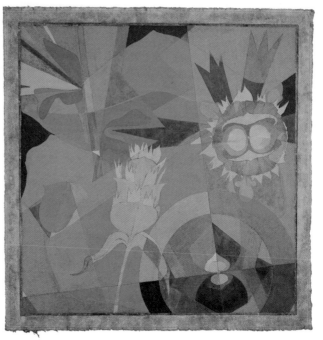

HEAL-ALL
*By Glenn R. Bradshaw. Casein on Suzuki rice paper,
37 x 37" (94 x 94 cm). Collection of the artist.*

When a heal-all flower head is seen from above, the circular shape predominates, surrounded by the tiny angular petals. Bradshaw has taken this viewpoint and exaggerated it in abstract form, with a simplified profile of the flower providing a contrasting view. The artist has made an innovative decision in using the natural purplish color of the flower as the choice for the abstract background, and painting most of the flower forms in shades of green.

EXPRESSION THROUGH FANTASY

Interpretation can take many directions, from the visual tone poems of Glenn Bradshaw to the personal symbology of Sally Emslie. Emslie, whose training as a potter enables her to use similar glazing skills in creating surface textures, now plays with the movement of paint and color on paper and board. Her work sings with chromatic energy that is kept well controlled as an adjunct to the visual world she creates. There is a constant search for increasingly effective means to express what is bursting forth from the imagination. Emslie has retained the sense of wonder and curiosity so necessary to giving vitality to imagery. Her observations are crystallized in unique visual comments on nature and man's place in it.

When an artist has the courage to step out of the currently accepted art styles to explore increasingly personal ways of expression, there are periods of nonacceptance in exhibitions, puzzled comments from friends, and times of frustration. However, it is only through such periods of creative investigation that the artist discovers what he or she really wants to paint and how best to go about it. Emslie approached this decisive period of exploration with a sense of determined adventure. It was a turning point in her work, and the path she chose still leads to further discovery.

The artist's love of color, shape, and texture all combine in unexpected forms of fantasy. A vibrant imagination takes over to create a system of symbols representing nature and its inhabitants. Emslie plays with contrasts. Humor may be combined with tragedy, joy with sadness, and the real with fantasy. The world as she sees it awakens us to examine our place and actions in it.

Emslie pours acrylic on a very wet surface, letting the physical properties of one color float into another. When this is dry, she adjusts surface shapes, defines areas, and begins to build toward her artistic statement. The dark areas are generously developed over underlying color, giving them a feeling of rich depth. This technical skill enables her to articulate her inner vision.

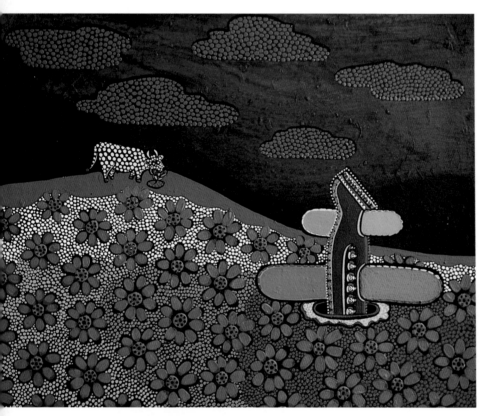

YELLOW COWS DON'T CARE
By Sally Emslie. Acrylic on rice paper bonded to wood, 18 x 28" (46 x 71 cm). Collection of the artist.

The artist makes brilliant use of intense color choices to exaggerate the dichotomy of the airplane crash near a cow who continues to graze in undisturbed placidity. The landscape painted in a flat color and childlike shapes utilizes the pattern of floral and cloud forms as compositional unifying agents. Beneath the deceptively decorative surface is a touch of humor and underlying comment on life's unexpected tragedies all too often ignored or forgotten.

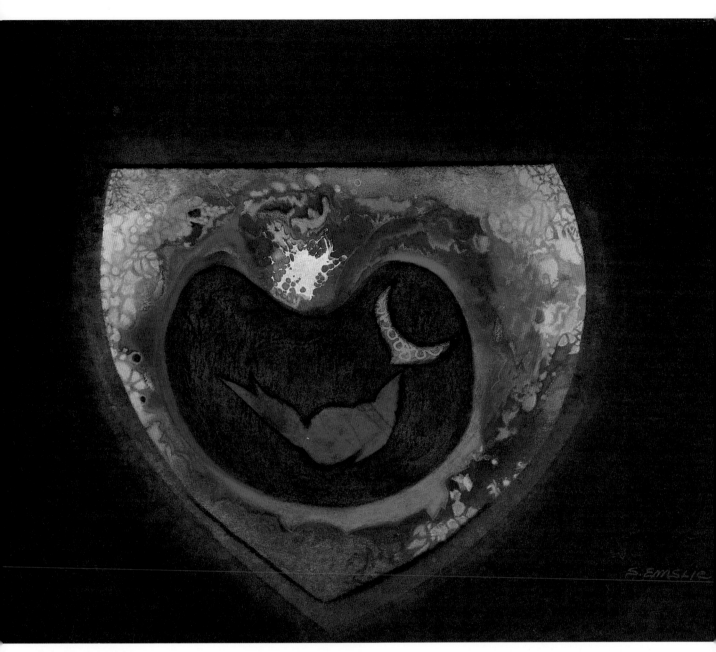

DEEP SEA ENCOUNTER
By Sally Emslie. Acrylic and pastel on paper,
27 x 37" (69 x 94 cm). Collection of the artist.

Interpretation can take the form of analogy. As the earth floats in the mystery of space, so does this jewel float in the inscrutable sea of the imagination. Glowing with unexpected chromatic contrasts, the artist's symbol of the deep reminds us of hidden wonders. Floating within the arc of color are two fishlike forms creating a sense of languid activity that helps the viewer move through the painting.

EXPRESSION THROUGH REPETITION

Repeating subject or shape is an effective way of emphasizing what you want to say. Repeating color gives an added emotional charge. Repeating directions horizontally or vertically increases or decreases the pictorial energy system. The success of a composition reflects a delicate balance between emotion and intellect as the artist makes these design decisions.

The human element is one of the most moving aspects of our association to the grand scheme of things. Finding ways to express and repeat the human form is a demanding design problem. You don't want to sacrifice either your own inner response or the spirit of the subject for contrived composition. One artist who successfully handles this complicated challenge is Paul Melia. Melia constantly searches for ways to express the core essence of a subject, and he finds that repetition emphasizes his intended meaning as well as establishes mood.

One of Melia's favorite models was an older woman he first met at church. Jane Sawyer had a dramatic flair for clothing. Melia states that he "went to her home many times to take photographs of her and her marvelous wardrobe, and now she resides in the house of God." He began to play with the idea of using a symbolic form of expression to create a loving tribute to her memory. The result was *Lady of the House*, in which the artist celebrates the fullness of life and its spiritual dimensions.

When Melia approached the subject of ships in a crowded harbor, he noted the variety and intricacies of shapes. He chose to simplify shapes and to give strong repetitive emphasis to the scene. The overall appearance is one of rest with the feeling of submerged energy.

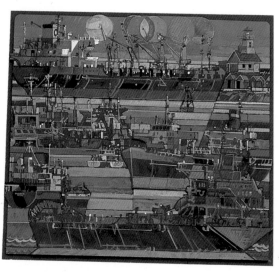

FROM NORFOLK TO HALIFAX
By Paul Melia. Permanent inks, gouache, and acrylic on Crescent no. 110 cold-pressed illustration board, 38 x 42" (97 x 107 cm). Collection of the artist.

Here Melia uses horizontal repetition to establish a quieting effect as evening descends on a busy shipyard. The ships are pulled together in connected forms for simplification purposes. Repeating shapes are subdivided into jewellike facets that the artist uses to direct attention to the larger ships and striplike shapes representing the sea area. Notice the repetition of the setting sun and its continuing reflection on the ships in the form of an undulating chain of glowing color shapes. This provides both movement and chromatic contrast in an otherwise cool painting.

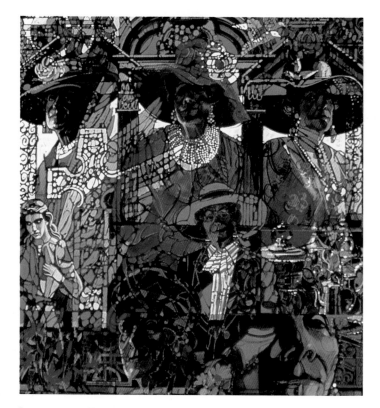

LADY OF THE HOUSE
By Paul Melia. Transparent inks and gouache on Crescent double-thick illustration board, 43 1/2 x 40" (110 x 102 cm). Collection of the artist.

The repetition of the "many aspects of Jane and her love of color and fashion, especially hats," is only one form of repetition within this painting. The repeated bird forms at the top of the painting symbolize Jane's earthly spirit and now her supernatural spirit. The composition is divided three times vertically to represent the parts of Jane's life (home, church, and eternity). The artist establishes a sense of mystery through the use of dark colors and rich accents, and the repeating of stained-glass window shapes helps create the connection to the spiritual.

COMBINING ABSTRACTION AND REALISM

Artists who are of a visionary nature sometimes choose to meld abstraction with reality to give a representational touch to their work. Such an artist is Doug Pasek, who works in acrylics to create paintings that represent the environment through the combination of abstract shapes, nature's life forms (represented most often by birds or man), and finally by "man's hand on nature through the use of geometric line."

Pasek's love of fishing and of the opportunity to spend time in contemplation is deeply expressed in his work. The paintings convey a feeling of inner reverence for the earth and its inhabitants. The artist's deepest feelings go hand in hand with his technical training to create works of elegant sensitivity coupled with environmental drama. During the painting process, he states, "I am always testing the painting and my mood simultaneously. It is my way of knowing, yet being very open to the mood and character of the paint."

The artist starts with transparent acrylic paint applied in abstract patterns. He states that his most useful tools are a 2-inch brush and inexpensive softener tissue used in household driers. The tissue works best once it has been thoroughly washed with soap and water and is kept wet during the painting process. This tissue can be painted through repeatedly, or used for blotting, or stamping rumpled texture onto the painting surface. He establishes a basic underpainting using the combination of textural shapes and smooth areas. Pasek then slowly brings this stage to final compositional resolution. The refinement includes the adding of lines, shapes, circles, and some touch of realism such as bird or man. He does not use an airbrush, although his work at times gives the appearance of that type of technique. The painting is not considered finished until he signs his name, for the choice of placement, color, and value of the signature all become part of the design.

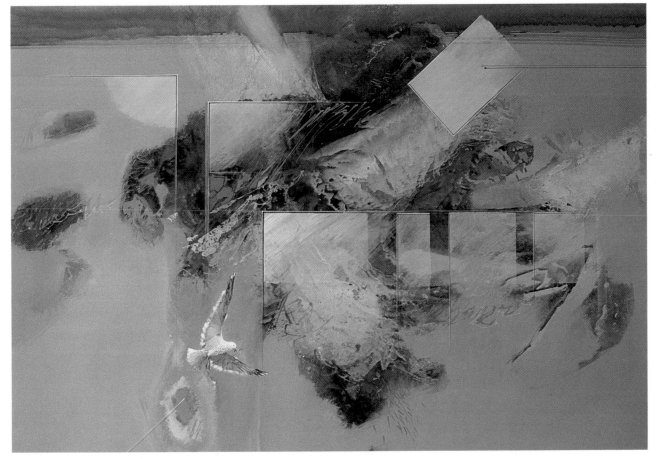

VISIONS
By Doug Pasek. Acrylic on Crescent no. 114 cold-pressed watercolor board, 28 x 36" (71 x 91 cm). Collection of the artist.

The loosely textured abstract landforms are structured within a framework of geometric shapes and smooth background areas. The play between abstraction and realism brings a vitality to the painting; the freedom of intuitive expression is skillfully kept under the control of thoughtful design. The artist plays with the concept of searching for multiple visions, of pairing imagination and deliberate thought.

RESPONDING TO INNER IMAGERY

Green Mansions is an example of working intuitively from an initial pouring of watercolor and ink over a partially dampened surface, letting the wet paint run freely in selected areas, and adding some textural effects with salt and water spray. While this was drying, certain shapes formed that suggested birds, possibly parrots or macaws. I had chosen to keep the color choices limited to greens, yellows, and orange-reds. The evolving shapes and texture needed to be the dominant features because additional color would have been too distracting.

Early in the process, I sensed the lushness of the tropical rain forest and kept thinking back to the vivid descriptions of it in one of my favorite books, *Green Mansions* by W. H. Hudson. I could feel the heat of the jungle, sense its smells, and see its colors. The painting had to retain the inscrutable nature of that location and my internal response to it. This was the challenge.

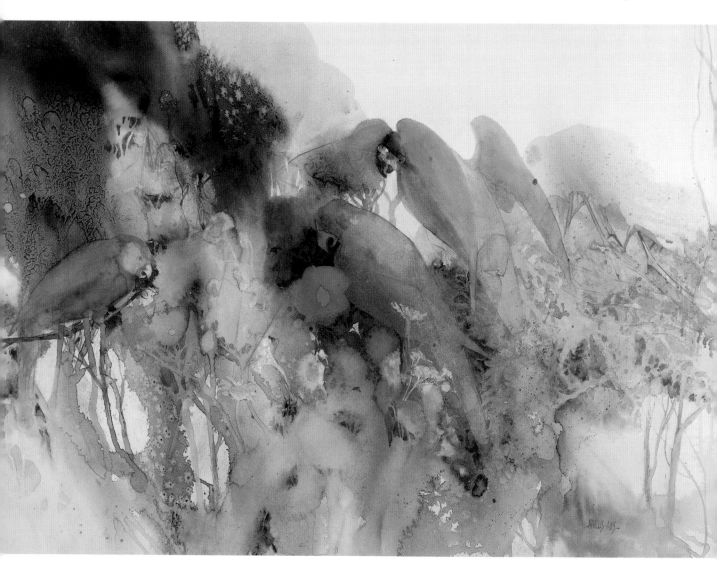

GREEN MANSIONS
Watercolor, ink, and gouache on Crescent no. 114 cold-pressed watercolor board, 19 x 28½" (48 x 72 cm). Collection of Mr. and Mrs. Robert Healey, Gates Mills, Ohio.

The free-flowing use of watermedia provided a spontaneous start of mass shapes, linear runs of paint, and a small amount of texturing from the use of salt. When the paint was dry, the upper right parrot was evident except for the far raised wing, which I added. I developed the other birds through negative shape painting around the bodies with some lifting out of color for the far left bird. Further definition was given by adding beaks.

EXPRESSING THE CONCEPT OF TIME

Countless artists have explored the effects of the passage of time on geological structures, on the changing landscape, and on the aging of man. The visual commentary ranges from the straightforward appearance of time's imprint on nature to more introspective forms of commentary on the meaning of time in relation to our lives.

Don Dodrill developed a series of watercolor paintings around the theme of time. These works make a perceptive observation on time in its association with place and events. Dodrill uses recognizable forms of symbolism to make his artistic statement.

A good exercise in creative thinking is to consider the many ways in which you might present the element of time. Dodrill uses symbolic realism. He explores the world in familiar visual terms, but develops unique pictorial relationships that focus our attention beyond the subject to the relentless moving of time. Dodrill's interpretation gently guides the viewer to a state of contemplation.

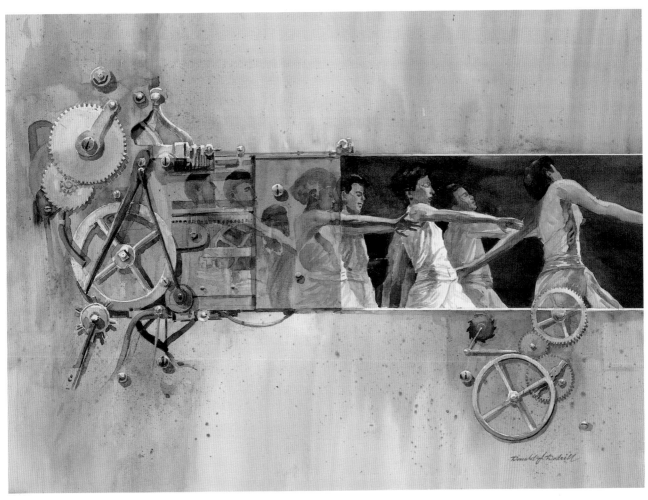

TIME MECHANISMS
By Donald L. Dodrill. Transparent watercolor on D'Arches 140 lb. cold-pressed watercolor paper, 19 x 29" (48 x 74 cm). Collection of the artist.

Dodrill has symbolically incorporated the human figure emerging from a clock mechanism to dance briefly across life's stage through the passage of time. Dodrill feels that textural surfaces were important in this painting. The background includes minimal spatter effects on the wet-in-wet surface to provide a gentle textural interest to that area. The clock gears were masked out and rendered to give the effect of highlighted metal. The dancers' costumes act as a rhythmic draping in contrast to the hard rigidity of the metal.

EXPRESSING THROUGH PATTERN

The search for full expression of content through form can follow many avenues of interpretation. If you are sensitive to the minutiae of the visual and experiential encounter with nature, you may wish to incorporate this inner reaction to the outer world in your work. There can be pleasure in breaking down larger shapes into smaller and smaller intricate components that complement and give new interpretive dimensions to a painting. Some might call this decorative abstraction. Artist Juanita Williams thinks of it as a form of classical abstraction. Whatever the terminology, the process gives expression to the deeper realities of subject matter through personal magnification.

Williams orchestrates her paintings of nature with a full spectrum of tonal vibrations executed in tiny patterns, shapes, and colors. Her initial image may be inspired by one of her photographs of a completely different subject whose shape or interior surface activates the creative flow. From this image, she does a rough sketch on the painting surface and then puts the photograph aside.

The embryonic composition takes on its own life as she initiates the painting process with loose washes to set the background tone. Her work in fluid acrylic paint is a slow building process of layers and intricacies of complex design directed at capturing the essence of subject through a series of variegated, changing patterns.

Her creations are not landscapes or images of what the eye sees, but of what the inner vision brings to the surface. These images are real in that they are the reality of the creative self. They have a sense of order in a musical and mathematical sense with progressions, rhythms, and tonal modulations. Williams is able to make the simple seem complex and the complex harmonious with its structural beauty. She stays open for the surprises that constantly appear in her creations and weaves them into the tapestry of the statement.

Jane Jones finds expressive interpretation through another form of creating pattern. Her landscapes are started with spontaneous fluid washes with some careful saving of the white of the paper. Once the original washes are dry, she examines the amorphous forms for both conceptual and compositional development. The main structural forms are blocked in, often with a distinct directional thrust for developing pictorial movement. These areas are accentuated with value changes or increasing intensity in hue as they wind and weave their way through the painting. This type of painting depends on the relationship of many small shapes to make a whole, much as a patchwork quilt presents a design made from many small parts.

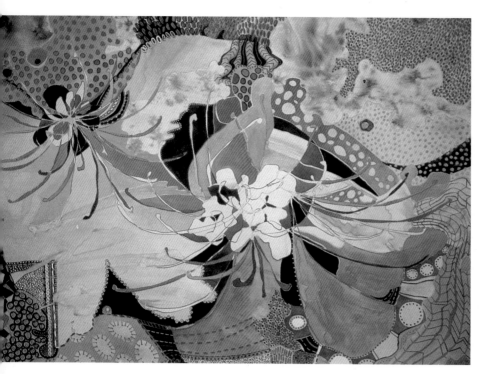

GOSSAMER WINGS
By Juanita Williams. Fluid acrylic on Crescent no. 100 illustration board, 30 x 40" (76 x 102 cm). Collection of the artist.

Inspired by one of her photographs of flowers, the artist freely brushed light washes of acrylic across the surface and kept her imagination open to developing shapes and potential images. Then the "time came when there needed to be thoughtful and conscious decisions." Shapes were defined, and finally the intricate process of adding dots, circles, lines, and other small patterns completed the painting. In the end, Williams felt that the painting expressed her love of nature and of life.

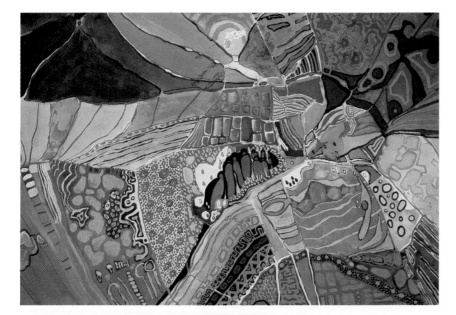

TAOS MAGIC

By Juanita Williams. Fluid acrylic on Crescent no. 100 illustration board, 20 x 30" (51 x 76 cm). Collection of the artist.

The design of this painting was partially inspired by a photograph of a spider web, but it became a New Mexico landscape spreading out in many directions with convolutions of shape and intricacy of pattern. The artist used diluted acrylics to paint the initial warm colors and then began to give definition and meaning to the radiating strands of the web structure. In the end, as she darkened around a central red area, there appeared a group of small people huddled together. These human forms make unexpected appearances in many of her other works.

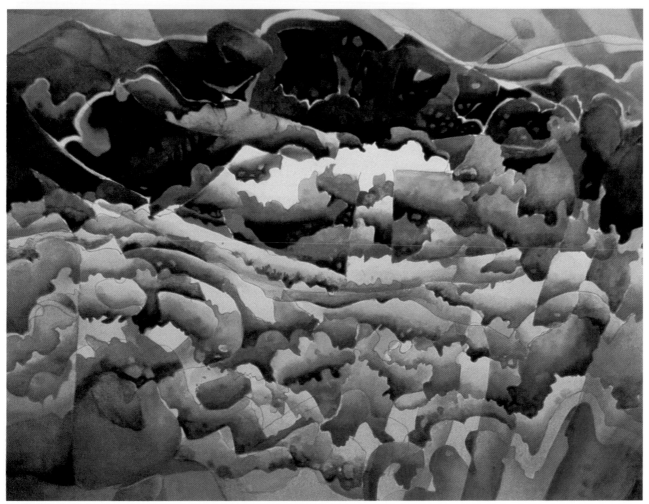

HAWAII SCAPE I

By Jane E. Jones. Watercolor on D'Arches 140 lb. hot-pressed watercolor paper, 22 x 30" (56 x 76 cm). Collection of the artist.

Following her fluid first wash to establish tone and ambiguous form, the artist combined features she had observed in sections cut from rocks to create the general idea of a landscape. Starting with background gradations and working to foreground, she established the general movement in space. Feeling the need for a design stabilizer, she added the diagonal directional forms that weave through sections of the painting.

DISCOVERING THE ARTIST WITHIN

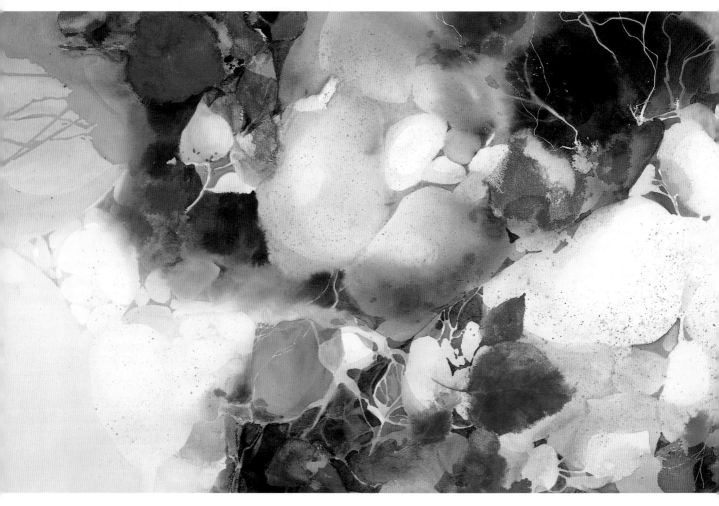

OCTOBER CREEK
Watercolor, ink, and gouache on D'Arches 140 lb. watercolor paper, 17 x 27½" (43 x 70 cm). Collection of Mr. and Mrs. Dan Califf, Piqua, Ohio.

Playing with shapes and colors is a good way to free creative energy. I had taken a fall walk when the sumacs were at their most brilliant red. That image of those intensely colorful leaves stayed with me, and I later used it in this painting of rocks washed by clear creek water with red leaves floating on it. I felt no need to use the sumac shape, but instead incorporated its bright color in my painting.

As artists, we run into periods of uncertainty, tightening up so that the creative flow is blocked, or times of producing unsatisfying work. What happens? It is a relatively common experience, but it can be resolved. As Stephen Nachmanovitch wrote in *Free Play: Improvisation in Life and Art,* "The work of creativity is not a matter of making the material come, but of unblocking the obstacles to its natural flow." There may be family or professional stresses that have temporarily overpowered the artistic psyche. Once the artist recognizes the situation, the problem can be examined and ways can be found to reopen the creative channels. It takes patience, a sense of humor, and willingness to "let go" to get the soul to sing again.

As mentioned earlier, collage is one way I've found to explore design, color, and textural ideas. In its simplest form, it can offer a wonderful period of relaxation that frees the mind to discover unexpected creative approaches.

I sometimes have my students try the popular academic "Blob" exercise to loosen them from their fears in a new class. A day or so before class, I prepare a loose, ambiguous shape by dropping paint onto a piece of paper, occasionally adding a bit of texture or using textured paper as the base, pressing another piece of paper on it to distribute the paint, and then letting it dry. Once dry, the image is photocopied at different degrees of darkness until I feel it has the right potential to stimulate the imagination.

Each student receives exactly the same image and is asked to develop from it whatever comes to mind. This is done in a limited amount of time so that students are forced to work quickly and freely. When they have finished, we put all the images up on the wall, and the students are amazed at the individuality of their artwork. They discover they each have something unique in their approach to creative work.

BLOB I
Spontaneous shape prepared with watercolor and ink, then photocopied.

INTERPRETATION OF BLOB I: LANDSCAPE
By Jane E. Jones. Felt-tip pen additions.

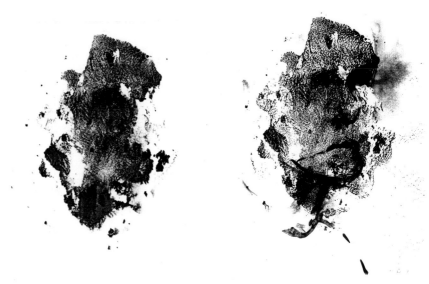

BLOB II
Another spontaneous shape prepared with watercolor and ink, then photocopied.

INTERPRETATION OF BLOB II: HEAD
By Abby Rudisill. Watercolor additions.

DEVELOP NEW IDEAS FOR SUBJECT MATTER

The transition to a different way of expression may come in small steps. Occasionally the artist makes big breakthroughs and ends up on a different plateau of presenting ideas. There are many awkward phases, and my work which is shared with you in this book goes through such stages. As I began to expand my vision and way of working, there were times of great excitement and times when I knew I was in way over my head. Then I had to back up, do my homework, gather additional technical skills, and—more importantly—gather ways of imaginative thinking.

Flowers had been a recurring theme for me over the years. I love gardening, but was never sure that traditional floral painting was my particular direction. My natural feeling was for some sort of abstraction that captured the beauty of flowers without being overly concerned with botanical renderings. My drawing was good, but tight descriptions for my personal expression seemed constraining, although I enjoyed the work of artists who chose that route. One day I was weeding the flower beds when the poppies and hollyhocks were in full bloom. I returned to my studio and began an artistic cross breeding. The effort was a successful and liberating experiment.

When painting a floral theme, I most often work semiabstractly, for it gives greater freedom to both the artist's and the viewer's imagination.

I like to create the feeling of fleeting imagery of natural growth, whether it be flowers or weeds.

One work that developed within this approach was filled with challenge and excitement from the beginning. I loosely placed two

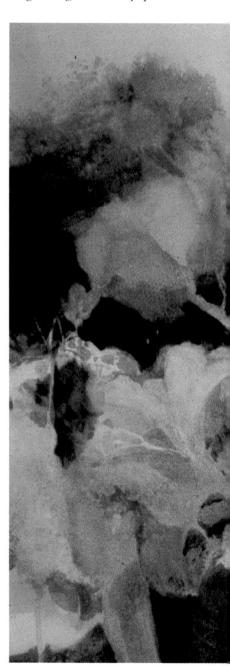

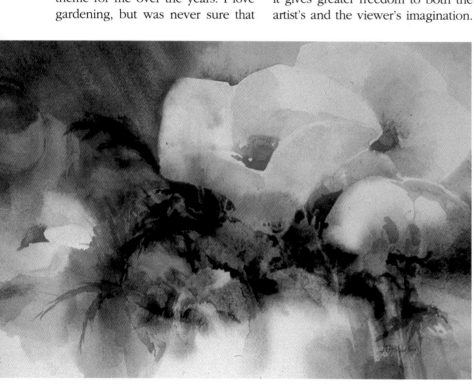

SUN BEACONS
*Transparent watercolor on D'Arches 140 lb. cold-pressed watercolor paper, 13 1/2 x 20"
(34 x 51 cm). Collection of the artist.*

Here I combined the shapes of the poppy and hollyhock to create an entirely new floral form. This type of imaginative floral painting gave me the freedom to play with placement, arrangement, and expression. The painting has an inner glow from the subtle tones within the light areas of the flowers, while the background and foliage give descriptive form and value contrast.

masses, one large and one small, on my paper and separated them with a diagonal open field of light. When the work had gone through the first drying stage, my decision was obvious. There was the opportunity for semiabstraction of floral growth. The challenge was not to overdo it and to connect one mass to the other across the sweeping division of light. I sprayed the paper to redampen the area of light, floated warm color into it, and floated in a bridge of cool color leading the eye from one shape to another. When that stage had dried, I began to develop the large mass with semiabstract shapes of flowers and weeds. Some were lifted out, while others were shaped by painting around already existing values with slightly darker values or tonal changes. The same procedure was repeated to a lesser degree in the smaller mass. The resulting painting presented a semiabstract, somewhat ethereal floral statement.

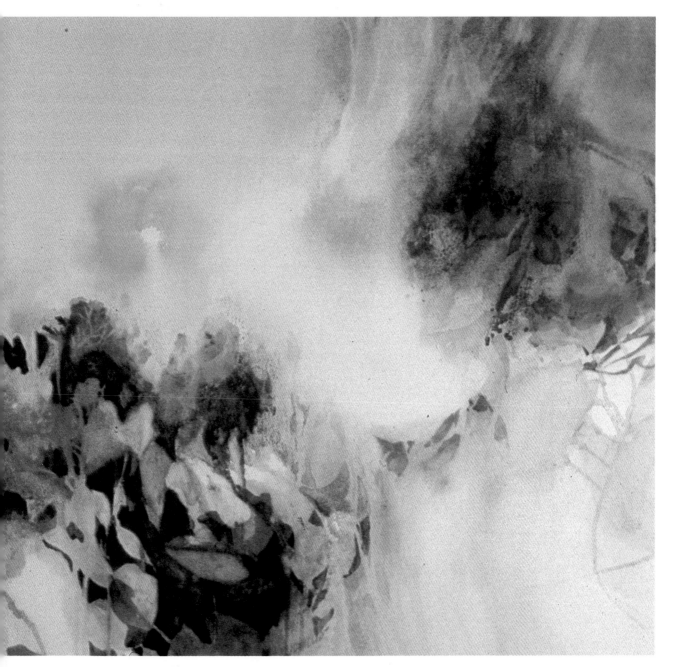

SUMMER REMEMBERED
Watercolor on Crescent no. 114 cold-pressed watercolor board, 20 x 30" (51 x 76 cm). Collection of David and Dorothy Danskin, Sedona, Ariz.

This was an early departure from both local color and tight representational painting. Floral forms are just suggested, with emphasis placed on the larger masses and the play of light between the larger and smaller shapes. A bridge of color connects the two areas.

KEEP A JOURNAL

A number of artists keep journals or sketchbooks to record their thoughts, fleeting ideas, quick visual notes, quotations—whatever seems to be of some future interest for their work. This is an excellent way to explore the potential of the artist within. We cannot instantly tap into all the ideas that are buried in our minds, but as they bubble to the surface, we can record them in a journal for inspirational or informational reference. After a period of time the journal may begin to emphasize certain ideas, and these can be used to develop into a painting.

Katherine Chang Liu is one such journal keeper. She states that usually her inspiration for a painting does not come from a visual form. It is more often a "word...or a verse...or a thought the word invoked...or a passage of music which in turn evokes a visual image." She may record several thoughts a week in her journal, or she may go for a couple of months before there is another addition. She finds that when an idea begins to maintain some level of interest, she "starts to think of ways to deliver that idea, first vaguely, then gradually more solidly."

TABLEAU
By Katherine Chang Liu. Watermedia on Daniel Smith 300 lb. painting board, 39 x 26" (99 x 66 cm). Courtesy of Louis Newman Gallery, Los Angeles, Calif.

This work with its rich surface and variety of textures, including stonelike fragments, relates both to the artist's current icon-type work and back to her earlier series of ancient wall paintings. In both she is conscious of texture, the wear and tear of time, and a variety of forms of many sizes. The symbolic nature of the work expresses her interest in cultural history. The process of painting parallels this: Many layers of pigment have been applied; some erased, lifted, or softened—only to be covered with other glazes that let the undertones reappear through transparent surfaces or from scratching through.

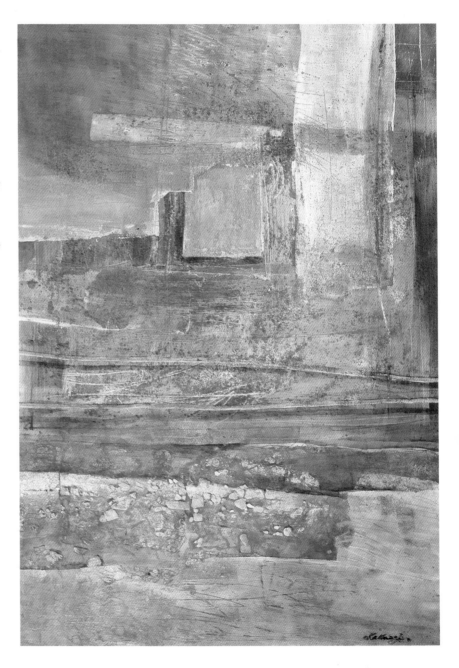

Liu begins with rough sketches, which may lead to paintings, which in turn generate more sketches and paintings developing from that stage of conceptual searching. She sticks with an idea until she runs out of enthusiasm; this may mean a series of some 20 paintings done over a period of two years.

Liu, who used to paint nature-based subjects in a more direct manner, now works in a more abstract way, although she feels her paintings are seldom nonobjective. They almost always have some conceptual reference within the work. Liu's most recent interest has been general human cultural history. She says, "As my work grows more introspective and emotional, the format is seemingly more simplistic, even minimal." Incorporating the imprint of cultural history along with building a "history" within the painting process itself, Liu became insistent on "placing all marks, lines, shapes, and textures by hand, rather than relying on the medium to create accidental effects or textures." She works in a process of building up and erasing layers, usually from light to dark.

She uses watercolor, acrylic, pastel sticks, charcoal pencils, acrylic mediums, and powdered pigments but feels that the statement she is developing is far more important than experimenting with exotic materials. When she uses collage, she prefers to use her own painted paper so that there is a consistency in color and texture.

Her paintings may take a week or longer of constant work. Her intense involvement in the specific creative process cannot be easily broken; she does not move from one painting to another until the previous painting is "satisfactorily resolved to a certain degree."

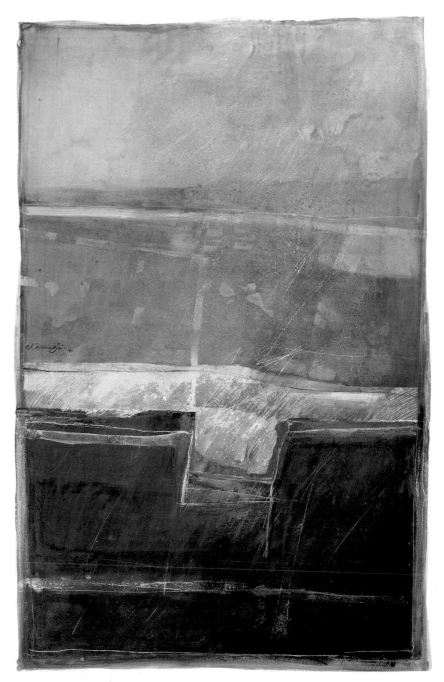

CHAMBER
*By Katherine Chang Liu. Watermedia on Daniel Smith 300 lb. painting board, 39 1/2 x 26 1/2"
(100 x 67 cm). Collection of Mr. and Mrs. Thomas Ballantyne.*

Liu feels that what carries her from one series to another is the usage of "rich, implied as well as literal, textures." Her palette remains much the same, for she enjoys exploring the relationship of secondary colors. Note the textural richness of the surface, the strong horizontal emphasis gently broken by linear form and interlocking shapes.

EXPLORE INTERPRETIVE COLOR

We habitually observe the world in superficial ways, as though our minds were scanning rather than absorbing information. We forget that concentrated awareness can enable us to see the commonplace in a new light. When we are able to do this, the simple act of observation is marvelously intensified. Our minds are infused with the wonder of what is around us, and we are inspired to look at our work in a whole new way. The process may happen in small stages, but there is a cumulative influence on our creative thinking.

The creative absorption of information leads to developing new perspectives, opening the boundaries of perception, and reorganizing approaches to pictorial presentation. As an example, this may lead to perceiving the familiar in terms of color rather than shape, or of optional hues rather than local color. I found that when I could free myself from local color, my paintings started to have a sparkle that had not been there before. Slowly I began to experiment with more interpretive color that expressed my *reaction* to the subject. There was still a believable quality in the choice of color, but it was not what the camera would have recorded.

In one painting, I wanted to experiment with the use of lots of open space within the composition but interlock into that space a well-designed shape that gave the essence of subject but little more. This was to be the challenge of saying just enough with minimal descriptive effort. A close-up view of wild growth was the answer. The simplicity of the composition was deceptive, for it took several tries to create proper placement of form.

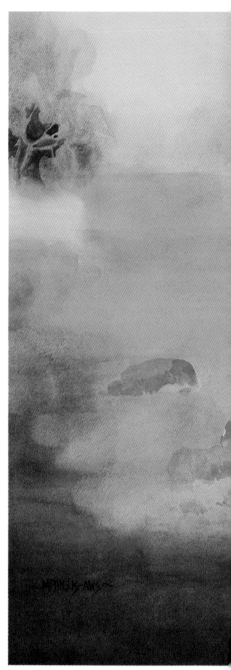

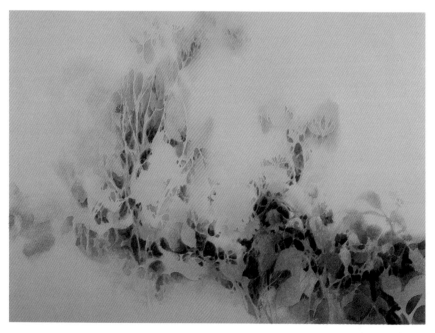

CHOSEN MOMENTS
Transparent watercolor on Crescent no. 114 cold-pressed watercolor board, 21½ x 29¾" (55 x 76 cm). Private collection.

Approaching a subject as though you were recapturing a treasured, momentary glimpse of nature can be a challenge in both design and conceptual presentation. The compositional problem here was finding a way to break up the space in an interesting format without being overly descriptive. Detail was held to a minimum. Color accents were added in the lower right area as well as greater value contrasts. These drew attention to the place of greatest visual interest.

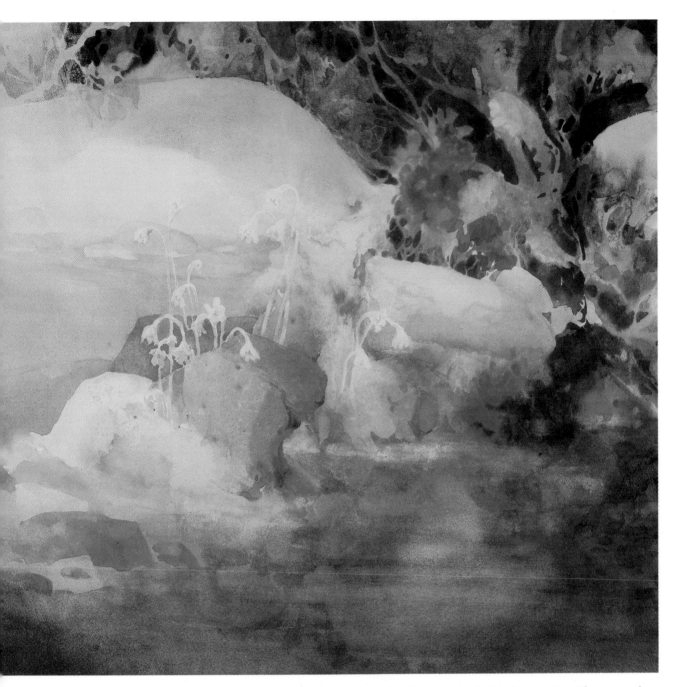

ETERNAL SPRING
Watercolor on Crescent no. 114 cold-pressed
watercolor board, 19 1/2 x 29 1/2" (50 x 75 cm).
Private collection.

I chose to use interpretive rather than local color in this painting. The warm glow surrounding the rocks and Indian pipes magnifies the pleasure of discovery of these flowers. I created them by cutting stencils to shape and lifting out the flower forms with a damp sponge. The rocks were defined by painting around them. The composition is kept to simple shapes and little texture except for the right half of the background, which fades into the darkness.

EXPERIMENT WITH CREATIVE IMAGING

Artists who work from an expressive base of interpretation may experience insights that help them to be more effective in their creative work. They gain a form of inner knowledge that is processed into personal guidelines, enabling them to clarify their direction and expression. Most of us do this in one form or another. Each event in our lives leaves some sort of memory and response imprint. When this knowledge is needed, it resurfaces and is utilized, often quite unconsciously.

Edward Minchin is an example of an artist who has used creative imaging to good effect. Born in England, he worked for thirty years as a graphic designer and art director before making the decision to become a full-time painter. He recognized the influences of the past and of his contemporary art friends who were major figures in the art world. He had a breakthrough in his thinking when he realized that he could become one of the "stars, shining and illuminated, . . . the source of which comes from within, not from someone else's inspiration." The result of this change of thinking brought forward a source of "unlimited expression and positive direction."

Minchin feels that his discovery of strong design and composition in close-ups or in focusing on a specific idea helped him to present "ordinary things in a different way." He also found a similarity of shapes, lines, and directional flow in both mechanical objects and organic subjects.

He has experimented with allowing the paint to lead in expression and statement. Landscapes are transformed into celestial expressions of "incredible color and imagination." A new frontier will be approached as he explores the interpretation of the inner self through the use of color, shape, and a new visual language. Minchin knows the importance of drawing upon the knowledge of the inner self and the effectiveness of anticipating positive images and strengths. He tries to "anticipate the visual painting by experiencing the emotional feeling of the painting before he begins." He is aware that creative imaging can be adapted to traditional thumbnail approaches as well as to spontaneous abstracts. Minchin feels that the depth of thought arising from the inner self and the expectation of emerging ideas are of crucial importance.

LOBSTER TANGLE
By Edward Minchin. Transparent watercolor on D'Arches 140 lb. cold-pressed watercolor paper, 21 x 29" (53 x 74 cm). Collection of the artist.

The artist had visited the coastal unloading docks and stood looking down at boats filled with many buckets of lobsters. The idea for a painting germinated while he worked out some thumbnail sketches based on abstract compositional presentation. When he was satisfied that everything had to go except the lobsters, he began his painting and kept it in a semiabstract state until it was near completion. At that point he added just enough detail to give the subject matter recognition as lobsters. His creative imagery and technical skills produced an eye-catching painting.

Use Dream Imagery

Elaine L. Harvey lets the paint lead her to discovery of a spark in the creative process that connects with images in the real world or in the inner world of imagination and dreams. As the concept unfolds, she finds that "there is a give-and-take between my original plan, the action of the media, and the ideas that come" as the painting develops. Harvey has learned to be open to adjustments that must be made in using the intuitive process. She can add, change, or subtract as she begins to understand the possibilities of the painting and her feelings about it. This acknowledgment of creative flexibility is necessary for pulling a painting together according to the principles of art.

The search for ideas never ends for an artist. Harvey has found that if she is responsive to her deepest thoughts, including dreams, she has unlimited possibilities for imagery and resulting conceptual statement in her work. This California artist has found inspiration in the subconscious and how it contributes to art. She worked on a series of dream paintings in a process she calls "respond to the paint and revise as you go." The works are filled with symbolism of the dream world and are grounded in her expert use of technical skills.

NIGHT JOURNEYS
By Elaine L. Harvey. Transparent watercolor on Lanaquarelle 140 lb. watercolor paper, 30 x 22" (76 x 56 cm). Collection of the artist.

The artist states that there is a mix of humor and mystery in this painting, which both questions and comments on the world of the subconscious. She chose heavily sized paper in order to adjust and move images around as she freely developed the concept. The numbers suggest Jungian dream symbols, or even an insomniac counting sheep in an attempt to fall asleep. The sleeping human figure—as well as that symbolic champion sleeper, the cat—appear in this painting and others in the series. She incorporated other images chosen from her own dreams or from dream reference books, some of which suggest journeys of the subconscious: flying, swimming, sailing, and so on.

USE TEXTURE FOR EXPRESSION

Texture is a powerful means of communication for the artist, whether it is created deliberately or is accidentally discovered as the painting evolves.

Two artists who have used texture in totally different approaches are Cara Smith Stirn and Mary Todd Beam. Both work from intuitive beginnings and both rely on internal imagery to aid in the development of emerging images. Both artists are closely associated with nature, Stirn at her western ranch and Beam in her Appalachian cabin. These are their homes away from home. They know the land around them, as well as the people and the animals. Both artists live part of their lives in urban locations as well, where their observations continue under different environmental stimuli. Both are constantly active artists and observers.

Stirn, who feels strongly about the preservation of natural resources and the beauty of our world, uses her skill as an artist to combine perceptive observations of nature with the intangible world of thought and feeling. Her creative work unites specific aspects of what she has seen and felt in an abstracted format. She sees her environment with wonder and captures segments of that attitude in her work. In order to free herself from overly descriptive renderings, she uses a base of spontaneous pourings of ink, which she textures with the application of plastic coverings until dry. The resulting forms are studied for compositional needs and specific subject interpretation.

Once Stirn senses the nucleus of subject matter, she further defines it through both negative and positive shape painting. At this point a certain creative vitality enters into the process; Stirn and her vision of the image almost coalesce into a unified purpose and destination. There is not entrapment of expression, but disciplined release. The artist is totally involved in the painting process, and this gives her work an integrity indicative of her inner voice.

Stirn's method incorporates textural strips used in a framelike manner to surround the subject. This brings attention to the image within and echoes, in a geometric format, the use of texture in the subject area.

Beam, a perennial experimenter with texture, constantly searches for new methods and interpretations to present her ideas. She is unafraid to go off the deep end in exploring the vast universe of art. The excitement of the search for how to express herself with paint and paper keep her brimming with enthusiasm. She moves back and forth from painterly forms to collages. Her love of shape and structure is evident in much of her work, but she also exhibits a lyrical side that fills some paintings with poetic expression.

Beam works in acrylics, applying them in a diluted form to her painting surface, which is most often heavy illustration board. She works initially in an intuitive manner with more concern for establishing a loose nonstructured textural surface from which to develop the emerging composition. She prefers to leave some unpainted areas for value contrasts. These can always be cut back during the designing process. There are many drying stages between applications of layered glazes.

She applies a variety of textures by using old shower curtains, sandwich wrap, lace remnants, salt, or rubbing alcohol. Whatever is handy or strikes her fancy is used.

Once her general understructure has reached a stage of obvious potential, she studies it for compositional resolution and how to convey what has captured her imagination concerning subject. Then she adds or takes out what is necessary to add just enough form without saying too much. The work retains its initial energy but has been clarified in its expression.

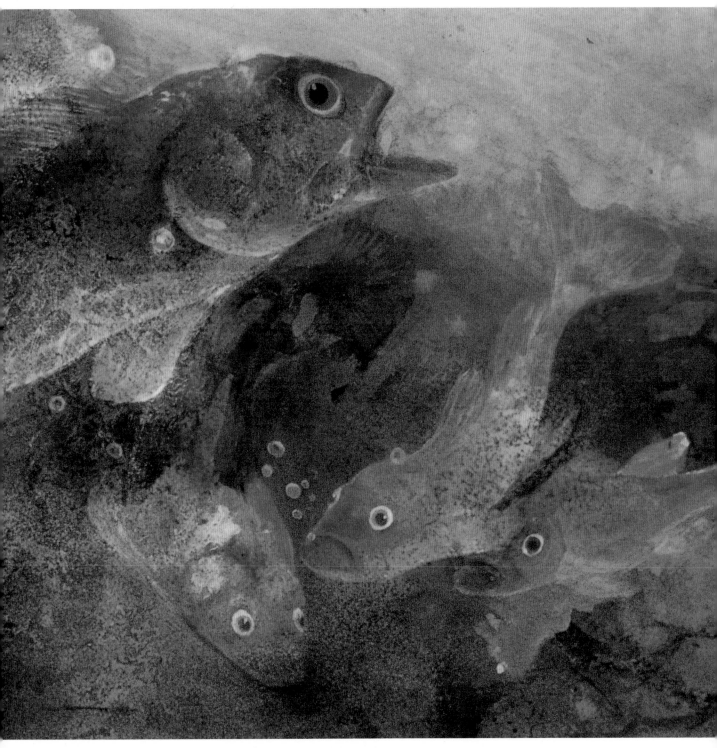

FIN AND FROLIC
Watercolor, ink, acrylic, and gouache on Crescent no. 114 watercolor board, 14 1/2 x 19 1/2" (37 x 50 cm). Collection of Mrs. Edward W. Stifel, Jr., Wheeling, W.V.

This work began as an experiment with textural effects, beginning with watercolor and progressing to ink and acrylic. A spray can of acrylic paint was in the studio and I decided to try it out on a portion of the wet surface. An amazing textural phenomenon occurred: The spray mixed strangely with the other pigments and created a surface that looked like scaly fish skin. It took only an instant for my subject to materialize. The feeling of movement was important as I completed this painting.

ELK AND WINTER
By Cara Smith Stirn. Ink on Morilla board, 29 x 19"
(74 x 48 cm). Collection of Mr. and Mrs. Kelvin Stirn.

*The artist dropped white, burnt sienna, indigo,
and rose inks onto stretched paper, followed by a
drying time under strips of plastic floor covering.
When the plastic was removed, the dried pattern
provided the stimulus for the subject: elk in snow
and the hardships they endure in the Wyoming
winters. Stirn is concerned about their survival as
more and more of their natural territory is
occupied by man.*

TO BLOOM UNSEEN
*By Mary Todd Beam. Acrylic on Crescent no. 100 illustration board,
40 x 30" (102 x 76 cm). Collection of the artist.*

*This multilevel view of water lilies floating on the water's surface relies
heavily on the textural aspects of the work as well as the shifting
horizontal forms from areas of darker value to those of glowing light.
The cool deeper colors gradually change into luminous bands of subtle
tones, bringing the viewer's eyes up to the surface view of the lilies. The
essence of the flowers is emphasized rather than detailed botanical
structure. This profoundly increases the emotional impact of the
painting.*

MAKE SWEEPING MOVEMENTS

An artist who has a fluid drawing style may want to use the brush in a similar manner, with vigorous sweeping strokes to indicate subject matter. The work takes on a dramatic and energetic definition that charges the painting with a quality of placement, movement, and direction. There has to be complete freedom to let the arm move in an intuitive way guided by the knowledge of the subject, but not trapped into replication.

Abby Rudisill, who excels in the field of drawing, found that she could apply her free-moving approach to painting. She looks at the subject in terms of the large shapes, intensifying them with bold applications of paint. She limits her palette to a small number of pigments in order to emphasize value and line over color. The forceful brushstrokes constantly reinforce the feeling of line through imaginative variation of type and width of mark. In the process, her subject matter is abstracted, departing in a lively way from its natural state.

When this approach is handled with intelligence and daring, the resulting paintings can be powerful statements of their natural origins. In their stark simplicity, these works have a magnetic quality that cannot be ignored. Even the artistically uninformed feel the sense of intense communication from the artist.

There has to be a willingness on the part of the artist to relate shapes to the whole of the composition in an immediate, direct way. There can be no nit-picking with detail; that is for other types of work. However, fine line moving in areas or throughout the painting in the form of dynamic scribbles can reinforce the sense of implied action. Rudisill uses this added form of energy expression to reinforce her major areas of mass and movement.

LEBANON FARM I
By Abby Rudisill. Watercolor and gouache on Fabriano 300 lb. hot-pressed watercolor paper, 21½ x 29½" (55 x 75 cm). Collection of the artist.

A photograph of a barn and its surrounding fields served as the departure point for this painting. The artist could visualize the subject lending itself to large compositional shapes. Rudisill states, "The subject matter excited me. It was important to use the medium in a direct, fresh manner." She found the biggest challenge was to retain the same spirit when it was "necessary to work back into the composition" for refinement purposes.

EXPLOIT THE NATURE OF WATERCOLOR

The fluid properties of watercolor itself—its fascinating unpredictability—excite and challenge many watermedia artists. The artist who works in the wet-in-wet technique is particularly aware of its many physical problems. Once artists have gained some measure of control over this elusive medium, they discover that watercolor's frustrating characteristic of doing its own thing can be utilized for an endless variety of expressive purposes.

Marti M. Fenker approaches each act of painting as a new experience. She wonders "what will happen *this* time when I pour, brush, or drop paint on the wet surface?" That initial action is what excites her and starts the creative process. At that point, her imagination takes over, and past visions or memories are awakened, leading her to express some moment or feeling. She states that as she gently guides the paint, she strives to "maintain that precarious balance between what the paint wants to do and what I want to do."

When there is the feeling of active inner exchange between painting and creator, then the process is fully charged with the artist's total involvement. Now the unique voice of the artist sings through the painting with the ring of authenticity. Stephen Nachmanovitch states in his book *Free Play: Improvisation in Life and Art*, "To be infinitely sensitive to the sound, sight, and feel of the work in front of us is to listen for our intuitive voice...."

Fenker works with the flowing commingling of pigment and water. She explores ways to retain the fluid look while at the same time giving it some feeling of structure. She tries to maintain a pattern of light throughout the painting and may reserve these areas for that purpose or use stencils to lift out shapes. She uses an airbrush at times to add fragile veils of color that create an air of mystery "inviting the viewer to step in and let his imagination drift."

Fenker's work tends to stay nonobjective for most of the painting process. Eventually some element of nature appears—almost without the artist's intention. When this happens, that subject is given just enough detailing to suggest shape or character, but little more, in order to be in keeping with the overall style of the painting.

Carefully selected areas of texture may be added to her work with colored pencils. She finds that if she uses these before she begins, they act as a subtle resist. The technique seems to work best on hot-pressed paper, which takes texturing well and also holds the brilliancy of color. Fenker has also found that watercolor crayons are useful in layering one color over another, especially light over dark (contrary to glazing with brush and paint). She has experimented with interrupting the flow of watercolor by using geometric shapes or bands of tape. This is a well-known process that can give various edge conditions depending on how wet the paint is when the tape is applied and removed.

ALIENATION
By Marti M. Fenker. Transparent watercolor on D'Arches 140 lb. cold-pressed paper, 16½ x 20¼" (42 x 51 cm). Collection of Marilyn H. Phillis.

This striking image of three figures emerging out of the mists evokes the imagination and entices viewers to ponder, to create their own stories to complete the artist's visual statement. The painting was done on an extremely wet surface with fully charged brush laying on pigment. The artist randomly applied the paint, all the while searching for a strong abstract pattern.

As the colors fused, she sensed the emergence of figures. Tissue was used to blot out faces, and as the paint went into the drying stage, just enough detailing was added to give meaning to the forms. The painting was taken no further in order to preserve its elusive, mysterious quality.

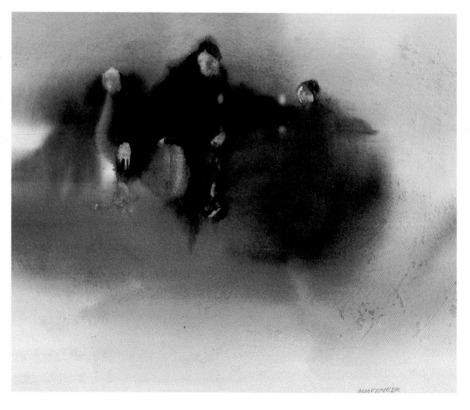

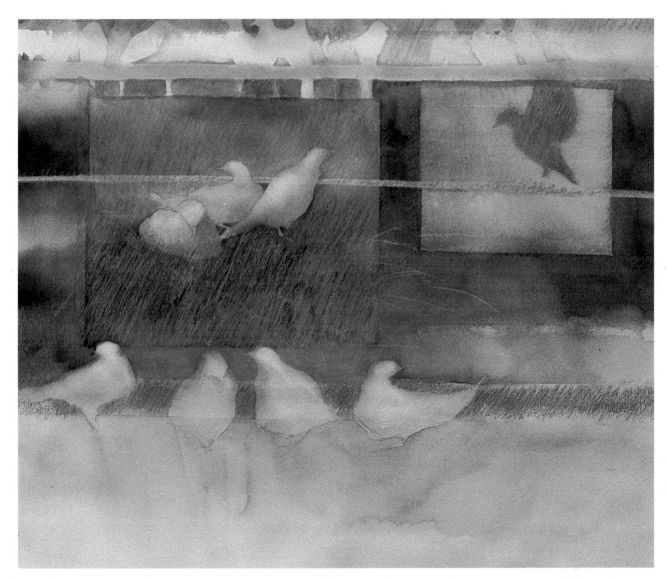

THE ASSEMBLAGE
By Marti M. Fenker. Transparent watercolor on D'Arches 260 lb. cold-pressed watercolor paper, 26 x 29¼" (66 x 74 cm). Collection of Deborah Young, Vista, Calif.

Starting intuitively and keeping a nonobjective format for much of the painting, Fenker reached a stage where the light areas suggested bird shapes. Some initial structure was formed by using masking tape to create squares and rectangles, which were then painted with white ink. Once the ink was dry, the artist poured paint onto the wet surface until a good abstract pattern containing soft, light shapes was established. The bird shapes were refined with pencil and with negative shape painting. Colored pencil was used in many overlays.

DEMONSTRATIONS: THE BLOB

Here are two examples of the Blob exercise described on page 79, but this time done in color as the springboard for a real painting.

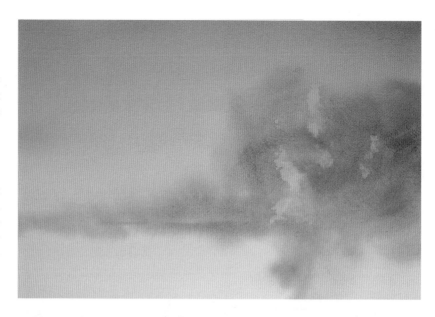

STAGE 1: THE BLOB
I added a loose shape of transparent watercolor to slightly dampened paper. In order to create more textural and value variation within the Blob, I blotted some areas with tissue.

STAGE 2: EMERGENCE OF SUBJECT
The light areas suggested the possibility of figures. The figure on the left began with the light area becoming an apron. Once I blocked in approximate figure size, the rest of the Blob began to take on meaning pertaining to space and content.

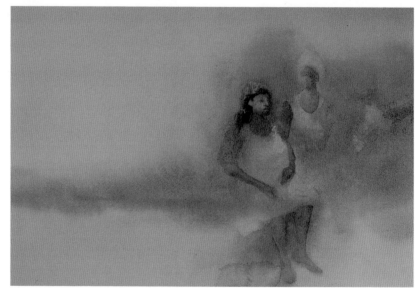

STAGE 3: DEVELOPMENT OF FIGURES AND SETTING
The three women are seen in a street where pottery and baskets are sold. The long extension of the Blob becomes a bench for display of wares.

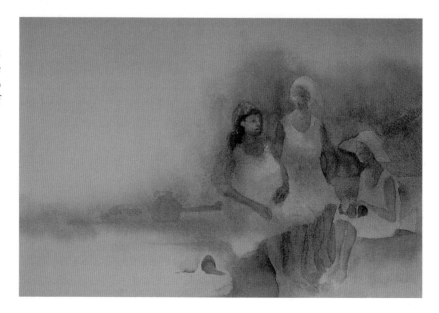

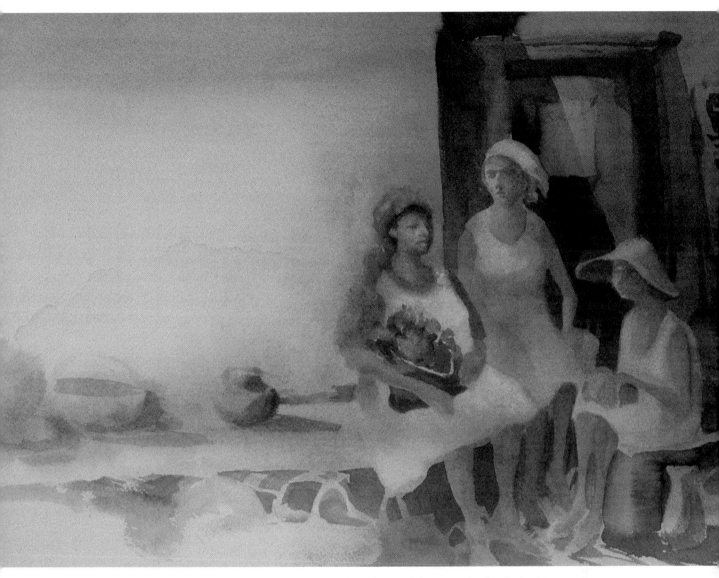

THREE WOMEN
Transparent watercolor on D'Arches 140 lb.
watercolor paper, 11 x 16" (28 x 41 cm).
Collection of the artist.

Dramatic darks and the thrust of the vertical side of a building and
doorway provide a contrast to the figures and give further meaning
to the setting. The Blob has become an artistic statement.

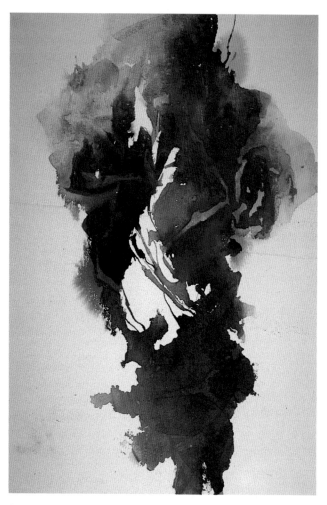

STAGE 1: THE BLOB

I have made a habit of turning my paintings in all directions while they are in the developmental stage. This spurs the imagination and keeps the eye sharpened for design and subject potential. More than one subject usually suggests itself when I view a spontaneous shape.

STAGE 2: SUBJECT CHOICE

The bright colors suggest a tropical theme. As I view the shape in a vertical format, there is the faintest suggestion of palm fronds. There is also an image of an emerging figure. I could have gone with either theme, but chose the palms.

STAGE 3: DESIGN AIDS

As the trees and fronds developed, I had some difficulty in final placement of the lower fronds. An old magazine with colored ads came to my rescue. I cut out large sections in a variety of colors and values, then shaped fronds from these and placed them on the painting to help with compositional decisions.

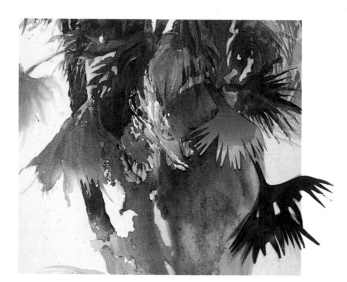

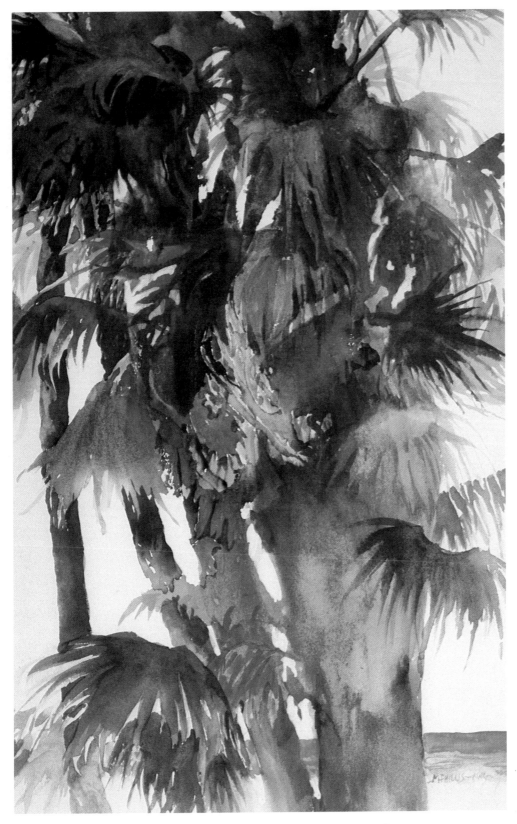

PALMETTOS
Watercolor, ink, and gouache on Saunders watercolor board, 16 x 10" (41 x 25 cm). Collection of the artist.

I overdid it by adding another palm trunk on the left; the composition is crowded. However, it still has a certain charm and is a simple illustration of what can develop from the Blob when an artist works freely and spontaneously with shapes.

BALANCING SPONTANEITY WITH CONTROL

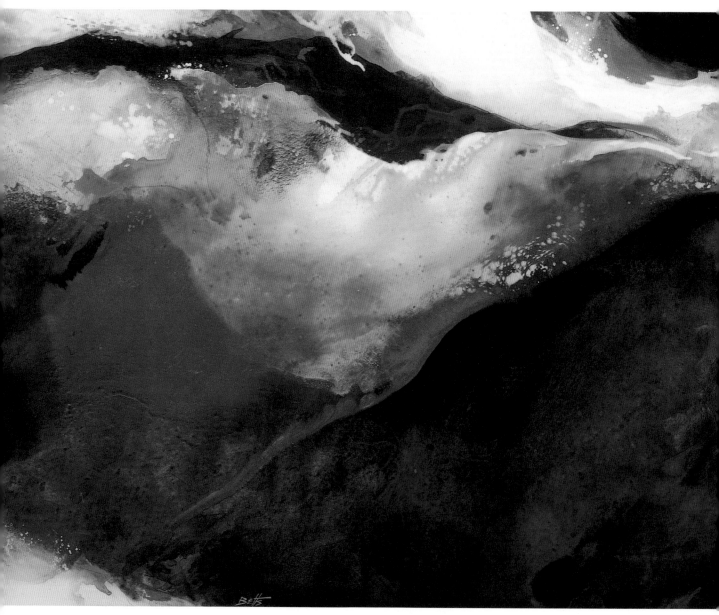

DARK WAVE
By Edward Betts. Acrylic on heavyweight
illustration board, 29 x 39" (74 x 99 cm).
Private collection.

*The artist let the wet paint move across the surface while he tilted it upright, then
returned it instantly to the horizontal position in order to halt the drift just where
he wanted it. Once he identified his subject of waves and deep water, "the next
challenge was to keep reworking and repainting in a series of superimposed
layers, nudging and gently guiding the movement of the wet paint without its
looking as though it had been deliberately painted by a human hand."*

There is a happy balance between the spontaneous approach to art and planned development of that intuitive act. You can have a great time with direct unplanned approaches—pouring or flinging paint, using random gestural brushstrokes, applying paint with a brayer, using imprinting techniques, or applying the many textural approaches. Rarely will these methods provide the finished product, however. They are often an exciting way to make a creative start, but on their own they will not make more than a disorganized statement.

Artists who prefer to work intuitively find that this approach permits them to let go, to free themselves from preconceived notions in the beginning of their working process. They are guided largely by subconscious feelings as they begin each painting. Once this first stage reaches a natural stopping point, the intellectually objective side of the personality comes forward to appraise what has happened. Adjustments may gradually begin at this point.

Not every artist's personality is made for this kind of approach. It is good for artists to try improvising from time to time, just to have an appreciation for the method and to give their imaginations a chance to grow. If their normal procedure is a very structured representational type of painting, they may find that they can make creative use of unexpected "accidents" in watermedia that would have discouraged them in the past.

The secret in the process is to *let go*, fully and wholly. This is often more easily said than done. Our minds want to be in full control all the time, so the free fall into improvisation makes us uneasy. Actually, what happens when we paint spontaneously is that we are implementing previous sensory experience to act as an inner guide, often without consciously realizing it. Our visual experiences and our reactions to them lay dormant ready to be tapped. Our painting gestures, choices of colors, and pace of application of medium to surface are all synchronized by the elusive inner system at work. When we do this without inhibitions, there is a feeling of wonderful exuberance as though we were bouncing on a creative trampoline. Any momentary thoughts of "What am I doing?" tend only to tighten up the whole initial process. There is plenty of time for that later.

It is enjoyable to watch young children paint because they have absolutely no fears of what they are creating, or whether they are doing it "well" or "right." Instead they are totally involved with what they and the paint are doing. Children splash and apply the paint with joyous abandon, and they often have a marvelous intuitive sense of composition. We lose much of that as we grow to adulthood. It is time to regain some of that experience and add to it the training of the artist.

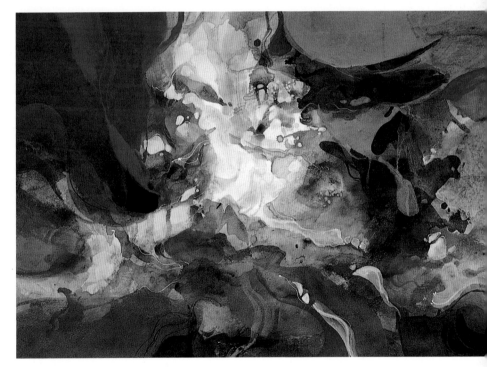

LADY DANCING IN LIGHT
By Edward Minchin. Acrylic on 140 lb. D'Arches cold-pressed watercolor paper, 30 x 36" (76 x 91 cm). Collection of the artist.

Minchin approached this experimental work by letting the paint lead him toward transcending the landscape into "a world of incredible color and imagination." Working from pure emotion, he painted layers of colors over an old painting. By reemphasizing the cool areas with further applications of cool paint and the warm areas with warm, he built toward a focus point. He states that the subject was discovered after the painting was completed. This is a good example of letting go, letting flow.

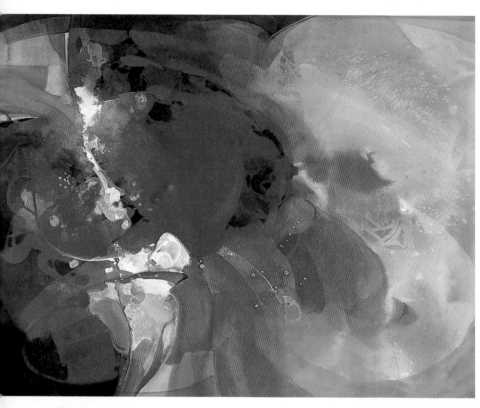

RED SHIFT
*Watercolor, ink, casein, and gouache on T. H. Saunders watercolor board,
30 x 40" (76 x 102 cm). Private collection.*

*This painting was begun intuitively by pouring and brushing paint. As it
developed it reminded me of something I had studied in an astronomy class: the
"red shift" of stars moving away from the observer. From that point on it was a
matter of strengthening areas, subduing others, and bringing into focus certain
places of intense activity. It mattered little whether the viewer connected this with
astronomy, but I did feel that there should be an obvious connection with an
intense system of energy.*

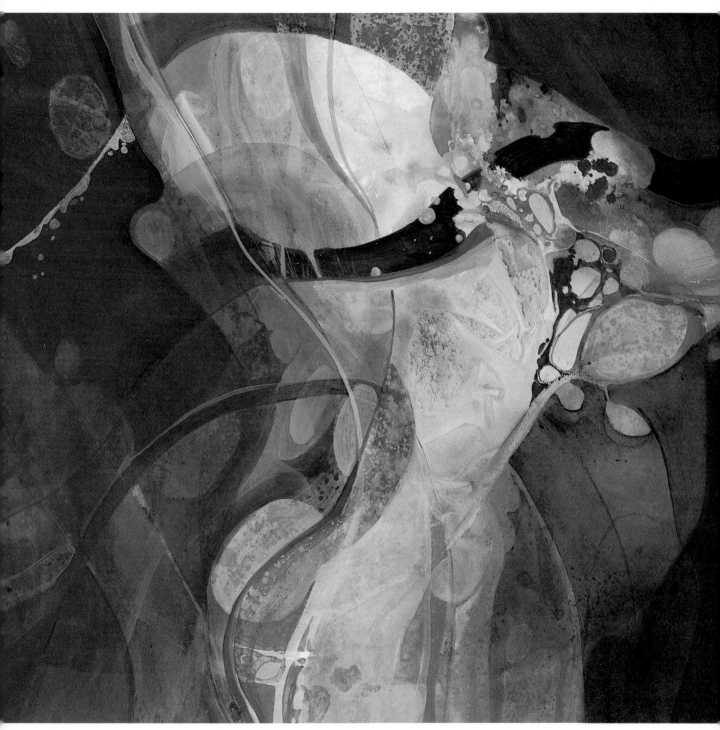

UNDERTOW
*Acrylic and gouache on Crescent no. 114
watercolor board, 19½ x 29½" (50 x 75 cm).
Private collection.*

*The organic movement follows through in this painting, but in a more structured
form giving undulating directional thrusts. There is the feel of the strong
undercurrent of the sea and abstracted suggestion of aquatic vegetation. The
painting developed from large sweeping strokes applied in a rhythmical fashion.
Many glazes were applied in varying tones to build the moving overlapping
shapes and feeling of movement. Slowly the curved area of light was defined and
shapes of interest within it.*

CONTROL THE FLOW

The artist must organize shapes, pull other areas together into larger forms, and give just enough definition to give compositional meaning to the painting. It may be organized into a nonrepresentational form, but often it will progress on to a semi-abstract statement concerning the representational world. Occasionally it will progress further to even more definition.

One of the secrets to this approach to painting is to let colors fuse and overlap. Shape definition, when that decision is made, is accomplished by changes in value or sometimes by intensity in color. Negative shape painting around selected areas of the form provides the suggestion of definition. It is important to leave both hard and soft edges so that there is a feeling of naturalness about the subject.

Working wet-in-wet can get out of control all too quickly. I find that when working on watercolor board, it is best to dampen the back surface in order to keep the board flat. Otherwise, it tends to curl up at the edges into a U shape that limits control. Once the back is wet, the front can be dampened as much as you like. If you are planning to work very wet, prepare your board before starting, while it is still dry. Either tape around all the edges or rub paraffin on them. This will keep the water from seeping under the surface and separating the paper from the surface below.

As you begin to refine and strengthen your composition, you may decide what it is you want to say in the work. This may come gradually during the improvisational process, or it may be an immediate idea. Give the artist within yourself a chance for expression. Just be prepared for many adjustments in the fine-tuning process along the way. These refinements will need to be consistent with the form of the initial washes, for otherwise there will be an incompatibility of approaches. This is where the experienced outer artist needs to be in control.

ROCKS
*Watercolor and gouache on D'Arches 300 lb. watercolor paper,
21¾ x 29½" (55 x 75 cm). Private collection.*

Although not preplanned, the rock theme became apparent fairly early in the process of painting. Once the initial washes were dry, I defined crevices and openings around the rocks in order to shape the rocks. The light rocks on the lower left lead the eye into the painting, and the movement continues through the flickers of light elsewhere and through the directional placement of the rock forms. Most of all, I wanted to retain that feeling of timelessness and mystery present in rock formations.

A DELICATE BALANCE
Transparent watercolor on Crescent no. 114 cold-pressed watercolor board, 29⅝ x 19⅝" (75 x 50 cm). Collection of the artist.

This painting is a symbolic statement about the balance between nature and man, but it remains abstract. As the paint dried, I lifted out shapes or painted through stencils to create them. The blush of warm ochre tones was an important addition to the neutral background and dark shapes. The warmth brought attention to the area of greatest light and to the balancing shapes dangling by the delicate threads of time.

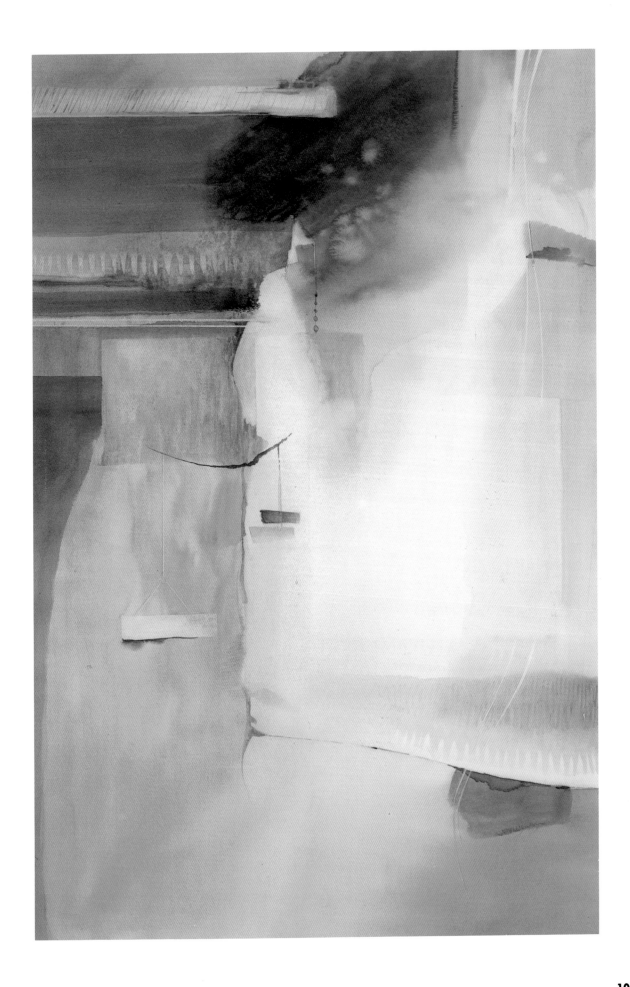

GIVE DEFINITION TO IMPROVISATION

Artists who work improvisationally find that they are constantly on the road to discovery of knowledge about themselves, about the world, and about the many methods of expression available to them. Because they do not have a preconceived set path to take to a known final result, they can be free to experiment, change, and slowly develop their concept as they progress with the work before them. It is as though the spontaneous start took them to a certain threshold, and once they pass through that doorway they find another, and

then another. At each point they are faced with several design and conceptual decisions. The path may not be straightforward, but one filled with many twists and turns before the painting is completed.

Sally Emslie discovered a process in painting backgrounds that gives her a rich playground for color and texture. She uses a porous paper that shows on both sides different aspects of the applied paint. She normally pours the paint and lets it float on the surface until it sinks through. After it dries, further applications may be made, or the surface

may be used immediately. She usually challenges herself with something that is uncomfortable for her to do. It may be color problems or certain textural effects or later working with difficult conceptual questions.

Living on a farm and having an enormous love for animals, she says she thinks as much of them as she does of people. In her paintings, often the animals are treated on the basis of this equality or given reverse roles with those normally played by people. She states, "if you can't imagine the opposite, you can't create the new."

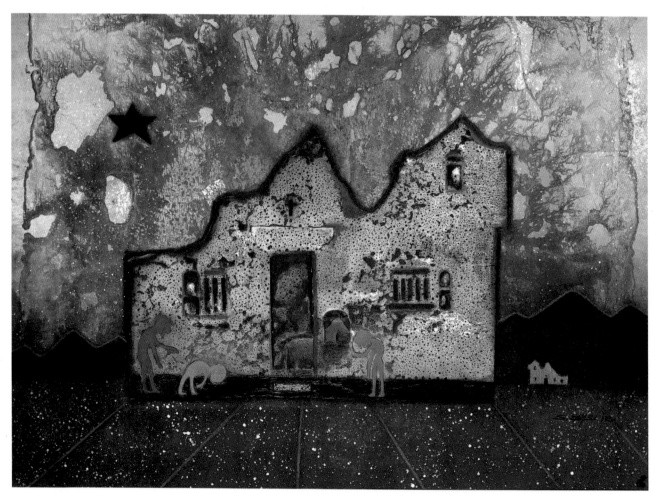

LONE STAR
By Sally Emslie. Acrylic on paper, 24 x 34"
(61 x 86 cm). Collection of the artist.

Emslie, finding it easy to relate to vibrant use of color, challenged herself to work instead with grays and rusts. The background was created by pouring paint through a porous paper surface. When the paper dried, various textural forms appeared that were used as a setting for her subject. Another sheet of paper went through a similar process and was then torn into an abstracted adobe shape. This was adhered to the background paper, and an imaginative process of developing the subject began. The foreground symbolizes encroaching asphalt.

COMBINE TECHNIQUE AND IMPROVISATION

When Utah artist Shirley McKay begins her painting day, she tries to take a time for centering herself by thinking "of a time when she felt especially creative and trying to relive that time in terms of how she felt, what she heard and saw." This relaxes, opens, and focuses her mind for the improvisational process ahead. A number of artists explore this type of discipline to aid them in being open to more innovative ideas during the initial stages of painting. The relaxation process and surge of ideas may come to others during physical exercise or listening to music. Each artist eventually discovers what gets the creative juices flowing.

McKay uses a layering process with acrylics and gradually imposes structure on the evolving shapes. She uses many of the well-known ways to apply texture and adds whatever else seems appropriate at the time. Light and rhythm are important elements in her work. She tries to orchestrate her personal vision of life, which includes light as a symbol of spirituality.

Carole Barnes and Shirley McKay both begin by using diluted gloss or matte medium brushed freely on the surface. The sheer act of moving the arm and brush freely acts as a warm-up for the use of color to follow. Color is added in thinned glazes, and texturing is sometimes incorporated into chosen areas of the damp paint. Slowly the process proceeds until the artist finds the place to develop needed expression of intent through color dominance, shape definition, and emotional content. McKay says she tries to "create on paper a vitality and vision that may help others respond more openly and appreciatively to their vision of the world."

Carole Barnes retains her improvisational initial approach, but begins to stretch mind and imagination to more abstract thought and images. She may reach a point in a painting where she feels conceptual direction taking hold, develop that with a succession of glazes, and discover that other ideas are coming forth to take over. She gives careful consideration to the possible new directions and does not hesitate to pursue them. This is one of the advantages of working with acrylics or caseins. Areas that aren't working with the rest of the composition can be painted out or readjusted as needed.

Barnes's most recent work pushes into symbolic imagery. She dared to depart from the body of semiabstract work that related to natural forms such as rocks and trees in order to explore nature's more difficult challenge of the mysteries of time and space. This meant taking chances in departing from her well-accepted previous work.

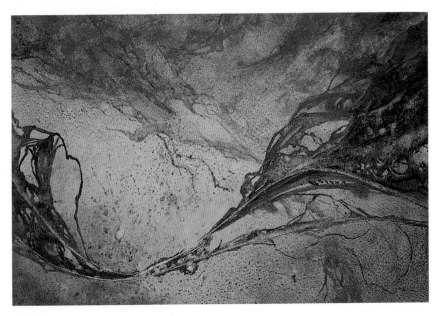

GENESIS
By Shirley McKay. Acrylic on Strathmore Aquarius 90 lb. watercolor paper, 22 x 30" (56 x 76 cm). Collection of the artist.

The artist used a layering process of building thin acrylic glazes in a succession of subtle colors to create the movement and feel of the sea and all that it brings to the beach. She sprinkled sand on the wet acrylic surface and let it dry to add to the textural effects of the painting. The gentle undulating form is repeated over and over again, with special emphasis on the seaweed-type shape in the foreground. She has succeeded in conveying her feelings about the constant, soothing motion of oceanic rhythm.

COASTAL REFLECTIONS

By Carole D. Barnes. Acrylic on Strathmore Aquarius II watercolor paper, 22 x 30" (56 x 76 cm). Private collection.

The artist had returned home from a trip to the beautiful coastal area of La Jolla, California. After sizing her paper with gloss medium, she began this painting as one of trees—only to discover, as she turned the work upside down, that from this viewpoint it looked like the rocky coast where she had been. She painted out the trees and further developed the rocks, glazing over parts of them to create the feeling of moving water. The resulting painting is a strong, abstract image conveying the powerful remembered images of the coast.

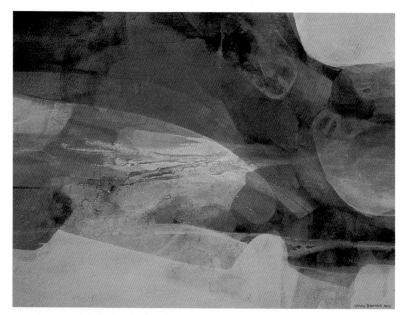

POEM OF ANTIQUITY

By Carole D. Barnes. Acrylic on Strathmore Aquarius II watercolor paper, 30 x 22" (76 x 56 cm). Collection of the artist.

The paper was sized with gloss acrylic medium. Much of the painting was done with her hand in a plastic bag, "a wonderfully tactile way to push acrylic around on the surface." The images, textures, and symbols often seemed to relate to Oriental forms, and Barnes pushed and pulled, "covered and rediscovered" them until all seemed in harmony. In order to do this type of painting successfully, an artist must actively respond to the action of the paint and to the internal images of the mind.

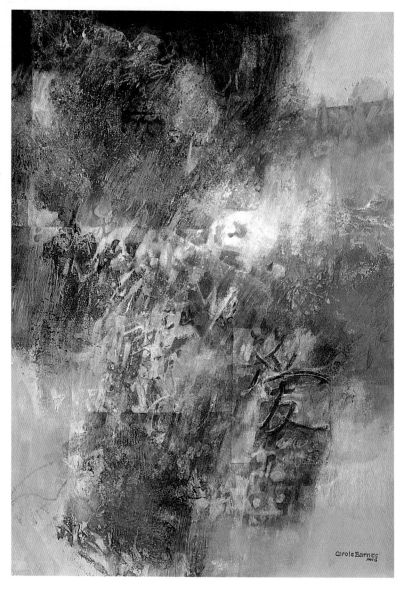

STRENGTHEN THE DESIGN

Sometimes an artist who works improvisationally feels as if the initial stages have become an exercise in chaos. It takes a great deal of training and experience to bring the composition and internal quality of a painting to a meaningful resolution. Sometimes favorite areas must be sacrificed if they do not work well with the composition as a whole. This is occasionally a painful decision, but the design and conceptual unity of the overall piece is what will give strength to the work.

Doug Pasek and Peggy Strohmenger both face these kinds of decisions constantly in their working process. The painting is the end product of a multitude of artistic decisions involving deletions, additions, and major and minor adjustments, all directed toward fusing the intellectual, emotional, and spiritual contributions of the artist into a form of interpretation in which the strength lies in the sum of its parts.

Pasek's training as a designer and his natural visionary nature are always evident in his paintings. He begins with spontaneous textural forms and then strengthens design with line and geometric shape. Strohmenger plays with texture and searches for compositional focus to give greater order to a busy surface. She lets the painting lead her to the choice of geometric or representational focal shape.

Joan Ashley Rothermel faces similar problems in many of her works, which begin with "covering the support as quickly as possible, then going back and bringing out images if it is to be an objective painting."

Rothermel, who has excellent drawing skills, uses these in a painterly way to bring out her subject matter, but keeps it well integrated into the improvisational structure. She sometimes incorporates geometric forms through an airbrush technique. The "back-and-forth process of brushing and spraying occurs many times, resulting in multiple layers with an impression of depth."

Rothermel's subjects are presented with a freshness of compositional viewpoint that brings the viewer back repeatedly to discover what else the artist has to say. She is widely traveled, and images of places and remembered artifacts enter her paintings in a dreamlike way—appearing, disappearing, and reappearing from layers of memory captured through her painterly vision.

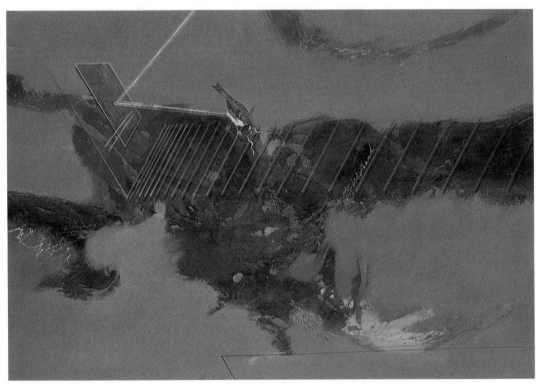

SPARROW LIGHT
*By Doug Pasek.
Acrylic on Crescent
no. 114 cold-pressed
watercolor board,
28 x 36" (71 x 91 cm).
Collection of the artist.*

Once the underpainting was dry, Pasek expertly imposed geometric forms over the maplike shape below. The mathematical progression of the angled lines becomes a form of movement marching across the surface, implying the potential for flight of the bird and of our imagination. This work makes a complex statement with simplicity and unity of design.

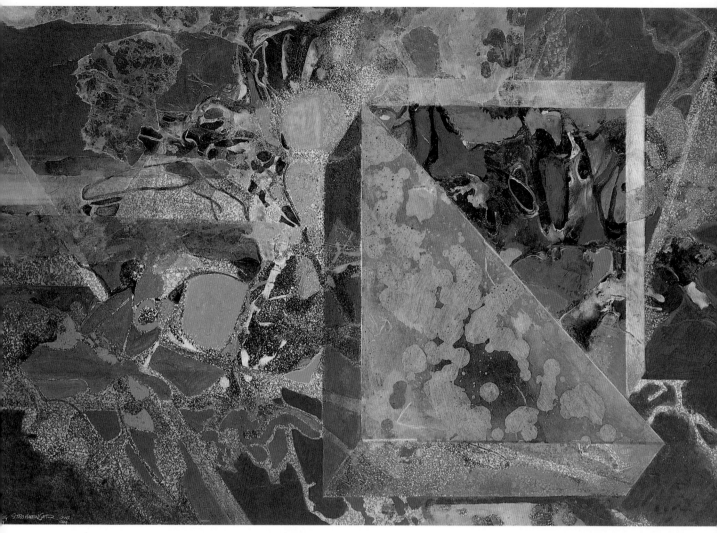

PERICLESIAN PARADOX
By Peggy Strohmenger. Casein, watercolor,
acrylic, inks, metallic watercolor powder, and
hand-colored rice paper on Crescent no. 110
illustration board, 18¾ x 29" (48 x 74 cm).
Collection of the artist.

After covering an old painting with black gesso, the artist challenged herself with
three goals: to use colors that were new to her, to work initially with a low-keyed
palette, and to work abstractly. The third goal was difficult for her. She imposed
triangles on the painting and kept thinking of them as land masses that always
wanted "to be turned into something." When she tried to move away from the
land mass idea, she felt "absolutely depressed." Then she remembered Pericles,
who "lost his strength as he moved away from his land. From that discovery the
land triangles remained secure and the struggle vanished with the recognition."

Strohmenger filled a bottle with a mixture of gel and acrylic mediums, which
she poured in large free movements over the gessoed surface. While these were still
wet, she dropped in inks and metallic powders for soft diffusion of color. Later
shapes were defined by painting within and around the arcs and loops. She
gradually added geometric form and refined the geometric center of interest,
which was too heavy. Airbrushing toned down areas, and hand-colored collage
pieces enhanced the double triangular shape, which played dark against light in
a yin/yang effect.

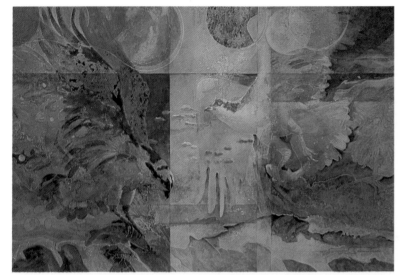

DE PROFUNDIS
By Joan Ashley Rothermel. Watermedia on Strathmore Print 90 paper, 28 x 38" (71 x 97 cm). Collection of Mr. and Mrs. Dennis E. Murray, Sr.

During a Maine vacation, the artist had spent hours of enjoyable study observing a nest of newly-hatched osprey. In this painting she tried to capture the power and movement of these birds. The work is divided into three panels to give greater compositional impact. At one point, she states that the down-pointed wing of the right hand bird was darker than the background. Airbrushing was used to make adjustments within the work for a softer feeling of depth and division of space, thereby strengthening the design.

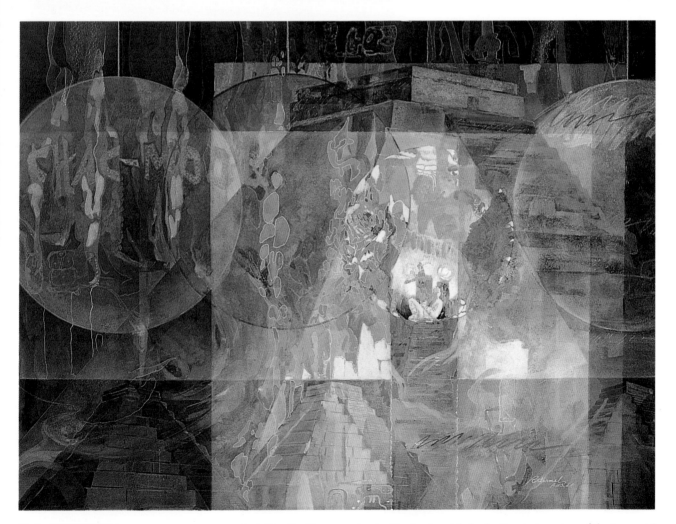

D. S., CHICHEN-ITZA
By Joan Ashley Rothermel. Watercolor, acrylic, gouache, and watercolor crayons on Strathmore Print 90 paper, 30 x 40" (76 x 102 cm). Collection of Mr. and Mrs. Dennis E. Murray, Sr.

A visit to the Mayan ruins in Mexico provided a lasting impression of the pyramid at Chichen-Itza and the statue of Chac-Mool, the rain god. The artist started with a quick covering of the paper in dark midtone washes before going back in to bring out a series of objective and geometric images. She "painted the large pyramid, then Chac-Mool at the top of a long flight of stairs, and finally, a row of small pyramids along the lower part of the painting."

CREATE DYNAMIC CONTROL

One of the masters of improvisational painting is Edward Betts. His works in acrylic vibrate with the expressive use of the medium beyond the obvious: He brings out the deeper connotations and hidden beauty of his subject. His paintings continue to feed the imagination and soul of the viewer. These are not superficial pieces sure to please the mass market; they are authentic expressions of the artist's deepest feelings. Artists of the caliber of Edward Betts have developed a means of expression that gives their work a unique personal interpretation and painterly genuineness.

Betts begins his work in a free, spontaneous manner using acrylic paint. He pours, brushes, and applies paint with abandon, watching its mixing and diffusing properties for unexpected happenings that he may want to retain—at least temporarily. When the basic layers have dried, he studies the work and begins to apply artistic control to strengthen design, intensify or diminish color, or bring out areas of shape suggesting natural forms. His main interest is in implying nature, rather than depicting it literally. This takes thoughtful organization of composition. He applies dynamic control to the work before him to bring it to its artistic conclusion.

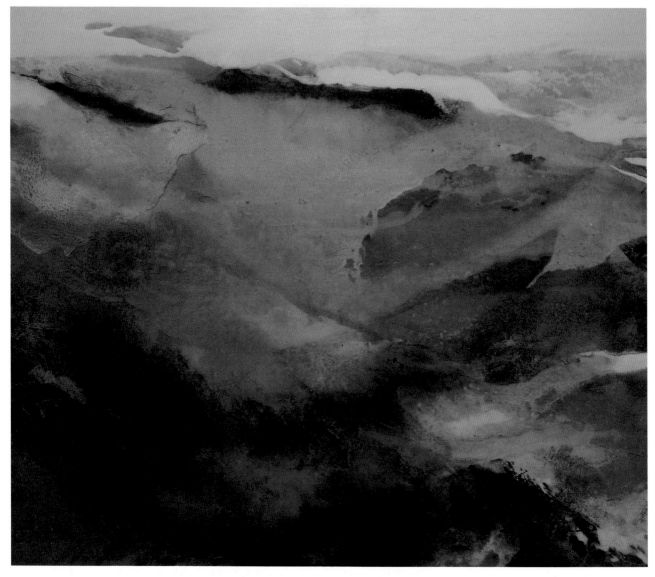

ISLAND MORNING
By Edward Betts. Acrylic on heavyweight illustration board, 25 x 30" (64 x 76 cm). Private collection.

Spontaneous applications of color took on the look of a foggy morning on Monhegan Island, off the coast of Maine. Betts kept the surf and fog in the upper area soft and atmospheric and echoed this in the lower regions. Through layering many thin glazes of colors, he was able to control subtle color, texture, and edges that "are pleasurable in themselves and produce a lyrical, universal interpretation of island weather rather than a literal documentation."

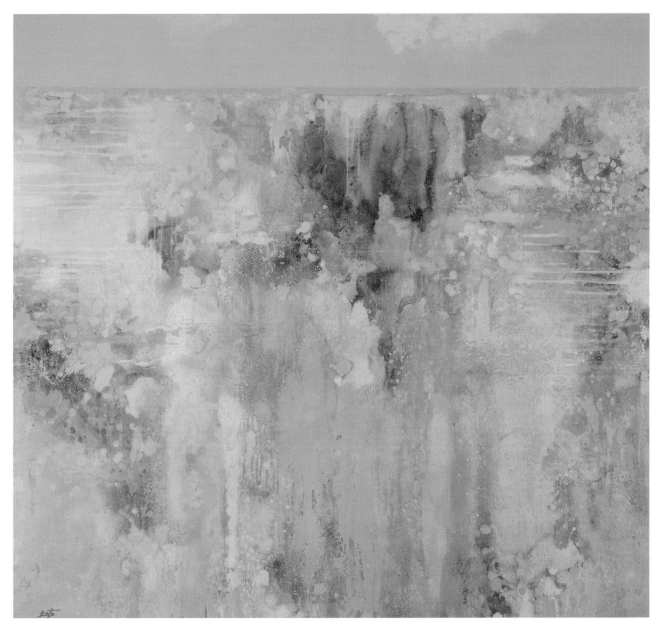

SUMMER POND
By Edward Betts. Acrylic on Masonite,
44 x 48" (112 x 122 cm). Private collection.

This improvisational painting quickly showed signs of relating to sunlit wet
surfaces that reminded Betts of Monet's gardens and pond at Giverny. There was
"no interest in redoing what Monet had done so magnificently." Rather, he
wanted to create a partially ambiguous surface "made up of interwoven touches
of color existing in an environment of thin color washes and glazes." This
involved the jump in color from one area to an adjacent one, along with its
weight and placement on the painting surface.

The artist's dynamic control is evident in the organization of the free-flowing
composition through the use of major horizontal and vertical elements. It was
important to evoke the essence rather than the specifics of light, water, and
reflections. Betts states that he preferred to stress "lyricism rather than factuality."
Direct observation of a scene was not the inspiration for this painting, but in the
painting process, "nature became a partner in the development of imagery."

EXPRESSING IDEAS THROUGH ABSTRACTION

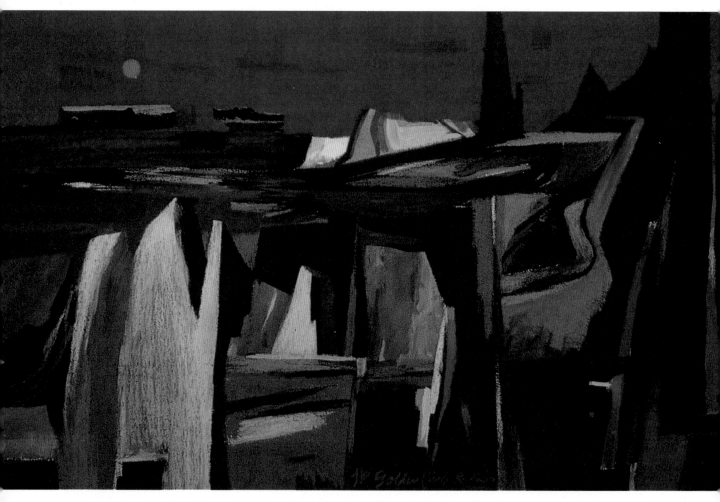

THE GOLDEN CIRCLE
By Richard J. Phipps. Watercolor and water-soluble crayon on Fabriano 300 lb. cold-pressed watercolor paper, 18 x 30" (46 x 76 cm). Collection of the artist.

A popular tour called "The Golden Circle" travels to outstanding landmarks in southwest Iceland, including lakes, rivers, waterfalls, craters, lava fields, rifts, and geysers. This abstract painting combines their features into a single rugged and dramatic landscape. Notice how crayon is carefully integrated into the composition to add texture and chromatic charge.

Beneath every representational painting, there should be a good abstract understructure. Artists working in styles that are closer to recognizable subject matter often let the individual parts of the painting become more important than the basic compositional form. This can lead to a disjointed painting where emphasis is on separate things rather than the unity of the whole. Becoming familiar with the abstracted nature of composition can give a tremendous boost of strength to the artist's overall presentation of an idea.

I hope the examples of abstract work in this book will help you appreciate artistic expression that is derived from or associated with the real, but that focuses on emphasizing certain aspects of that subject. Sometimes the familiar takes on an extraordinary change when we can break it down to the essential components of form, color, line, or movement. There may be times when the underlying basic purpose of the artist is to share internal reaction to a subject. Whatever the choice, it is abstracted in thought—that is, reduced to essentials for the purpose of more effective expression. Marcel Proust once said, "Only through art can we get outside of ourselves and know another's view of the universe which is not the same as ours....Thanks to art, instead of seeing a single world, our own, we see it multiply until we have before us as many worlds as there are original artists...."

A few years ago, I decided to set a problem for myself in working with abstract shapes. I worked out a basic overall abstract design with a variation and repetition of rectangles. I had no subject matter in mind, since I wanted to work intuitively. However, artists who must have subject matter in mind initially could use the same process, for the understructure would relate to the basic design thinking in both cases.

I began with a simple interlocking line form drawing—just enough to give me some sense of direction. I did several quick little sketches before I chose a satisfactory design. Then I did a very rough value sketch, but it was only a guide, something to get me started in the creative process. From my normal method of working, I knew that once the painting started, I could build, adjust, and revise much of the basic structure. However, that foundation was important for the overall general statement of shape placement.

I approached it in my usual way of playing with paint on a wet surface, placing large shapes first, doing a bit of texturing, and letting all this dry. Light values, middle tones, and a few splashes of darks were used in this first stage, particularly in the area where you see the woman's skirt. At the time, I had no figure in mind, but when that area dried, it looked much like paisley fabric. That was the spark that gave the idea for subject matter.

The upper body was added by painting around the form. The legs were brought down from the lower edge of the skirt. There were suggestions of other forms within the surrounding background, which I developed into the little vendor's stand, but always thinking of shapes more than of each specific item. The other figures were also considered as accompanying shapes. I refined the image further by suggesting the upper window and other architectural indications. It was important not to overdo detail work, but to keep the work related to the free-flowing start. What started as abstract form had become a representational painting.

Another painting that evolved from abstract understructure to a semiabstract figure study was originally a study in warm and cool shapes with a play of light sweeping down through the composition. It was a nonobjective study focusing on color and movement of form. I had chosen an elongated format as a further challenge and was quite pleased with the resulting abstract painting. Some time later, I looked at the work and thought, why not push this back to a semiabstract state?

I could see the possibility of figure development starting with the area that became the woman's face. Some sort of exaggeration and resolution of shape would need to be employed to imply figures, but not take them to the point of usual representation. The abstract understructure came to my aid, since the face was faintly suggested in an elongated form. The problem was now not to emulate Modigliani, but to use the linear exaggeration of the figure as a way to bring my concept to a semiabstract means of expression.

Now the fun began. First I carefully studied the existing shapes, then did some light drawing with a brush to indicate the large outlines, and finally did negative shape painting around selected areas. I used only the most necessary positive shape painting. The face was activated by the addition of eyes, elongated nose, and suggestion of mouth. The large shadow form on one side of the face also helped to accentuate the abstraction. While in the process of exaggerating the hand, I discovered the shapes that suggested the infant. Some of the original texturing provided the lower left indication of fabric. The man's face came last as the sustaining form coming out of the dark behind the woman. The resulting painting kept to its intended semiabstract format, retained the feeling of glowing light that was used to emphasize parts or all of the figures, and gained a charge of emotion that was not present in the original nonobjective state.

Exploratory abstract sketches for Passing Fancy.

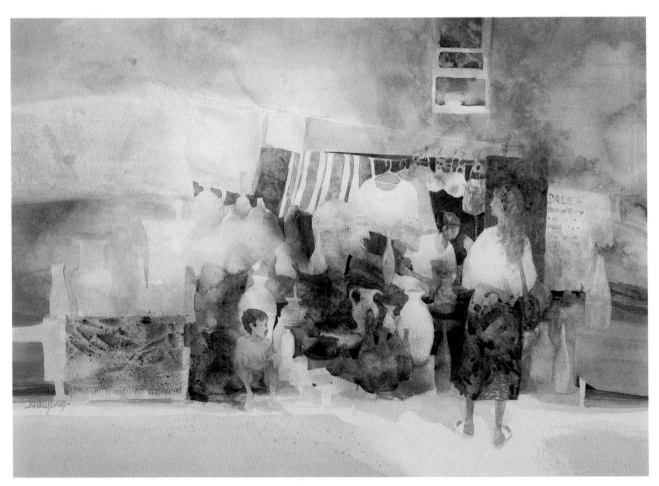

PASSING FANCY
Transparent watercolor on D'Arches 140 lb.
cold-pressed paper, 14 x 19¾" (36 x 51cm).
Private collection.

What started as an exercise in abstract shapes ended as a representational painting. (See text for detailed description.) Once I had decided that there would be recognizable subject matter, the whole process evolved like putting together a puzzle, but with a great charge of emotion. I thoroughly enjoyed bringing to attention the figures and wares for sale.

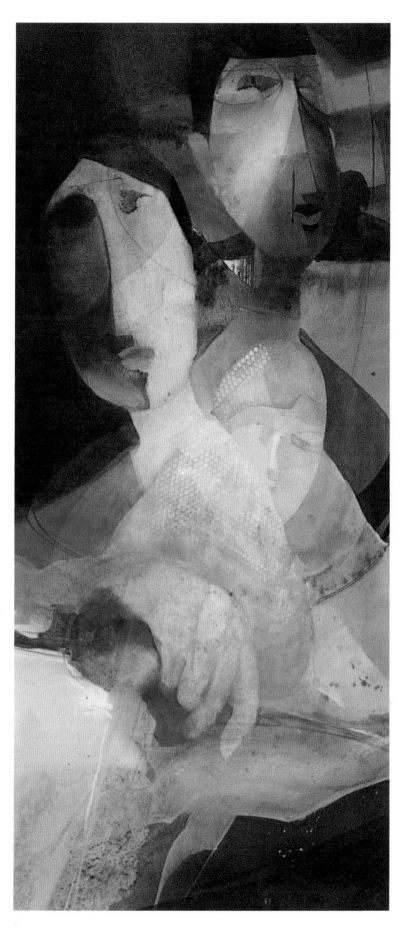

THE FAMILY
Watercolor and gouache on Crescent no. 114 cold-pressed watercolor board, 19 x 9" (48 x 23 cm). Collection of Drs. Andrew and Ilze Bekeny, Westlake, Ohio.

This semiabstract figure study stresses the use of overlapping color, exaggerated shapes and features, and the movement of light from the dimly lit upper areas to bright diffusion across the lower figures of child and mother. Once the subject was decided, it was important to keep a consistency in style and to infuse the painting with an emotional charge of chromatic energy emphasizing the family unit.

EXPERIMENT WITH VISUAL LANGUAGE

Further exploration of abstract expression can open new avenues of excitement and ways of visual articulation that begin to take us past words to a new language of art. Visual language is made up of many different types of imagery and symbols. Some are instantly recognizable and understood, for we see them in the everyday world. The work has subjects with which we are familiar and color that seems to be the local or natural choice. The painting or sculpture seems straightforward with little required of us to understand the purpose of the artist. This is not to say that representational work has less to offer; it has a great deal to add to the enjoyment and enrichment of our lives. The best of this work over the centuries has made a lasting impact on our minds and souls.

What we are seeing may not be as important as *how* we are seeing. Once we can get beyond thinking of objects and begin to see the dynamics of the composition in terms of the relationship of shapes, energy of movement, the interactions and transitions of color, and the emotional charge imparted by the artist, we are entering a whole new world of awareness. We even discover that when we look at representational painting from this viewpoint, we have a fresh and deeper appreciation of the work. When we use the same reference for looking at abstract art, we discover that we have found one of the keys to understanding this other form of creative expression. We have made the transition into a new language that takes us to places that may open our vision of the nonrepresentational world.

SEA WALL
Watercolor and gouache on Crescent no. 114 cold-pressed watercolor board, 30 x 40" (76 x 102 cm). Private collection.

Many of the linear shapes here were masked out and not removed until the painting was dry. After several sprays of water and color glazes, the surface took on the feeling of an old, battered seawall. The abstract presentation of the ever-changing energy forces of nature was of foremost importance, not the replication of a wall. Reality exists for an artist when inner world and outer expression can be successfully resolved into a unified form, giving order to chaos.

BEGIN A SERIES

It is not uncommon for an artist who is totally involved in a particular concept to find that with the excitement of that creative thought, other ideas begin to spin to the surface. A series helps to develop the artist's deeper range of conceptual thinking and gives that person a chance to explore more than one facet of the same subject, seeing it from a slightly different perspective and philosophical angle each time.

An artist whose innovations have developed into a series comes to recognize when the time has come to move on to other things. The familiar is comfortable. The unfamiliar can be threatening.

Elsie Boyce is in the transition period of departing from familiar ways of expression and continuing her search. During this time, she is discovering what she prefers as medium and the method of using it to best express her ideas. For now, acrylics and charcoal give her the necessary freedom to convey the particular abstract vision she has of nature. She states that it is important to find "a technique that is natural and use it as a tool to process inspiration from nature in such a way that it evokes emotion in both the doing/doer and in response/responder—an invitation from the doer to witness and enjoy the search!"

Shirley McKay embraces painting much as she embraces life: with joyous vitality. She finds that working in an abstract series relating to a particular idea and using an acrylic layering process to express it gives her an in-depth exploration of her philosophy of time, place, and circumstance. She begins each painting by covering paper with an "organic and unstructured" flow of acrylic. McKay gradually builds structure and imposes layers of texture by spraying, blotting, using crumpled tissue, plastic wrap, and finger painting. The process continues until the expressive and conceptual statement reaches a satisfactory conclusion.

O. & G., #3
By Elsie Boyce. Acrylic and charcoal on Strathmore Aquarius II 80 lb. watercolor paper, 30 x 22" (76 x 56 cm). Collection of the artist.

The initials stand for Organic and Geometric, one painting in a series in which Boyce incorporated the use of organic underlays as a subtle support for the more geometric forms that were fused into the surface. The line of rock formation was drawn with charcoal, and then acrylic was applied while superimposing the geometric forms. The integration of media provides a visual experience that is simply stated and effectively presented.

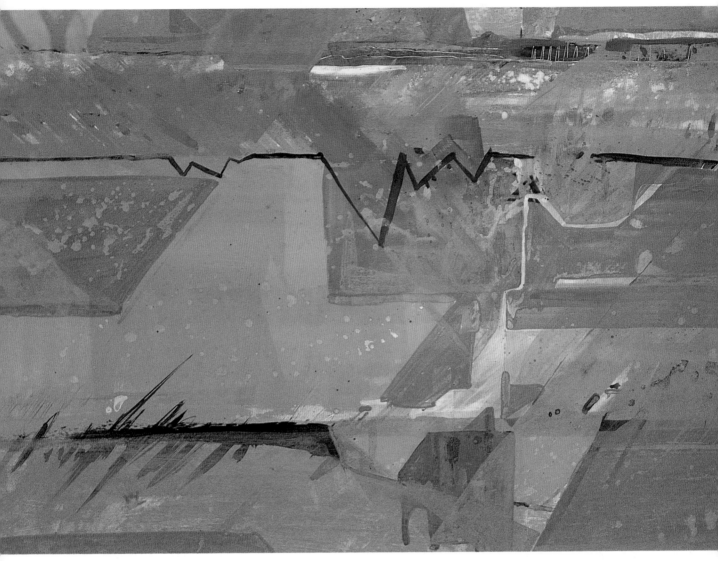

CANYON SUITE
By Shirley McKay. Acrylic on Strathmore Aquarius 90 lb. watercolor paper, 22 x 30" (56 x 76 cm). Courtesy of Art Masters Gallery, Park City, Utah.

McKay's series of paintings relating to canyons begins with loose acrylic underpaintings as she develops structure and texture. She uses a layering process of adding and removing paint, revealing and obscuring form to give a reflection of canyon life. Note how much the complementary yellow-oranges add to the overall cooler tones.

EMPLOY NARRATIVE CONTENT

Iku Nagai combines content and process in a way that reflects her experiences with both traditional Eastern and abstract Western art. Her paintings represent her visual interpretation of "the mental, physical, and spiritual transferences which shape our being." Her "Cycle" paintings are interpretations of the unending cyclical patterns of man's nature, as realized through Zen and Taoist principles, in which artists attempt to assimilate themselves with nature in an effort to be one with the world. Nagai's paintings convey "visual poetry and metaphorical interpretations of nature: reflections as seen through both my real eyes and conceptual eyes."

While working with watercolors, Nagai found that she could create richer colors and surface textures by mixing watercolor with Japanese and Chinese dry mineral pigments combined with "nikawa," or deer glue. She began to experiment with the use of Japanese gold and silver leaf, haku, which is of extraordinary thinness and delicacy. Once adhered to the surface, it can be easily painted over, unlike ordinary gold and silver leaf, which act as resists to subsequent layers of pigment. The resulting overlay lets a "subdued beauty shine through."

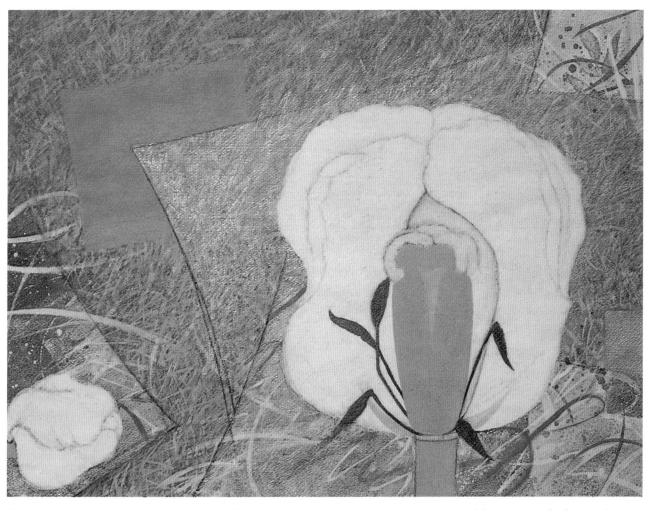

CYCLE I
By Iku Nagai. Watermedia, mineral pigments, and silver leaf on 75 lb. cold-pressed watercolor paper, 25 x 32" (64 x 81 cm). Collection of the artist.

Working in a layering process, the artist depicted the pristine tulip bud as the birth of life and the large tulip as the symbol of the approaching end of life. There are included implications of male and female relationships. The "superimposed rectangular form, like pages of poetry, signifies a record of existing life." The artist within observes the world without and uses pictorial means to fuse form and content.

CREATE PATTERNS BY OVERLAPPING SHAPES

Joy Shott's abstract images of orchids beautifully illustrate the use of abstraction from botanical subjects. She explores the relationship between overlapping shapes, movement, color tonalities, and space. She states that her "love for color and patterns has found the subject of orchids to be a marvelous vehicle for self-expression." Recognizing the orchid's exotic nature, she finds classical qualities in their structure that she simplifies by "rendering their forms as flat, simplified patterns."

Before painting, Shott carefully plans the composition, then transfers it to the watercolor paper. Because of the intricate design, she masks out with a liquid friskit all the small shapes that are to be left white. In addition, thin linear shapes are masked because they will later help define spatial planes. She uses multiple transparent glazes of primary colors, which build from the lightest light to the darkest dark of the composition. At certain stages of glazing, when she wishes to retain an acquired tone or achieve a particular hard edge, she lets the area dry and then masks it in order to preserve shape and color. The meticulous technical process can be lengthy, but it helps to retain clearcut, clean images.

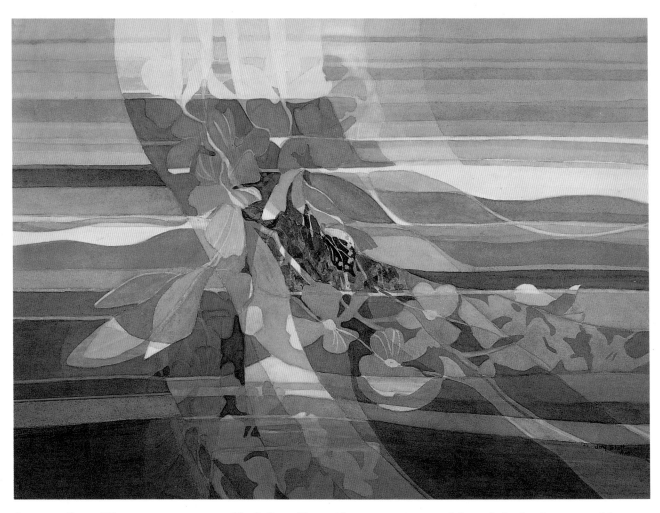

CHANGING LIGHT WINDS
By Joy Shott. Watercolor on D'Arches 300 lb. cold-pressed watercolor paper, 22 x 30" (56 x 76 cm). Collection of the artist.

The feeling of languid movement is created through the dominant use of the horizontal overlapping shapes, broken by an occasional curved diagonal thrust. The flower forms are well placed within the composition and contribute to the feel of movement, as though a light breeze has blown through the orchids. Nothing in the painting is left to chance. The artist is in absolute control.

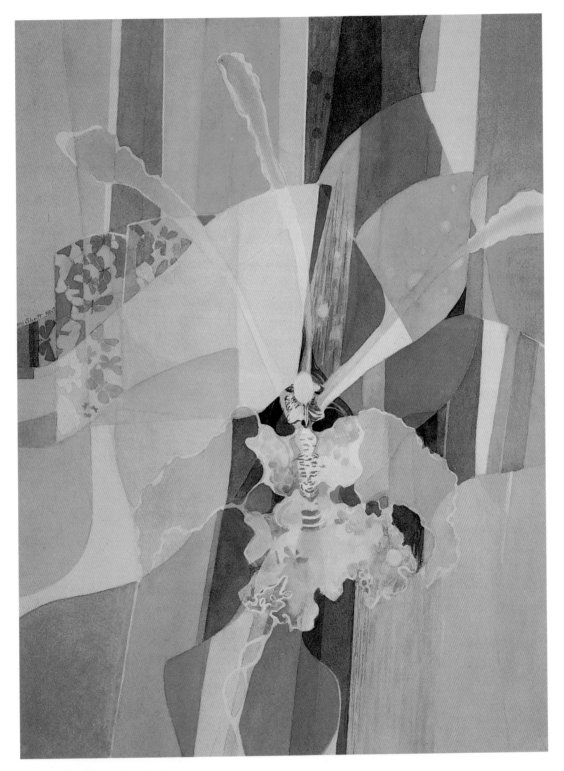

ORCHID SERIES—PAPILION
By Joy Shott. Watercolor on D'Arches 300 lb. cold-pressed watercolor paper, 30 x 22" (76 x 56 cm).
Collection of the Creative Arts Center, West Virginia University.

The strong vertical, overlapping shapes are gracefully intersected by the diagonal thrust of light on the left. Planes are kept simple but varied, with careful attention given to thick and thin, plain and broken passages. The focus is on the slightly textured organic orchid shape, with an echo of similar texture in selected parts of the composition. The subtle tonal and value transitions offer the feeling of depth within the picture plane of this beautifully designed painting.

SUGGEST THE ENERGY OF NATURE

Two artists whose work portrays the energy of natural forces from different environments are Patsy Smith and Mary Todd Beam. Both artists begin the process of painting by pouring on color as freely as possible. Both artists enjoy painting on large surfaces. They rely on memories to guide them in the development of evolving form. Both use a variety of watermedia pigments such as watercolor, acrylic, water-soluble colored pencils, water-soluble crayons, and graphite pencils. They prefer unrestricted use of materials in achieving whatever ends are necessary in the creation of their work.

Smith has strong memories of the "swirl of the breeze through grain fields beneath the rolling cumulus clouds" on the Nebraska prairies, and that same movement keeps coming forth in her work. She is used to seeing the weather change from the caressing of the grain to the violent energy of the tornado, and some of her linear surfaces "definitely describe encounters with these forces." Flowers often inspire her colors, and she prefers to use "vivid wild colors on softened neutral backgrounds.

Smith plays with line, pattern, and texture, selecting dominant forms and colors in the process of selecting and applying what is most appropriate for the content of the painting. To achieve textural variations, she may use crushed paper, lace, burlap, and various found objects. The development of texture is always part of the natural progression of the work and is well integrated into the whole. She deepens the surface forms with shades and tints of color glazes, watching "rhythm, contrasts, tension, and compatibility of the total production."

Mary Beam, whose working methods were described earlier in the book, often makes her color choices according to the mood she wishes to establish. She prefers the abstracted format in which she derives subject matter from the real but emphasizes only certain aspects of that subject, such as the expression of movements in nature—whether the powerful and disturbing forces or the more quiet and subtle ones.

One such painting began traditionally as a painting of a hummingbird flying through a window. When Beam turned the work upside down, a whole new idea presented itself: a painting of greater depth of expression and connectedness to life experience. An apple, as a symbol of the spiritual life, took the place of the hummingbird, and strong design brought impressive order to the work.

In my own work, I have explored the immense natural forces *within* the earth, where energies are sensed but seldom seen except in catastrophic geological events. Red became the expression of energy, while charged shapes emerging from darkness represented form.

FANCY FLIGHT
By Patsy Smith. Watermedia on Strathmore Aquarius II 80 lb. rough watercolor paper, 29 x 37" (74 x 94 cm). Collection of the artist.

The artist describes her linear work as being strongly influenced by the forces of nature. One can almost feel the turbulence of the wind on the prairies. The swirling forms, flowing with color, revolve with endless vigor. They are set against a cool background of contained energy, adding the necessary silent contrast for the erupting forms in front.

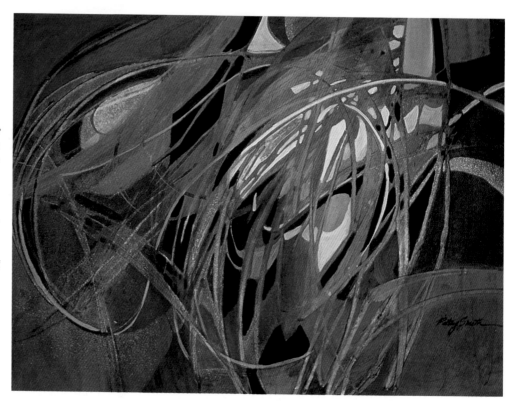

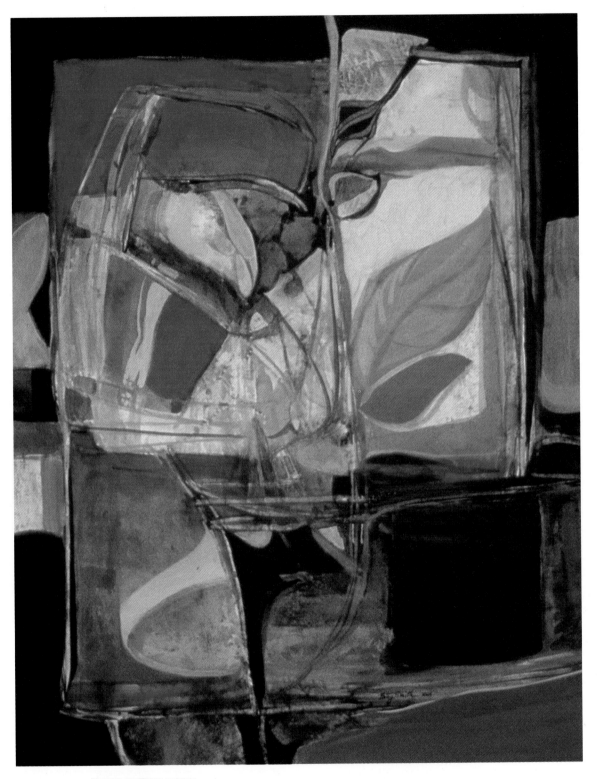

FANTASY ENCLOSURE

By Patsy Smith. Watermedia on four-ply rag mat museum board, 55 x 43" (140 x 110 cm).
Collection of Mr. and Mrs. Fred S. Kummer, Jr.

This compositional structure—which has all the imperfections, surprises, and
strength of nature—captures the viewer's attention with forceful energy. It is
further enhanced by the use of vivid colors and strong value contrasts. The
surface has been built with successive vigorous glazing, leaving exposed
underlayers of color. The spatial divisions are constantly varied and continue the
interest of viewing throughout the painting.

LABYRINTHS AND DISTILLATIONS

Acrylic and rice paper collage on Crescent no. 114 cold-pressed watercolor board, 29½ x 39½" (75 x 100 cm). Collection of the artist.

This work, developed through layering paint and paper, expresses the enormous complexity of the organic and geological processes within the earth. The three divisions of the painting surface use chromatic emphasis and shape variety to articulate nature's released energy. The seeming chaos of inner surgings is balanced by structural forms, and the contrast and tension between the two keep the painting activated.

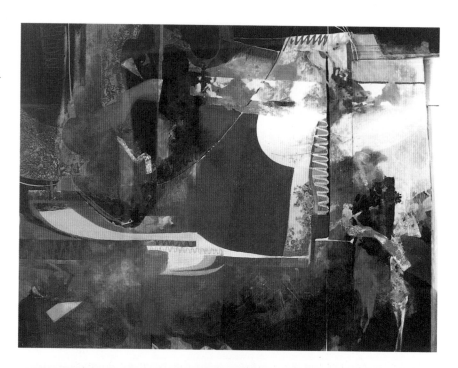

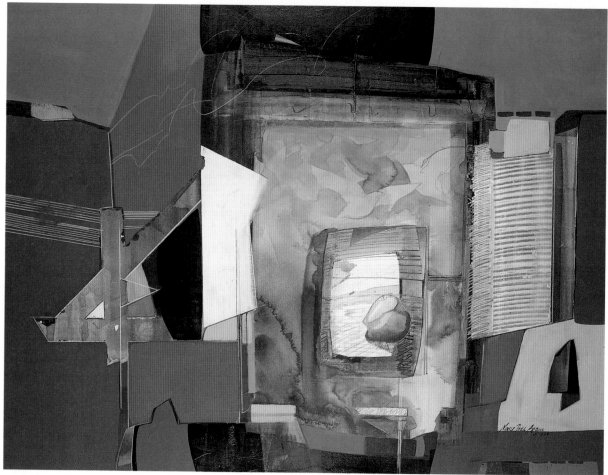

SYNTHESIS

By Mary Todd Beam. Acrylic, water-soluble colored pencil, and graphite pencil on Crescent no. 100 cold-pressed illustration board, 30 x 40" (76 x 102 cm). Collection of the artist.

This painting juxtaposes nature's quiet energy, as symbolized by the bird, against rectangular shapes symbolizing civilization. Defined edges are set against soft passages, transparent against opaque, and the apple serves as a focal point for the whole. The geometric shapes and fine lines are a natural choice to depict order.

CREATE ABSTRACT LANDSCAPES

When an artist goes on location, there is the natural inclination to record it as it is. This is the beauty of keeping a sketchbook and using a camera for reference. Some artists will want to continue on with serious representational studies, while others may wish to interpret the scene or subject matter in an entirely different way.

For Richard Phipps, the vigorous semiabstract approach best serves his intellectual and emotional purposes as an artist. A trip to Iceland had a profound effect on the artist as he viewed the ancient ruins, natural landmarks, and museum records of excavations pertaining to early settlements. He felt that the dramatic starkness of much of the land had to be translated into visual images that would relay a feeling of rugged geometric order. Phipps's normal dynamic approach to painting was ready-made for this kind of subject.

He approached the work improvisationally, with only a general plan of his direction for each work. He prefers to lay in a few marks on the painting surface, giving him just enough structural information to proceed. Often these marks will assume the form of "geometric patterns, or space divisions, creating a strong underlying abstraction." He states that the "common denominator in all of the works was the use of various wet and dry media in concert on the same surface." Then, with the basic structure as a guide, he let the creative energy flow and "capitalizing on the characteristics of each medium, allowed the painting to come to its own conclusion. Hopefully, the final result would be different and more exciting than the preconceived image or idea."

This approach takes great confidence coupled with a strong background of experience to be successful. Phipps approaches his work with daring and willingness to wrestle with whatever problems arise. In the end, in spite of the intense energy within the paintings, nothing was left to chance—for every mark, smudge, and edge of every shape was done with intent. Through his vision of what a landscape could be, he transcended the obvious.

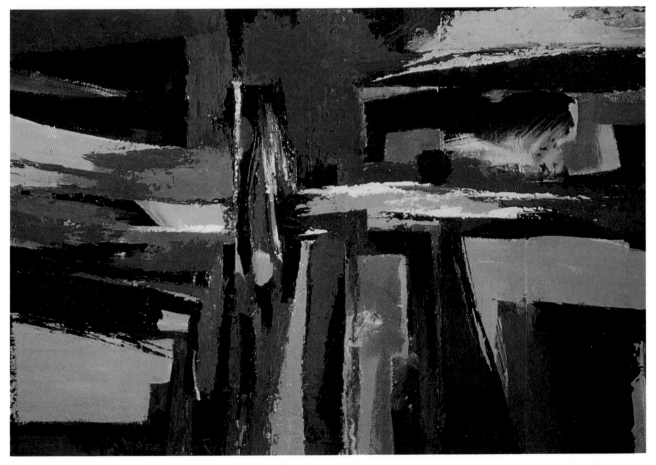

A NORSE RUIN
By Richard J. Phipps. Acrylic, gouache, graphite, Conté crayon, charcoal, and collage on Crescent no. 110 cold-pressed illustration board, 20 x 30" (51 x 76 cm). Collection of Ms. Daina McGary.

This painting is loosely based on the line drawings, photographs, and woodcuts made by researchers who excavated structures used by early Norse explorers. The composition is a distillation of many sites with the intent of giving the general appearance found in such places.

EXTRACT THE ESSENCE

Arriving at the basic form of a subject in order to extract the essential structure, meaning, and color demands more than a superficial way of seeing. The artist must hone in on the basic reality of the subject. What parts are absolutely necessary to make a statement? What parts might be sacrificed without destroying its identity? How can all this be organized into a unified statement? These questions must be examined closely before some sort of clear vision of the projected image can develop. This does not mean that all questions are answered or that a finished picture appears in the mind of the artist. However, removing the nonessential clears a path for the statement to develop with some freedom of expression and purpose.

Al Brouillette uses this process in developing his paintings. It is important for him to extract the essential forms, which in turn become the underlying nucleus of the developing subject. He works first with color and value to build a surface of layers of transparent color and texture. Brouillette states that "by extracting the essence of my subject to its simplest forms, I've given myself full rein to use my material as freely as I choose. When I'm working in a series using the same forms, each completed work can be recognized as springing from the same source, but…each is uniquely different."

As he begins a new painting, Brouillette keeps his mind open with no intention of developing any specifics. When he is about halfway through the painting process, he starts to add small amounts of opaque white to his color mixtures in order to block in selected light areas. These in turn establish the darker areas, which may become part of the subject. He says that "once the separation of values begins, that is when the design starts its evolution. This fact is important because it will be the arrangement of color and value, not the subject, that will make the most telling impression." There are many changes of direction, but underlying the process will be intuitive guidance based on observations and interpretations made *before* he began the painting.

GRID SPACE
By Al Brouillette. Acrylic on watercolor board,
22 x 30" (56 x 76 cm). Collection of the artist.

An overhead trellis provided the inspiration for this painting. The artist focused on the geometric facts of the trellis and the flowing organic shapes set against the light background of the sky. The work evolved in stages of layering transparent and opaque passages establishing color and value, which then led to the development of the design.

126

THE ROOTS OF NATURE IV
By Al Brouillette. Acrylic on watercolor board,
23 x 29" (58 x 74 cm). Private collection.

This beautifully designed work, part of
a series, gives strong emphasis to the
vertical shape filled with the root-
bound trailing vine. The gracefully
trailing vines emerge out of the central
area and fall to overlap into the lower
right, less busy section. The proportions
and color distribution are expertly
handled, and the artist has succeeded
in capturing the essence of his subject.

FRAMEWORK
By Al Brouillette. Acrylic on watercolor board,
22 x 30" (56 x 76 cm). Collection of the artist.

Here the artist is working more toward nonrepresentational expression, but there
is still the sense of connection to nature. The glowing orb of light serves to remind
us of the many sources of natural and man-made light in our own lives.
Brouillette has skillfully used a grid format for his composition and celebrated
structure and shape for their own sake.

DEMONSTRATION: ABSTRACT EXPERIMENTATION

Abstract experimental methods are useful in expressing concepts of matter, space, and energy in non-representational form. This particu- lar teaching example began with the placement of abstract shapes cut from friskit paper and adhered to the painting surface. As random shapes and glazes of paint gradually developed, both a conceptual idea and compositional format for the painting emerged.

STAGE 1: BLOCKING IN AND MASKING SHAPES

This abstract exercise was approached from a partially geometric viewpoint. I blocked in large areas of white by cutting friskit paper into appropriate shapes and applied the sticky side to the dry painting surface. Next I added a light wash of watercolor in the unmasked areas. The white shapes needed variety and some feeling of implied connection, so I cut shapes and placed them accordingly.

STAGE 2: ADDING LINE

Once the first washes were dry, I added linear touches with 1/16-inch graphic tape. The tape can be used at the same time that other whites are blocked out, but I chose to wait until some color was added so that a hint of color would show through when the tape was removed. I prefer to use white graphic tape, but this tape was gold.

STAGE 3: WORKING TOWARD THE SHAPES

I worked from the outside edges toward the larger shapes and from light to dark. This gives the greatest potential for development and pre- serves the white areas until final design decisions are made. At this point I found the beginning hint of conceptual connection to earth energies.

EARTH MEMORIES
Watercolor, gouache, and water-soluble crayon on Crescent no. 110 cold-pressed illustration board, 15 x 20" (38 x 51 cm).

After removing the large rectangular shape of friskit, I toned and shaped that area to direct the eye to the left and to develop a faint image of an abstract tree form. Additional glazes were added to the lower areas. Shapes on the left were given further interest by breaking into the static white forms. Spatter added a burst of energy to the upper left. Finally, I added one additional line by a lift-out method. After cutting acetate in a curved shape and spreading it slightly apart, I used a damp sponge to lift out the underlying paint. Water-soluble crayon marks added action to the shape adjoining the whites on the left.

PUSHING THE BOUNDARIES OF EXPRESSION

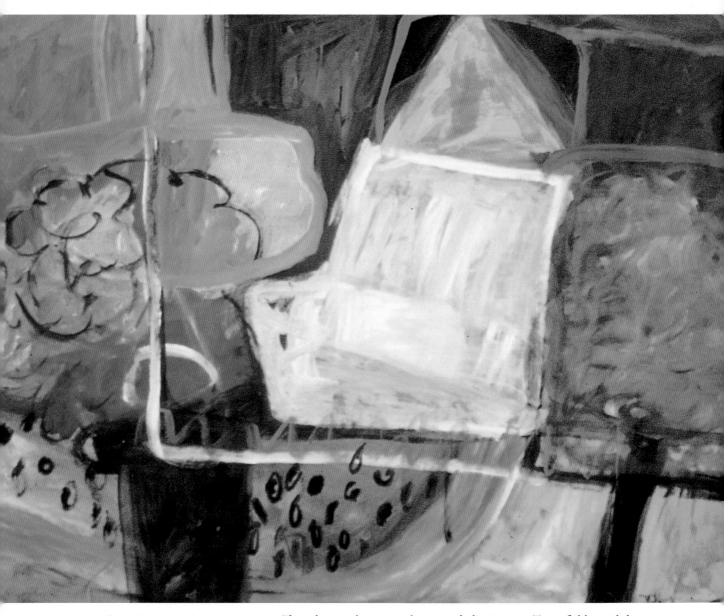

IT'S THE BLUE HOUSE, PASS THE ONE WITH ALL THE GERANIUMS
By Jeanne G. Keck. Acrylic on D'Arches En-tout-cas paper, 41 x 52" (104 x 132 cm). Collection of the artist.

This whimsical piece implies a symbolic journey. Trees, fields, and sky are glimpsed as if through the mind's vision of other places, and it seems that we could ride the dominating chairlike form like a magic carpet. The underlayers of paint peek through to give a mysterious feeling of territories not yet explored.

Artist Henry Moore once said, "Because a work of art does not aim at reproducing natural appearances it is not therefore an escape from life but may be a penetration into reality...an expansion of the significance of life, a stimulation to a greater effort in living." (This astute comment was quoted in John Read's biography *Portrait of an Artist, Henry Moore*.) There should be some mystery about art so that we continue to ask questions about the intent of the artist and about our own nature as we relate to what is before us. This is what keeps our interest alive.

For many generations, watercolor was used to record places and events. Now daring new concepts are being expressed through watermedia; old boundaries are being broken. As in any change from tradition, this direction is disturbing to those who do not wish to depart from the familiar. But there remains room for both approaches. During the time of searching by artists for new ways of thinking and creating, there are the inevitable false starts and digressions that later are discarded or modified until the full extent of the artist's intent can be expressed with strength and individuality. What is finally created is a visual statement of reality: the reality of the artist's mind. It may not reflect what is normally seen, but it may "penetrate," as Moore observes, to a deeper dimension of understanding. These are moments of wondrous insight for artist and viewer alike.

I was beginning to explore a form of abstract painting just about the time that the space age had made a major impact on the field of science. What greater mystery can there be than that of the cosmos? I was fascinated by the magnificent photographs taken from space, which communicated the beauty of our earth and galaxy so strikingly. Not only that, but the beauty is *abstract*, even nonobjective.

The abstraction already present in nature overwhelms us. We need not go to the telescope or the microscope to discover the miracles of shape and evolving form. The sensitive eye will notice these wonderful patterns in many familiar places, such as in the bark of a tree or in rock formations. We need only look, and think, and imagine. A new painting experience awaits once we learn to see in this way.

TRANSITION
Watercolor and acrylic on Crescent no. 114 cold-pressed watercolor board, 29 x 19" (74 x 48 cm). Collection of the artist.

Outer space was my subject, freely evolved from amorphous forms and transparent pigments. Structure was imposed gradually. I wanted to convey the feeling of reaching out, of going beyond the common boundaries of existence. A window effect and a sense of motion enhance the sense of penetrating into distance. Note that only a small section of the painting literally indicates the darkness of space.

CONNECTIONS: ART, MATH, NATURE

Artists must find ways to divide visual space so that they can express their ideas with the greatest compositional impact. Rochelle Newman began exploring this idea some years ago in her search for the connection between art, mathematics, and nature. She discovered that through the discipline of geometry it was possible to "describe physical relationships about space that were rooted in the natural world."

Newman feels passionately about ideas that can be expressed through abstract images. She states, "For me, the essence of this world lies in abstraction—the general case that includes all the specific variations, much like the mathematical theorems." She approaches the geometry of the painting surface as a rectangular or square shape that has a ratio of width to length; then she examines ways to divide that interior surface into a meaningful visual statement.

In the well-known golden ratio, a line or shape is divided (by lines called golden cuts) in such a way that the ratio of the smaller part to the larger part is the same as that of the larger part to the whole. Many artists use this guideline to find an aesthetically pleasing focal point for a painting. Newman points out that this similarity of segment to segment and area to area "is connected to the natural world in many ways and with interfacing concepts of symmetry." Mathematicians think in terms of order, regularity, intervals, and placement in space. These same principles spill over into the world of art.

Artists searching for a sense of unified structure may use a grid pattern to imply a sense of order. The work of Mondrian comes immediately to mind. But representational work may also fit this pattern. For example, the enormous portrait close-ups of Chuck Close are all based on an overall grid pattern. Each is an abstract statement within itself, but when seen as a unified group, the segments coalesce into a recognizable portrait. Picasso's great cubist painting *Guernica* has an underlying grid pattern that adds an unseen compositional strength to the work but does not detract from its impact of the chaos and horror of war.

Through the use of computers, the field of mathematics has discovered ways to present graphic depictions of multiple solutions of nonlinear equations. These images are called fractals and have repeated patterns, many of which are quite beautiful. Some appear geometric, while others eventually take on an organic appearance. Newman has given the visual expression of an artist to some of these phenomena and has incorporated the forms within a grid format.

WITH WOVEN ELEMENTS
By Rochelle Newman. Acrylic on watercolor paper, 19 x 23½" (48 x 60 cm). Collection of the artist.

Here the passion for ideas and mathematical principles sings out from color and form. Newman determined where golden cuts should be made for placement on the surface sheet. Then she designed a pattern for a tiling unit by finding the golden cuts of a triangle. Some sections of the painting were slit open and woven, while in other areas the strips were laid on the surface. She states that the "arbitrary and the ordered were worked together to form a unity."

GRID VARIATION #1 WITH WOVEN ELEMENTS

By Rochelle Newman. Acrylic, glitter, and graphic tape on watercolor paper, 19 x 23½" (48 x 60 cm). Collection of the artist.

Newman creates many tapestries and likes to incorporate structure and a tactile quality into her works on paper—as well as an element of surprise. Taking sheets of watercolor paper that she had painted in various colors, she cut them into strips and began reorganizing them in the process of weaving. Golden cuts were used to subdivide the paper's surface, and the woven sections were placed in mathematically designated areas. Tactile points of paint were placed on the surface.

MOCK FRACTAL SOUP

By Rochelle Newman. Acrylic on watercolor paper with raised areas, 30 x 24" (76 x 61 cm). Collection of the artist.

Newman decided to generate fractal images through handwork and patience. "Inside the rectangle, each side of the pentagonal units was divided at the golden cut, and a smaller pentagonal unit was added at that point." Through the process of repetition, the unit was used to tile the painting surface. "In places, the paint was used to create a tactile element so that both sight and touch are engaged. Color became the element that was idiosyncratic: personal, whimsical, magical, not necessarily tied to logic as was the form."

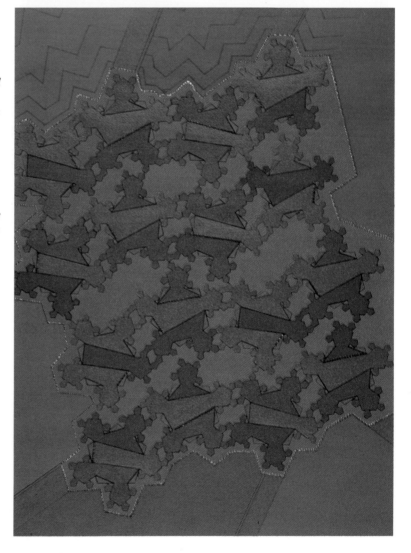

GRIDS AND GESTURES

Pat San Soucie spent many years of her life in the Midwest. She remembers the abundance of weeds and her art school assignment of doing weed contour drawings that later developed into paintings. She says, "...early groundwork of weed-strokes in all their gestures and wildness shows up in most of my work, still, whatever the subject."

Creating a painting, San Soucie feels, "is somewhat like losing one-self in a map, one that allows many entrancing ways of getting to an undefined destination. There are serendipities and pitfalls, side trips, view findings, and explorations along the way. Often the trip ends far from the original intent of the journey, but at a satisfactory rest area, anyway."

San Soucie's work exhibits a vigorous combination of gestural stroke and loosely defined but orderly grid pattern understructure. Her paintings burst with energy of movement and vibrancy of color, but always within their structural format. The unifying brushstrokes covering the surface become seismic marks of the inner rumblings of an active, creative mind. Fascinating obscurities entice the viewer to continue to search for hidden meanings and discoveries. This process alone keeps these paintings constantly activated.

BUTTERFLY HUMS AND SHOUTS
By Pat San Soucie. Watercolor and gouache on D'Arches 140 lb. hot-pressed watercolor paper, 33½ x 25½" (85 x 65 cm). Collection of Cornelia Mason, Larchmont, N.Y.

The artist strove to maintain the gestural spontaneity and still keep each brushstroke thoughtfully placed. Gradually the "natural bubblings and marblings" of transparent and opaque paint found their own logic. In the artist's words, "It was the unexpected patternings and yet the insistent upward motions of the pigment that kept the Butterfly title stirring. The light mood carried through in the colors, the gestures, and all the humming."

CONTAINER OF PURPLES
By Pat San Soucie. Watercolor and gouache on D'Arches 140 lb. hot-pressed watercolor paper, 22 x 30" (56 x 76 cm). Collection of the artist.

A field of weeds from long ago embedded its image in the artist's mind. The emphasis on grid and gestural brushstroke pattern appears again, but in a slightly different structural form. The white paper shows in sparks throughout the field. San Soucie had a lengthy pause in the painting process as she laid in the gray-blue area that gives definition to the darker, more colorful shapes. She feels that it is the contrasts and mixes of white paper, juicy darks, and matte outer grays that keep the long-remembered weed patch in mind.

EARTH ENERGIES

Many artists are fascinated by the power of geological forces: the energies that shape the earth over the millenia of time. As I explored this theme in my own work, I found that my paintings became increasingly abstract.

Jean Deemer has created a series of works based on natural geological forms. Her work crosses the line between painting and sculpture. She works on thick handmade paper that she can cut, deface, peel away in layers, and roll back so that areas beneath are seen. She is interested in showing the forces of nature in symbolic form, rather than depicting an actual formation or erosion.

After initial watercolor glazes, she may use a stabilo pencil to add line and texture. These markings are softened with further glazes. She constantly evaluates what she is doing, refines and revises areas by enriching or mellowing the surface. Designing the fractured areas is an important part of the design process. When she has decided where these broken lines should be, she carefully incises the paper, pulls back the top layer, and paints the areas below in contrasting tones. Within her works she attempts "to evoke a sense of mystery and invite the viewer to interact by becoming a part of the continuing creation."

Deemer successfully establishes a synthesis of complex ideas that draw the viewer past the surface patina to the inner depth of ancient rock through the inference of an immense passage of time and events. As we study these works, their inner symbolic power builds, and we realize that they can also be metaphors for human experiences. The fragments of life—all still part of a whole, some broken away, some neatly fused to other pieces, some small, some large—bring a deeper meaning to the work.

AMALGAM
Watercolor and gouache on Crescent no. 114 cold-pressed watercolor board, 29¾ x 19½" (76 x 50 cm). Private collection.

This work, one of a series on earth and space energies, is filled with erupting forces ready to burst from the picture plane. That turbulent energy is held in check by the structural elements in the background. The basic skeleton of a statement was created by strips of masking tape, cut in different widths. From there I worked intuitively from light to dark, and from outer shapes gradually into the interior. You can see where I dropped a great burst of fluid pigment on the surface and tilted the paper back and forth for proper effects.

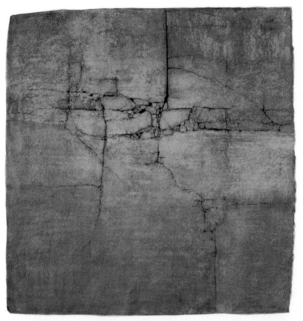
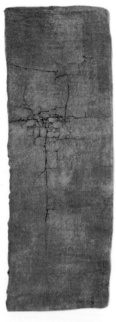

TIME FRACTURES: EARTH FORMS SERIES NO. 3

By Jean Deemer. Acrylic, ink, water-soluble crayon, and interference pigment on Indian Village 200 lb. handmade watercolor paper, 32 x 40" (81 x 102 cm). Collection of First Bancorporation of Ohio.

Here the artist has not only fractured areas of the paper, but has divided the paper into two unequal parts. The division helps to dramatize the deliberate brokenness of the composition and bring attention to the major portion of the painting. Because of the thickness of the paper and its inability to stay flat, the painting assumes a faint relationship to three-dimensional work as well as kinship to the archetype of rock itself.

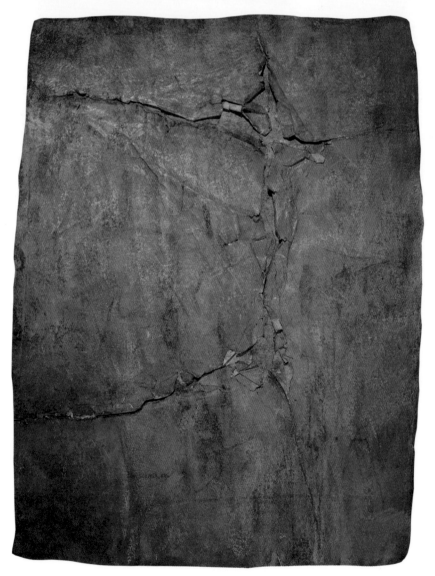

SPIRIT WALL: EARTH FORMS SERIES NO. 17

By Jean Deemer. Acrylic on Indian Village 300 lb. handmade watercolor paper, 31 x 23" (79 x 58 cm). Private collection.

Because the artist wanted the paper to become an integral part of the painting, she used a heavy handmade watercolor paper that has uneven edges and does not lie flat. Working intuitively, Deemer covered the paper with thin transparent washes of acrylics, alternating layers of warm and cool colors, and building textures through blotting, scumbling, or scraping. The fractured areas were created by incising the top layer of the paper, peeling it back, and painting the layer below.

COMBINING MEDIA

Artist Marian Steen finds that she can express nature's essence more effectively if she starts with a small thumbnail sketch or photograph. She often works in series and sometimes begins outdoors, where she can immerse herself in the "sights, sounds, and smells of the underbrush and try to weave these sensations into the paper by using color and texture." The location, the photos, and the sketches activate the fusion of conceptual and painting process. Steen chooses not to replicate nature, but to present the translation of her vision in abstract terms.

Steen combines watermedia with pencil, collage, oil pastel, crayons, and other media into paintings of unusual vibrancy. The opaque oil pastels act as a resist to the watercolor and leave a unique texture.

Sometimes she begins a painting by using the oil pastels to define negative shape areas and some linear forms. Over this she places washes of both darks and lights, letting the paint run as she tilts the board. She maintains just enough control to reserve some white areas that will later turn into images as she builds further glazes around them, creating rocks, stems, leaves, and flowers.

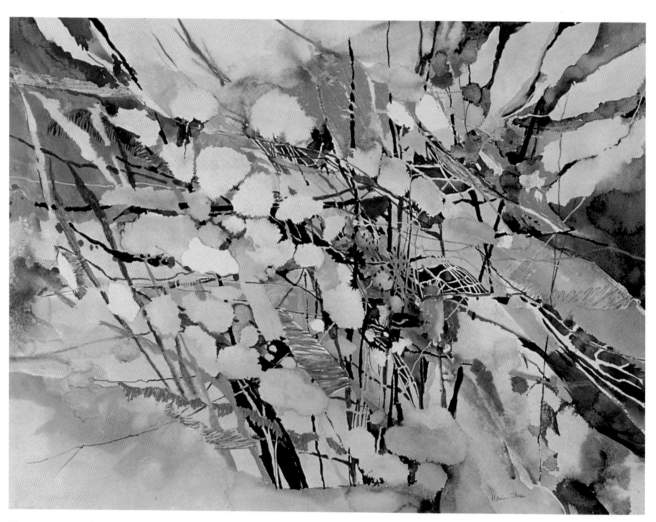

THICKET SERIES/COPSE
By Marian Steen. Watercolor, acrylic, watercolor crayons, pencil, and oil pastel on D'Arches 140 lb. cold-pressed watercolor paper, 22 x 30" (56 x 76 cm). Private collection.

Concerned with capturing the essence of weeds, Steen used oil pastels to create a water-resistant base of quick lines and dark negative areas. The addition of a wash of watercolor as it passed over these areas developed a bubbly texture. Completing the painting with additional glazes and selected opaque passages, she gradually defined the plant forms. "The stems became mere wisps of lines, but their delicate whiteness provided a contrast against a darker wash." Keeping the painting in a semiabstract form provided the desired visual excitement.

TOWARD HONEST EXPRESSION

Artists who use watermedia to explore new expressive territory often find that their artistic search has led them to a fuller understanding of the world and of themselves. They no longer paint objects, but more universal feelings and concepts that go beyond representational images—just as music can express more than words.

Jeanne Keck expressed what art has meant to her, "Certainly, art has enriched my life. I was interested in self-knowledge before I was interested in painting. The creative process has pushed me into new confrontations with myself. One can be aided by the teaching of art skills through art classes, but finally it is one's own insights, awareness of oneself, others, and life itself that teaches one to paint." She points out that honest expression of one's own creative ideas is not easy because we can be too easily influenced by "the learned ideas and techniques one gathers in classes, books, and museums that belong to someone else. The most difficult part of the growing process becomes the unlearning."

Keck keeps a journal where she records her thoughts in words, knowing that words can stimulate the nonverbal subconscious. For Keck, it is important to paint uninhibitedly, unafraid of self-discovery and willing to paint what she may not understand initially, in order to accomplish "that magical and ineffable communication of the universal."

Keck begins by drawing with a brush on the painting surface, adding spontaneous paint strokes, layering more drawing and painting on top, and continuing the process until it achieves an effect of depth, letting previous layers show through at selected areas. She wants the "artistic struggle" to be seen and experienced. This relates in some ways to similar procedural thinking by Katherine Chang Liu and Richard Diebenkorn. Individual working processes must suit the artist's personality, and Keck feels that this "hands-on, straightforward, no-gimmicks approach" suits hers.

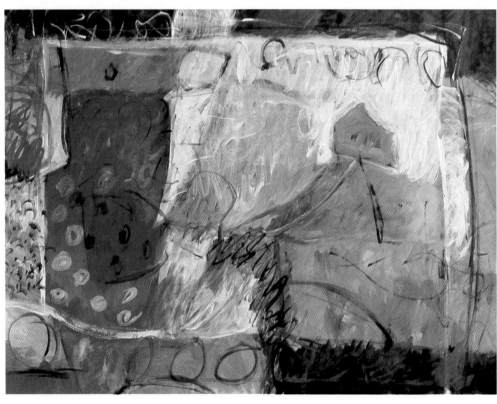

PICNIC IN THE COUNTRY
By Jeanne G. Keck. Acrylic on D'Arches En-tout-cas paper, 42 ½ x 52 ½" (108 x 133 cm). Collection of James Fenton.

Keck enjoys painting on large surfaces. These give her the freedom of physical movement to work in great gestural strokes, marks, and shapes, building layer by layer to the final statement. This abstract work refers in some personal way to the pastoral pleasures of life away from home. Notice the use of color and textural form to build a feeling of adventure. The artist purposefully does not tell all.

LIFE/PASSION/COMMUNICATION

By Jeanne G. Keck. Acrylic on D'Arches En-tout-cas paper, 38 x 48" (97 x 122 cm). Collection of the artist.

Here symbolic color, shapes, and line play against one another with passionate encounter. The building of texture and richness of surface is an important expressive conceptual means for Keck. She prefers surfaces to show some sign of the developmental process as one layer peeks through another. The linear form weaves in and out of the painting, unifying and accenting her statement.

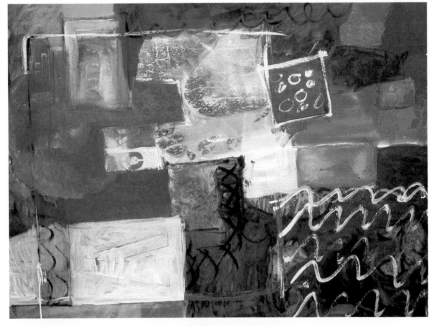

VESSEL I

By Katherine Chang Liu. Watermedia on Daniel Smith 300 lb. painting board, 39½ x 26½" (100 x 67 cm). Courtesy of Louis Newman Gallery, Los Angeles, Calif.

This painting grew out of the artist's interest in a singular, iconlike, symmetrically placed object. Liu's fascination with cultural history and her own cultural background led her to portray her subject as one abstract, symbolic image: the oriental vessel. The painting's multilayered surface expresses the imprint of manual work within the frame of time.

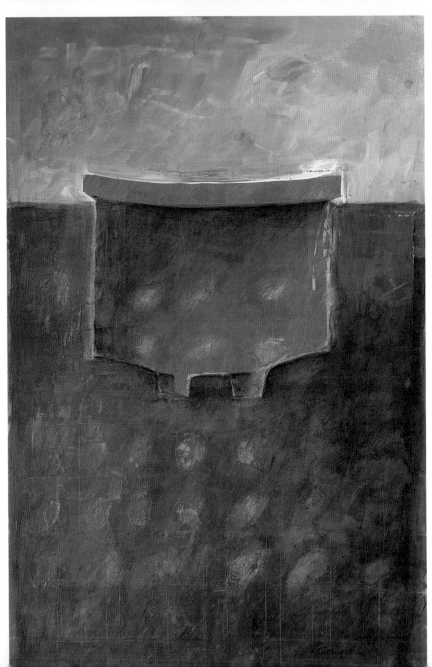

THE RELATIONSHIP OF MUSIC AND ART

Humanity has responded down through the ages to the beat of the drum, the note of the pipe, and use of the human voice. We dance, we sing, we respond heart and soul to those sounds. How can our art not be affected? Art may reflect an actual musical experience, or it may independently project the feeling of music within its structure by using the design principles of rhythm, intervals, and movement.

With the arrival of the twentieth century and its inventions of radio, television, and stereos, artists soon discovered that they could fill their silent studios with the music of their choice. For many artists, music is often their only companion during long hours of work. For others, music serves as a stimulus to energy or memory, as a deliberate reinforcement of the intended mood of a painting, or as a means to quiet the mind and center on the task at hand.

No matter what your musical taste, experiment with listening to music while you paint. If you are like many artists, you will find that music stimulates your creativity and enhances your work. You may also discover that listening to music while viewing a painting will enrich the experience. For example, I found that Sibelius's Symphony No. 4 in A Minor (sometimes called his *Psychological Symphony*) expressed the presence of the underlying energies I had painted in *Descending Angle*.

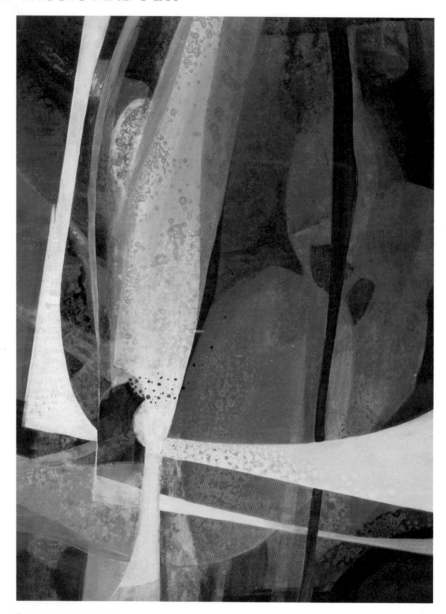

DESCENDING ANGLE
*Acrylic on Crescent no. 114 cold-pressed watercolor board, 30 x 40" (76 x 102 cm).
Collection of the artist.*

This work is closely related to musical form and expression. While listening to music, I began by masking off the structural shapes and then applying loose acrylic washes to the background. The painting unfolds rhythmically from the larger geometric shapes in the foreground to the softer, more organic forms, as if receding into the mysterious distance, but ready to burst forth again. Even Einstein recognized mystery as "the source of all true art and science."

CONCLUSION:
THE UNENDING SEARCH

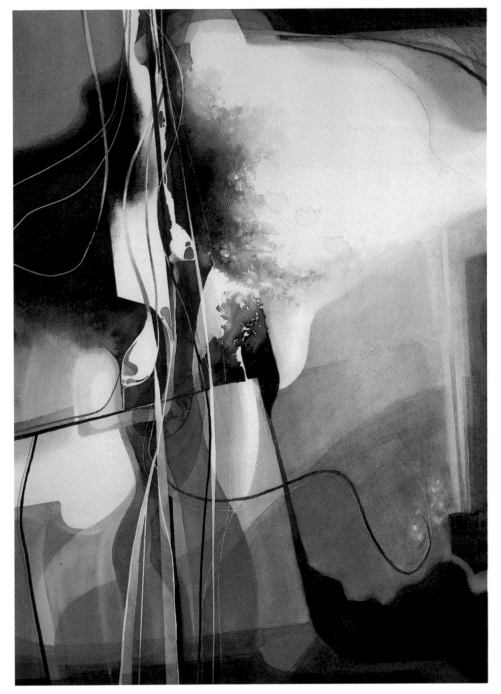

REMEMBRANCE
Transparent watercolor on D'Arches 300 lb. cold-pressed watercolor paper, 22 x 30" (56 x 76 cm).
Collection of the artist.

*This watercolor is full of symbolism involving my husband's illness, death, and
transition from this life. It speaks of pain, hope, separation, and beauty. The
drooping oval forms portray our night-blooming cereus plant, which was a great
joy to us both and bloomed once again shortly after his death.*

This book has given examples of watermedia painting by artists working in many creative ways, both from a technical standpoint and from the standpoint of seeing. Whether an artist is new in the field or has long years of experience, the search for more effective means of expression continues year after year. We continue to be students, for learning never stops if our work is to stay vital. There can be no sitting back and saying that this is it!

I once taught an introductory college art class of young people and a sprinkling of retirees. At the end of the course, one young man came up to thank me for expanding his vision of art. He ended by saying that at the beginning of the course, he had not been too excited to see the retirees, but he had found out that they too had something to offer. He had realized that people never stop learning, and he wanted me to know that he appreciated their presence in the class.

COMPETITIONS AND EXHIBITIONS

In the early part of your career, once you have reached some degree of competence and feel that your work has merit and shows signs of individuality, juried shows may be a way of testing how your work stands up against that of your peers. It is also a test of belief in yourself: If your work is not accepted, that may simply mean that the show is being balanced in a certain way, or that a juror may have particular preferences. Never lose belief in what you are doing. Use a rejection to learn, and go on to further improve your efforts. This is a time for growth.

When I jury national and regional exhibitions, I am often surprised and touched by the number of amateur entries. I know that these artists are excited about what they are doing, and they want to give the competition level a try. I always hope that they can learn from seeing the show of selected paintings or at least the award winners in the catalog, and that they will quickly recover from their disappointment at not being included in the show. This is when they face the bigger test of continued determination and exploring how best to make their artistic statement effective.

In the world of watermedia painting, organizations such as the American and National Watercolor Societies, as well as other national, regional, and state groups, have provided some opportunities for watermedia artists to exhibit their work. Many museums still tend to look at this medium as impermanent and at the work as inconsequential. Old prejudices hang on from the last century, when watercolor was given second-class status, mere preparation for more ambitious oils. There were breakthroughs now and then with painters such as Turner, Homer, Cezanne, and in our own century, Marin, Burchfield, Klee, O'Keeffe, Joseph Raffael, and others. In the later half of this century, great strides have been made in the use of watermedia, the development of more lightfast pigments, and the manufacture of oversize paper. Even greater strides have been made in watermedia expression, which certainly is as strong as in any other medium. There is a sense of creative breakthrough in watermedia that museums cannot long ignore.

SHARING AND CHALLENGE

This book was meant as a sharing of thought, of knowledge, and of the diversity of work within the range of watermedia painting. I did not hesitate to use some of my earlier work to illustrate one artist's progression through representational form to more abstract statements. The works of other artists were chosen to clarify certain topics of discussion. More importantly, they were chosen to inspire and challenge you in your work and conceptual thinking. You may not relate to all the work, which is only natural, but you can respect efforts and ways of thinking different from your own. There are many doors to opening creativity, and you may want to enter several before dedicating yourself to deeper exploration in any one direction.

My husband, who shared his life so beautifully and generously with me before he died, always enjoyed the art world. He was trained in law and accounting, but always found artists and their work fascinating for their openness and exploratory attitude. His world fascinated me and my world enriched him. It was a good combination.

Years ago when my parents died, I found an old newspaper clipping containing a poem that my mother had saved since the early part of the century. I never knew about this poem until after her death. The poem's author was listed as unknown, so I feel free to share it with you, as I have with others in some of my lectures. This is not great poetry—it is typical of the popular press of the day—but what it says rings with truth.

Here at the easel, the brushes at hand
Each, for a time, is permitted to stand.
White was the canvas when first we began
Ready to paint the picture of a man.
Now we splash the pigments about
Knowing the reds and blues must give out:
Soon we must turn to the dull hues and the gray
And paint the sorrows that darken the way.
Let me when trouble is mine to portray,
Dip, with good courage, my brush in the gray.
After sadness and sorrow, let there be
Something of faith for my children to see:
Oh, let me paint, not in anger or hate,
Grant me patience to work and to wait.
Make me an artist, though humble my style
And let my life's work be something worthwhile.

—AUTHOR UNKNOWN

INDEX